Convention and the Art of Jane Austen's Heroines

William H. Magee

Convention and the Art of Jane Austen's Heroines

William H. Magee

International Scholars Publications
San Francisco - London
1995

Library of Congress Cataloging-in-Publication Data
Available upon request

 p. cm.
 Includes bibliographical references and index.
 ISBN 1-883255-85-6: $69.95 - ISBN 1-883255-84-8 (pbk.): $49.95

Copyright 1995 by William H. Magee

All rights reserved. Printed in the United States of America. No part of this book may be used or reproduced in any manner whatsoever without written permission except in the case of brief quotations embodied in critical articles and reviews.

Editorial Inquiries:
International Scholars Publications
7831 Woodmont Avenue #345
Bethesda,MD. 20814

To order: (800) 99-AUSTIN

CONTENTS

I	The Art of the Central Heroine	1
II	The Conventional Heroine as Jane Austen Knew Her	13
III	Heroines in Two Worlds -- Parody and Protest in the Juvenilia	41
IV	Catherine Morland and the Double Delusions of Fiction	63
V	Elinor and Marianne Dashwood: Social Protest and Sensibility	77
VI	Elizabeth Bennet and the Golden World of Pemberley	95
VII	Fanny Price: The Passive Heroine as Social Outsider	113
VIII	Emma Woodhouse: The Active Heroine as Social Leader	135
IX	Anne Elliot: The Passive Heroine as Social Critic	155
X	Compromise with the Convention	171
	Notes	177
	Further Reading	189
	Index	191

CHAPTER I

THE ART OF THE CENTRAL HEROINE

Time, which has highlighted the artistic brilliance of Jane Austen's heroines, has obscured their fictional ancestry. Despite their considerable historical accuracy they inherit both the personal strengths and the social ambitions of their prototypes in the novels of the preceding generation. Beneath their vital wit and intense inner life, their essential characters and most distinctive responses to society are untypical of their times, and they are untypical in the same traits and concerns as those of their predecessors. While avoiding the extravagances in character and incident of the minor women novelists following Samuel Richardson in the last generation of the eighteenth century, Jane Austen adopted and adapted their distinctive convention. Her skill at portraying the life of her times has masked her allegiance to their stylized world. Their long neglect and her youthful parody of their tales have also helped to hide their legacy to her. Her early burlesque of their arbitrary art in her Juvenilia is informed as well as delightfully precocious. Her assumption of a detailed knowledge of it in even her last written fiction reveals a lifelong devotion to it. As Steeves observes, she "assimilated most of what the eighteenth century had learned of the novel through experiment."[1] Her transformation of conventional heroines from her teen-age skits through to her final *Persuasion* and *Sanditon* shows an ongoing development of the themes and techniques initiated by her predecessors. This perfecting of the inherited model became her underlying principle of continuity from novel to novel in her career as an artist.

(i)

The novel centred on a heroine instead of a hero provided writing women a unique outlet in Jane Austen's day. It attracted such diverse feminists as protesters like Mary Wollstonecraft, educators like Maria Edgeworth, and artists like Jane Austen. With women effectively barred by custom, lack of formal education, and contempt from the intellectual debates carried on by men in the journals, it offered them a public outlet for expressing their own concerns.[2] Their often limited knowledge also fitted them better for writing fiction rather than more learned prose. In their

fiction they implied and sometimes openly expressed their resentment at the discriminations which their sex encountered in every social institution of their times. Into it went their daydreams of an alternative society, for in it women could with some plausibility live for themselves and act as equals of men.

Artistically, the feminine novels created severe difficulties. In the male-oriented eighteenth and nineteenth centuries the women novelists faced two distinct but related obstacles, one social and one artistic. Society allowed women few if any obvious opportunities to initiate the decisive action needed to control their own lives, manage family business, or exercise leadership in public affairs. As a result it denied them plausible chances for the heroic action needed to dominate the incidents of adventure customary in male fiction. The traditional plot structure and characterization called for heroic action from men, but not from socially representative heroines. Novelists who wanted to dramatize the potential contribution of a heroine to civilized living needed to create different types of scenes and emphasize different character traits, and they had to do so from unspectacular lives. Unless the feminine novelists could invent plots which would free their central characters from the most oppressive restrictions on women, even this least biased form of writing would frustrate their objective. They needed a new or at least a restructured form to turn the example of Richardson into a theme of liberating ideals for women readers.

If discrimination barred a heroine from dominating a realistic story, her very resentment and resistance could still vitalize her. The social, financial, and educational slighting of women in eighteenth-century England included several assumptions which Richardson and his feminine followers refused to accept. The received social attitude favouring discrimination appears as the norm in masculine novels like *Tom Jones*. Fielding's hero thrives as a central character on the opportunities open to men in the life of the times, but those opportunities are what cause heroine Sophia Western misery after misery. To Fielding the social assumptions about women were facts of life. Sophia may resent but must accept distinctions like the intensive education of boys but not girls, the double sexual standard, and the right of a father to forbid the marriage of his daughter to the man of her choice. Richardson's heroines dramatize the decisive moments in their lives by objecting to such inequalities. Pamela the lady's maid with a mind of her own repeatedly struggles against the social code of Mr. B. and his neighbours, which tolerates his assaulting her at will. Clarissa resists in increasing

isolation her father's demand that she accept a marriage of convenience. She becomes actively heroic when she rejects the judgement of all the social leaders canvassed that marriage would atone for Lovelace's rape of her.[3] Harriet Byron uses her solid if eclectic learning to expose the masculine pomposity of an Oxford scholar contemptuous of women's minds. In none of these situations are Richardson's heroines representative of their society, as Sophia Western unhappily is, but in resisting its impositions on them they gain their artistic tension.

To Richardson his heroines may have been moral examples, but to his followers they became a social protest and artistic model. They anticipated a generation of independently minded heroines who were drawn from a literary pattern instead of directly from life. Reshaping Richardson's model, the feminine novelists constructed a fictional world in which a woman could centre and even dominate the society around her, as she could not plausibly have done in everyday life. By means of this fantasy they and their readers could dream of an escape from a life style which legally, morally, economically, educationally, intellectually, and religiously degraded them. They also inherited some of Richardson's power of protest. The indignation that seethes through his tensest scenes wells up at times in the novels of the next two generations. It gives Fanny Burney, Charlotte Smith, Clara Reeve, Elizabeth Inchbald, Ann Radcliffe, Maria Edgeworth, and their lesser contemporaries some of their most effective moments. Their feminine convention amused the teen-age Jane Austen for its extravagances, but she accepted its underlying vision of heroines whose range of knowledge and means of self-determination were equal to men's. In *Mansfield Park* she denounced the double sexual standard,[4] in *Pride and Prejudice* Elizabeth is wiser than her well-read father, and in *Persuasion* Anne Elliot asserts her right to marry the man who accepts her importance as a woman.

Of all the discriminations against women, the extreme authority of fathers over their daughters and husbands over their wives perplexed the feminine novelists the most. It frustrated their repeated attempts to develop central heroines who can think and act for themselves. In those patriarchal times unmarried women lived in total financial dependence on the sometimes tenuous bounty and good will of their fathers. Educational and social dependence usually followed economic need. Daughters who were worldly wise could scarcely allow themselves to develop an independent personality. Combining social fact with aesthetic theory, Charlotte Smith in the 1790's

reiterated Pope's assertion that "Most Women have no Character at all".[5] When old enough to become assets for a marriage of convenience--their family's convenience, not their own--they could expect to be passed on from the rule of their father to the rule of their husband. Social sanction of paternal pressure isolated the young woman who rejected the suitor of her father's choice, even in what Lawrence Stone describes as the less oppressive decades of the late eighteenth century.[6] Charlotte Smith was married at sixteen, and unhappily, so that she would not encumber her father's second wife. When women in the masculine novels accept subjugation as their lot on principle, they speak only as society encouraged them to do. Horace Walpole has Hippolita turn subservience into a moral precept in *The Castle of Otranto* when she tells Isabella and Matilda, "'It is not ours to make election for ourselves; heaven, our fathers, and our husbands, must decide for us'".[7] Such women could be heroines only technically. In the early years of the nineteenth century, after the scandal of Mary Wollstonecraft's biography impeded feminism, the parental tyranny reasserted itself more strongly than ever, as Lawrence Stone again remarks.[8] For a self-respecting central heroine such a social code could well mean tragedy, as it does for Clarissa. But tragedy was at odds with the prevailing literary temper. In that age of comedy, when happy endings were in vogue, the women novelists dreamed instead of independent lives for their heroines.

While rescuing their heroines from parental tyranny, the women novelists evaded or exaggerated it in their fantasies. In their novels the few kind fathers are apt to die early, like St. Aubert in *The Mysteries of Udolpho*. Many heroines are orphans, and so free from the most oppressive restrictions of the patriarchy. Long-lived fathers like Clarissa's are typically haughty, dogmatic and callous. Elizabeth Inchbald in *A Simple Story* and Charlotte Smith in *Marchmont* followed Richardson's caustic example with tyrannical fathers who humiliate their daughters and anticipate Jane Austen's more credibly difficult ones. Her best are apt to be foolish like Mr. Woodhouse, her worst cold and indifferent like Sir Walter Elliot. Almost every one hinders rather than helps on the maturing of his daughters. The indolent, self-centred Mr. Bennet merely neglects his girls, but the austere Sir Thomas Bertram almost forces his to disgrace themselves. Both create an environment which drives daughters away from home, to the shame of Lydia Bennet and the ruin of Maria Bertram. Taken together, these patriarchs

continue a standing protest of women novelists against the treatment of marriageable daughters.

From fathers to husbands, from husbands to all other men, the tale told by these storytellers records the tyranny of the patriarchal society. Clergymen, lawyers, business men, all expected to control heiresses and their assets. At best a married Pamela lives in dread of displeasing her self-satisfied husband. An Amelia Booth must pay with her own misery and that of her children for her husband's extravagances and delinquencies. Heroes in masculine novels grow in stature in such surroundings and accept them without thanks. Heroines in the feminine novels have to occupy much of their thought and energy struggling to break free from enervating restrictions. For a Clarissa, doing so could become a career that absorbs her thoughts, her actions, her prayers, her correspondence, and ultimately her life. On the women novelists this social inferiority imposed their major handicap. Representative women of the times were passive dependents rather than positive individuals working out their own lives. But these novelists, including Jane Austen, refused to accept this oppression as inevitable and devoted their art to providing case histories of feminine independence.

(ii)

The artistic difficulty of the *central heroine*, the heroine who dominates a plot instead of serving a central hero, baffled most dramatists and novelists before the twentieth century. She required a different species of incidents from the physical adventure of masculine romances. Jane Austen's feminine predecessors had happened on an especially difficult form of fiction which would have intrigued an ambitious young artist like her who was looking for a challenge. Until the late eighteenth century few writers had tried to centre their plots on women, and few of those who tried had succeeded. They were frustrated not only by the social limitations on women but also by the unsuitability of the techniques of a male-oriented art for their purpose.

A theory to define their artistic difficulty was not formulated and its implications explored until 1908. In the "Preface" to *The Portrait of a Lady* Henry James noted that the great heroines of Shakespeare and George Eliot "are typical ... of a class difficult, in the individual case, to make a centre of interest." Even of these authors he notes that "their concession to the 'importance' of their" heroines

> suffers the abatement that these slimnesses are,
> when figuring as the main props of the theme,

never suffered to be sole ministers of its appeal, but have their inadequacy eked out with comic relief and underplots.⁹

As James concluded, no central heroine could dominate the standard stories of martial or other physical prowess or public influence without losing the feminine traits which made her representative of her society. A St. Joan can control the action of a plot only because she is unique as a woman. She acts like a man in a man's world. Nor could women in earlier centuries converse with the men in their stories about theories and principles, even those involving their chief concerns in life, without looking eccentric. Mrs. Shandy has by far the greatest influence on the upbringing of Tristram, despite all the abstract discussions on the subject by his father Walter and his Uncle Toby which constitute the bulk of *Tristram Shandy*. Yet as a practical theorist no one is more voiceless, and it is difficult to see how she could have been otherwise without losing her typical traits as a housewife. Jane Austen also knew that she could plausibly allow Anne Elliot to argue at length only on a very feminine topic like the durability of women's emotions.

Henry James followed his definition of the artistic problem with an explanation of his own solution when telling the story of Isabel Archer. He described two techniques for dramatizing her social and artistic significance which complete his theory of the art of the central heroine. The first one, the "trick" as he called it, is to present her through her relations with other characters. Yet how substantial such relationships could make her is dubious if they are to be the chief method of characterizing her. James recognized this weakness when he advised playing down her dealings with men. This "trick" might suffice in a nunnery, but a girl's relations with the hero must be the most important in a love plot. That was the very plot expected in the tradition of comedy out of which the eighteenth-century novel grew. James preferred his second technique, dramatizing the heroine's inner life. As he remarked, the heroine is an individual whose "relation to herself" must be made to matter: "'Place the centre of the subject in the young woman's own consciousness'".¹⁰ Although James first formulated the problem and these solutions to it, in practice neither was new with him. In the beginning of the novel as an art form Richardson had demonstrated the difficulty and worked out both responses to it for his feminine followers.

Richardson solved the problem of the central heroine with a success which would have fascinated an artistic disciple like Jane Austen. A glance

at his solutions shows what the aesthetic perception of the difficulty would have been as it came to her. Anticipating James's theories, he developed conflicts for Pamela and Clarissa through which each heroine comes to matter more than anyone else to the other characters in their novels, and he dramatized the inner agony of their struggles. As a result he created two unforgettable individuals with a heroic independence of their own, though they were far less representative of their society than Sophia Western was. For those who understood, like Jane Austen, it was a successful lesson in the two techniques which James was to formulate as theories. In particular, as Pamela grows into the absorbing goal of Mr. B.'s life, she gains depth and maturity. Then she dominates the story as the despised young woman of her times fighting for civilized treatment, and at a level at which she is as effective as any central hero. With a still more basic urge for independence, Clarissa struggles to convince her more populated and so more socially oriented world that her thoughts and actions are superior to its. By refusing to acquiesce in the expectations of her family and society about marriage, she forces her mind and emotions to delve into the philosophy of marriage and so to posit a new and more egalitarian ideal. By doing so she grows into a convincing heroine. Without a marked moral and intellectual divergence from her society, she could not give the lie to Lovelace's assumption that women are inferior to men. His contempt would have seemed a truism in the days of Lord Chesterfield and his assertion that "women, then, are only children of a larger growth".[11] In such forbidding times Richardson created a literary climate in which a positive image of a central heroine was possible.

(iii)

Although Richardson featured the hero in *Sir Charles Grandison* (1754), the heroine shared in its extraordinary influence in establishing such literary fashions as the docile suitor, voluable sensibility and actively literate women for novelists of the next two generations, including Jane Austen. As a representative young lady of her times, Harriet Byron, not the social-climbing servant Pamela or the near perfect Clarissa, would have seemed the model young lady of her society to Fanny Burney and her followers. In the first half of the first volume Harriet also provided a compact model for novels centred on women. She is the dominant character before the flirtatious villain kidnaps her and Sir Charles appears to the rescue.

Early in the novel Richardson developed a handful of devices which his followers seized on as arbitrary solutions to the problem of the central

heroine. As the novel opens, he has freed Harriet from the authoritarian rule of a father of the times. She is the archetypal orphan leaving the country home of her girlhood for London. By this device Richardson replaced the spirited resistance which establishes the heroism of Pamela and particularly Clarissa with a mere air of independence. The air was much the easier for his successors to reproduce. In an age when a typical father and daughter relationship would leave a girl silent and submissive, an orphan could open a novel with an aura of personal freedom. This initial assumption so attracted novelists with central heroines that it became routine for them to start their stories with teen-age orphans. As a result they also created a self-contained world for the heroine by giving her a new beginning in life after the dependency of childhood was ended.

Once in London Harriet attracts a society around her through several other devices which were also to become conventional. First, her beauty, which is all facial, became a prototype for a static image of superiority. Richardson stressed Harriet's fair complexion glowing because of a sweet temper, her healthy cheeks and unadorned hair, and especially her lustrous eyes. Together they persuade one rake with views parallel to Lord Chesterfield's that "women *have* Souls. I am now convinced they have".[12] Then Richardson surrounded her with suitors attracted by her beauty. By judging and rejecting them, she comes to dominate her London society. Yet for Richardson, Harriet's greater excellence lay in her inner assets--her moral strength and her intellect. Her virtue, learning and reasoning became repeated attributes for heroines, but unlike most of his disciples he not only praised but dramatized his heroine's superior mind. He had her expose the Oxford pedant by defining his university as the "*lesser*" in contrast to the "*greater*" that is the world.[13] Before she surrenders the narrative centre to Sir Charles, she has come to control the early plot. Yet these assets, which are mostly undramatized traits, leave her more dependent on the hero than Pamela or Clarissa is. Developed chiefly through them, she has become an ominously static pattern for scores of socially disaffected heroines.

In the main plot which follows, Sir Charles himself helped to establish a fictional etiquette which if dramatized judiciously could allow women to dominate the men in their novels. After his violent rescue of Harriet, his main function is to behave like a gentleman and wait while the women decide which one will marry him. This "truly good man" of "un-ostentatious merit" is kind to heroines technically as well as socially.[14] He supplanted the heroes

of romantic adventure with a new type of hero who is less formidable for them to control. In Lovelace and again in Harriet's abductor Richardson villified the old type of hero and replaced him with a new convention--the gentle man.

Sir Charles Grandison further anticipated the feminine novels by stressing sentiment as the active agent in courtship. In an age of arranged marriages, when family interests of class and wealth typically overshadowed or excluded personal feelings, emotional indulgences enhanced the importance of love, and so of heroines as individuals. In the ensuing novels of *sentiment*, or a delight in emotional rather than intellectual responses to life, and *sensibility*, or, often, a concern for the proper degree of emotional response, women could at last be on equal terms with men in literature. For a century oriented towards reason and against feelings, the tears which men like Belford and Sir Charles as well as women like Clarissa and Harriet forced out of readers like Dr. Johnson gave heroines a new stature. Richardson increased the artistic appeal of distraught heroines like Clarissa sitting beside her coffin through the intensity of their inner response to violent men. With a more peaceable man like Sir Charles even a weeping Harriet could be made to seem prominent through tears. Sir Charles may be calm, but the sentiment increases steadily for Harriet in his part of the novel as she has to endure the agony of recopying his letters about the courting of Clementina. By enervating the masculine passions with sentiment, Richardson helped to emancipate heroines artistically for two generations.

(iv)

In undertaking the challenge of the socially representative heroine, the feminine novelists looked back to Fielding as well as to Richardson. They derived at least two crucial features of their version of the courtship convention from the manners tradition--a stance and a theme. It was oriented to public rather than private family life and to the more social implications of proposals of marriage. The advent of the comedy of manners in the late seventeenth century increased the possibility of representative women becoming heroines in their own right, as Congreve had shown in *The Way of the World*. In a battle of wits a Millament can remain feminine and yet emerge as at least as substantial a character as a Mirabell in social encounters. She bids fair to remain his verbal equal in a marriage in which flows of wise words will give durability to the happy ending as the acme of civilized living.

The novel of manners improved the prospects for representative central heroines, but it also exposed their artistic difficulties. Fielding its creator fixed on a panorama of everyday life rather than the exclusively masculine events of war and physical adventure as one of the essential attributes of his comic epic in prose. When the women novelists narrowed the panorama to the drawing room and the dance floor, they could retain its social perspective while redesigning the male-oriented plot. Guided by Fanny Burney's example, they formed a centre around a heroine opposing both a hero and a villain for control of the action. Then they characterized everyone else, including the Grandisonian hero, in terms of his attitude to the heroine's struggle. Yet the trait of respectability still made it difficult for a heroine to dominate representative social situations. She could not control men overtly without seeming shrewish, and she had to acquiesce to them like a lady in scenes reflecting the literate society of the times. Harriet Byron has to be coaxed to proffer each new argument against the Oxford pedant. Novelists who abandoned respectability could make their central women unforgettable. Defoe turned girls of the street like Moll Flanders and Roxana into memorable women of the times, but he offered no example of how to turn respectable ladies into heroines.

More purely artistic restrictions on central heroines also baffled the feminine novelists. The novel of domestic manners, which was the most liberating genre available, still required incidents which were awkward for women to control. Although its variation on the courtship and marriage plot featured the one time of life in which the voice of eighteenth-century women was heard, it was far from the loudest. In a socially representative plot a man would still be expected to initiate and a woman only respond to the dramatic events in a courtship, as Richardson had so violently shown. Even when the parents were not arranging a match, a lady could only listen, and accept the lead from a man. She could neither woo him nor open a typical proposal scene and remain representative. A hero in love might be dramatized like Tom Jones as actively in pursuit of women, struggling to break free from mistresses, or opposing marriage to other ambitions. Such vitalizing conflicts were closed to ladies. A woman's life was mostly in the home, and any prominence of hers in social assemblies amused males like Sir Anthony Absolute. When Sheridan dramatized such gatherings he satirized women as stupid and frivolous. At home too wives and daughters were not expected to make the crucial decisions which decided the fortunes and prestige of a

family, even if their marriages were the means to that end. It is Clarissa's insistence on doing so that leads to her tragedy.

Faced with such a restricting concept of the role of young ladies in society, the novelists who tried to centre plots on them were repeatedly frustrated. Every move towards making a central heroine memorable made her unrepresentative--if not a disreputable Moll Flanders, then a near perfect Clarissa. Consequently only a few central heroines are actually typical of the life of their times. They may stand out in unique situations,but they sink into domestic obscurity when they revert to a normal role. In a pale galaxy of faded ladies Sir Walter Scott drew a memorable heroine in Jeanie Deans. She dominates even her stern father and seethes with a vital inner agony during her sister's trial for child murder and on her heroic walk to London to implore the king's pardon. Although brilliant in this unique role, she sinks into domestic banality in her later role as Mrs. Reuben Butler. In this triumph Scott advanced no nearer than Defoe towards solving the problem of the representative central heroine.

To succeed as heroines, typical young women had to dominate scenes without the feats of physical endurance and roles of public influence which gave instant prominence to heroes. They had to affect and even direct other characters without seeming aggressive or shrewish. Above all they had to create and centre a social milieu that generally resembled the life of the times but also emancipated women from its most severe restrictions. This was the challenge that Richardson's feminine followers encountered. In attempting to meet it they developed their own pattern of the courtship and marriage convention, and Jane Austen directed her greatest artistic effort to perfecting it. As master craftsman among English novelists she was the best qualified to do so.

CHAPTER II

THE CONVENTIONAL HEROINE AS JANE AUSTEN KNEW HER

During the two generations between *Sir Charles Grandison* (1754) and *Sense and Sensibility* (1811) dozens of feminine novels created the model which Jane Austen was to develop. Their central heroines anticipated hers as both figures of protest and artistic studies. Their novels suggested the numerous details of character, incident and language in her juvenile and mature fiction that Frank W. Bradbrook has noted.[1] She was so familiar with them that they stirred her creative mind even as she was writing some of her greatest scenes.[2] Their legacy of details appeared in her writing to the end of her career, but their total impact was the larger inheritance. These works of her predecessors formed her concept of the novel, introduced the themes that she probed, and first met the artistic obstacles that she had to overcome. The best surmounted the social if not the technical difficulties involved in drawing central heroines. At the same time they so stylized the convention and exaggerated its daydreams that a great artist had to redirect its perspective towards everyday life to make the social commentary relevant and the art effective.

(i)

More than Richardson, Fanny Burney fixed the social and artistic model of the heroine for the next generation of women novelists. Although this able diarist was by inclination a conservative reporter of her times, she sensed that young ladies were yearning to order their own affairs. While inclined to represent their typical life in her novels, she contrived situations in which they could think and act for themselves. The "Preface" to *Evelina* (1778) singled out the decisive moment in a young lady's life, when she entered society to look for a husband, and extended it into half a year:

> ... a young female, educated in the most secluded retirement, makes, at the age of seventeen, her first appearance upon the great and busy stage of life; with a virtuous mind, a cultivated understanding, and a feeling heart, her ignorance of the forms, and inexperience in the manners, of the world, occasion all the little incidents which this volume records, and which form the

natural progression of the life of a young woman of obscure birth, but conspicuous beauty, for the first six months after her ENTRANCE INTO THE WORLD.[3] For these six months Fanny Burney carved out a brief period of independence unusual for a young woman then. With no living parents and removed from her guardian on prolonged visits with friends, Evelina like Harriet Byron is living as much on her own as she could plausibly have done. THE WORLD open to such a girl was narrow, consisting here of the public amusements available in London and a fashionable spa, but she is allowed to make her own way in it. Before leaving it, she determines the course of her future life by choosing one of her suitors to marry.

Evelina's "ignorance" and "inexperience" helped carry out the avowed intention of drawing her character "from nature", but her extended period of coming out allowed her a spell of freedom which was more fantasy than a just representation of life in her time. Fanny Burney had managed to create a gap of independent living for her heroine between the authority of her guardian over her childhood and the rule of her husband over her married life. Perhaps without fully realizing it, she had hit on a brilliant choice for a heroine who would represent the aspirations of eighteenth-century women. Such a gap occurs in almost all the feminine novels of the succeeding generation, including Jane Austen's.

As a character Evelina combines the example of Harriet Byron with some arbitrary but potentially heroic traits of her own. Following Richardson, Fanny Burney introduces her as an orphan grown up and fully educated when the story begins. Like Harriet Byron she is leaving her girlhood home on a series of visits which constitute the novel. Soon her new social world is similarly revolving around her as she attracts admirers with her beauty. The man whom she most wants to please, Lord Orville, is a placid gentleman drawn on the Grandisonian model. He is taken with her allegedly witty conversation, unaffected simplicity, and common sense, all of which she passes on from Harriet Byron to her literary daughters. As her circumstances and traits became conventional, so they became exaggerated. Evelina inspires the spa rhymster as his ideal of human beauty in his verses on "The Beauties of the Wells",[4] and a sensational though humiliating reunion restores the orphan a living if not devoted father. Devices like these give Evelina a certain static prominence as a heroine, and they sufficed for most of her fictional offspring.

What the latter seldom share are her life-giving embarrassments and dilemmas due to her lack of social experience.

A girl like Evelina would look naive rather than heroic when coming out into society, and Fanny Burney assigns her no special learning or insight. What little formal education was available to girls then was rarely solid. It stressed superficial *accomplishments*--deportment, dabblings in the arts, smatterings of French and Italian. Evelina lacks both a formal knowledge like Harriet Byron's, which some authorities considered detrimental to the feminine career of marriage,[5] and the social insight to assess and restrain false suitors. She can tell that one man is an anti-feminine fop and another a masculine jester, but she cannot discourage them with grace and finality because of "her ignorance of the forms, and inexperience in the manners, of the world". Soon she faces unwanted and deceitful attention from the bold Sir Clement Willoughby without knowing how to silence him. This clash of initial excellence with embarrassed indecision creates a vital tension in her character, though it weakens her role as heroine. It leaves her looking simple. Yet it helps her to carry conviction as a figure of protest, for it captures the agonies of girls in a restrictive society. Less sophisticated than most of her offspring, she brings their problems to life with the same zest of innocence that adds charm to Catherine Morland in *Northanger Abbey*.

Yet although spirited as a youthful observer of class manners, Evelina lacks strengths of character which are relevant to the love story. Whereas Catherine Morland matures as Jane Austen creates social obstacles for her to surmount, Evelina remains static and sometimes uninvolved. She can act decisively if none too plausibly to prevent her brother's suicide by seizing his pistol, but she cannot take charge of her own fate. In the unifying courtship and marriage plot to which Fanny Burney here committed the convention,Evelina is only nominally a heroine. Credible though she is in her social inexperience, she looks immature when sizing up the men she meets.

Though untrained for entering the social world, a girl like Evelina had quickly to master the subject of evaluating suitors, as Jane Austen saw from the beginning. The curriculum was parties and dances, but the final examination was a future of happiness or misery. As heroine of no more than her own life she would have to judge rationally between a manly but quiet Lord Orville who respects her as an individual and a brash Sir Clement Willoughby who treats her with contempt. Evelina is given the chance to judge between them, but she trivializes it. When she is forced by the

epistolary format to justify her preference, her standards turn out to be neither shrewd not searching. A letter forged by Willoughby to discredit Lord Orville offends her for its "impertinence" and her guardian for its "impropriety".[6] They have no better reasons to offer. In face-to-face encounters as well, Evelina judges her suitors by an air and a look, tests of politeness rather than the respect of men for their wives. In contrast Jane Austen's heroines are actively judging their suitors as early as the juvenile "Catharine". Later, in *Northanger Abbey*, Catherine Morland assesses John Thorpe as a boor by his words and actions long before he proves to be as dangerous as Sir Clement in lying about the heroine. Fanny Burney established the convention by relating the traditional love story to the facts of a young woman's life in the late eighteenth century, but she left it for her great follower to develop and dramatize.

In another innovation Fanny Burney found a sound technique for providing her heroine with the decisive role in her love story, if only for six months of her life. She discerned the logical principle for unifying the traditional plot of courtship around a heroine. She inverted the familiar love triangle by basing it on the heroine's choice between rival suitors rather than a hero's clash with a villain over her fate. Again she missed fully exploiting the technique to her heroine's advantage. Hounded by Willoughby and convulsed to tears by a kind word from Lord Orville, Evelina waits to be chosen rather than actively deciding between the two. For her there is no calculated rejection of the suit of an emotional bully like John Thorpe in *Northanger Abbey* or Henry Crawford in *Mansfield Park*. She fails to mature in self-confidence as Catherine Morland and Fanny Price do after judging and rejecting high-handed men.

In even more of an anticlimax Fanny Burney summarizes rather than dramatizes the scene of Lord Orville's proposal to Evelina, which is the proper climax of the courtship plot. The heroine ends her experience of unusual independence without any sense of triumph. Evelina may understandably admit, "I cannot write the scene that followed, though every word is engraven on my heart", but she cannot retain her role as central heroine without doing so.[7] Nor does she defer her acceptance as an assertion of feminine independence, but because she is too dutiful a ward to act without consulting her guardian, the man of her girlhood. Embarrassed and anxious, she remains convincing as a girl of her times, but as a central heroine she endures the domination of others rather than determining her own future.

Jane Austen's heroines may share Evelina's modesty in their proposal scenes, but they do decide for themselves whether to accept or reject their suitors.

Evelina's few months of living on her own conclude not just with her betrothal but also with a restoration of family rights in a melodramatic conclusion which also became conventional. She is reunited with her father in a sensational meeting which further detracts from her force of character. Perhaps as a costly price for her earlier independence as an orphan, Evelina pays the debt of an improbable explanation of her ancestry. It also exhausts her stamina. When she finds her father fostering an imposter whom he prefers to her, she lacks the resilience of later heroines in the convention. Lord Orville and a Mrs. Selwyn, who is scorned as a woman for acting with determination in mixed company, have virtually to drag her before him. This subservience, which amply illustrates Tompkins' view that women then cultivated their own degradation, cuts short her serious development.[8] It is outside the courtship plot, alien to the novel of domestic manners, and beyond the experience of representative young women.

As the character who turned the example of Harriet Byron into the convention for a generation, Evelina provided a model of mixed value. She outlined the traits and incidents which had to be filled in if they were to dramatize the potential independence of a heroine in her relationships with the men in her society. The initial observer entered into the social life of London with zest, but the further she made her way into it the more it subdued her spirit. She trifled away her advantages of the time and opportunity to choose her own husband until she lost her very identity in the final melodrama. Yet by creating the gap between parental and marital authorities, outlining the image of superiority, basing the love triangle on the woman's choice, and encouraging the heroine to judge between suitors, Fanny Burney fixed the format of the feminine convention for her many followers, including Jane Austen.

(ii)

The women novelists who followed the example of *Evelina* in the 1780's and 1790's turned it into the convention that meant the *novel* to Jane Austen. A few particularly impressed her. She singled out Fanny Burney's two novels of these decades for special praise in *Northanger Abbey*, though they stereotyped the themes and techniques as thoroughly as any others.[9] *Cecilia* (1782) opens with the static image of a superior heroine and raises the

crucial topic of her independence only to leave them unexploited. Cecilia looks like dozens of minor heroines of these decades in her initial excellences:

> her form was elegant, her heart was liberal; her countenance announced the intelligence of her mind, her complexion varied with every emotion of her soul, and her eyes, the heralds of her speech, now beamed with understanding, and now glistened with sensibility.[10]

Traits like this beauty, generosity, sense and sensibility start Cecilia and her literary sisterhood off as the superior people in their novels but remain so static that the heroine fails to dominate the ongoing action.

Cecilia also starts out with the rare--and unrepresentative--personal independence of not just the orphan but an heiress with a fortune contingent on her keeping her maiden name on marrying. Self-determination for young women promises to become a theme of the novel, justifying the assertion that she is "mistress of her destiny".[11] Instead, a subservience as total as Evelina's soon follows, as the men in her life thwart her potential freedom and with it any active heroism. Men in those days were not used to respecting independence in a woman, but Fanny Burney exaggerates their disregard of it. One guardian abuses Cecilia's generosity and sensibility by threatening to cut his throat unless she give him her inheritance. Another so scorns her socially that she agrees to a secret marriage with his son, Mortimer Delvile, despite the moral stigma it then involved. So in more plausible ways would Wickham in *Pride and Prejudice* try to seduce Georgiana Darcy for her fortune and Frank Churchill in *Emma* subject Jane Fairfax to the indignity of a secret engagement. Jane Austen found hints in Cecilia's story for even some of Elizabeth Bennet's brilliant scenes with Darcy, but she could find no pattern for the self-assertion of heroines against overbearing men.

In *Camilla* (1796), to which Jane Austen was a prepublication subscriber, Fanny Burney developed a heroine more representative of girls of her times. Unlike Cecilia she also acts independently for most of the novel. Although not an orphan for once, she has the freedom of the tourist. In the beginning she is a typical teen-age daughter of those days made to stand out from her family by acting positively in times of stress, like an Elizabeth Bennet. Camilla has to exert herself to reconcile her conflicting loyalties, to her father and her sibling, as Elizabeth must do when advising her father about not sending Lydia to Brighton. She also works to protect her crippled sister Eugenia from the cruelty of their spoilt cousin Indiana, just as Marianne

Dashwood in *Sense and Sensibility* tries to shield Elinor from Mrs. Ferrars' contempt. Fanny Burney also provided Camilla with the necessary freedom from a father in prolonged visits in which she makes friends with women of her own choosing. Unfortunately for her independence they prove too costly for her purse. They in fact lend support to the enslaving demand of her preferred suitor, Edgar Mandeville, that he select her women friends for her. With a similar though less haughty interference Knightley urges Emma Woodhouse to make a friend of Jane Fairfax rather than Harriet Smith. When the extravagant climax also supports Edgar's demand, Camilla like Evelina and Cecilia comes to look like an eclipsed heroine obscured by a man's world and needing a man's guidance in it. Yet Fanny Burney's followers found an attractive vision of self-importance in her heroines for girls aspiring to lead their own lives. So apparently did Jane Austen, though she must have wanted to strengthen the realism, intensify the characterization, and deepen the significance of these once independently minded heroines.[12]

In the early 1790's Charlotte Smith typified the feminine convention particularly well. In the juvenile "Catharine" of 1792 Jane Austen treats her as the current popular novelist.[13] In her nine novels heroines reminiscent of Harriet Byron and Evelina struggle more consciously for personal freedom, but in an increasingly bizarre world. The first novel, *Emmeline, the Orphan of the Castle* (1788), creates the most positive heroine and develops her struggle for independence the most skilfully. Unlike Camilla, Emmeline earns the right to make up her own mind as to women friends and suitors. While doing so, she also discovers an active occupation for herself in those forbidding days. Apparently another poor and illegitimate orphan like Evelina, Emmeline is hounded by her guardian uncle in the conventional way because his son Delamere loves her. Responding with a rare stamina, she sets out to live on her own and makes friends with various women, some of whom unlike Camilla's are reliable. These include Adelina Westhaven, a seduced and pregnant young woman whose plight inspires Emmeline to act forcefully. She protects Adelina during the birth of the baby and later cares for both mother and child. As a result she wins the love of Adelina's brother William and eventually marries him. In a similar though less sensational incident Elizabeth Bennet earns the right to become Mrs. Darcy by preserving Georgiana's family secrets during the Pemberley tea party. Emmeline's many miseries result as usual from men--her scornful uncle, his malicious lawyers, and the neurotic Delamere. Her trials become increasingly melodramatic,

though despite critical tradition they are not Gothic. Slowly worn down by Delamere's hot and cold ardour into briefly accepting his suit, she finally asserts her hard-won self-reliance by rejecting him. Apparently it was improper if not immoral for her to do so. Sir Walter Scott, though a generous reviewer, criticized this change of heart as the novel's one flaw.[14] In such a hostile climate of opinion, a convention which applauded a woman for rejecting overbearing suitors would encourage both the feminine novelists and their women readers.

Emmeline deserved to inspire Jane Austen, but Charlotte Smith's later novels must have disappointed her. Still, details from each of the other eight echo through even the most mature of her own.[15] After beginning with the active and self-reliant Emmeline, Charlotte Smith turned aside to passive and submissive girls like the nature-loving heroine of *Ethelinde, or the Recluse of the Lake* (1789) and the routinely humiliated Monimia in *The Old Manor House* (1793). Unlike Emmeline they make no plans of their own and no considered choices between suitors. Instead like Harriet Byron before them and Fanny Price after them they wait for their one true love to come to them. Their appeal depends not on their initiative but on their pathos and the increasingly extravagant plots. These now include the temptation of illicit love. One of Ethelinde's admirers is her married host. In *Celestina* (1791) another Willoughby, the suitor of the homeless heroine, comes to fear that he is really her brother and deserts her. The married Geraldine Verney of *Desmond* (1792) waits in misery until she can marry her true love when her husband dies. In all these novels the heroine can escape humiliation in a masculine world only by wedding the one man in the story who respects her as a woman. Althea Dacres of *Marchmont* (1796) lives in secluded disgrace rather than marry her father's ruthless lawyer. For these passive heroines freedom is a daydream of the convention. Like Fanny Burney's Cecilia and Jane Austen's Anne Elliot they are shown little respect as individuals.

The still more passive heroines of Ann Radcliffe, whom Jane Austen parodied in Catherine Morland, endure sensational Gothic plots with deep sensibility. It is the one trait which helps them put up with oppression, though not to mature. A heroine of "extreme sensibility" like Julia in *A Sicilian Romance* (1790) gains a certain distinction through physical action as she rejects her father's chosen suitor and flees with her own favourite through underground passages. Her sister Emilia remains routine as a character despite the superiority of a "clear and comprehensive mind".[16] Both anticipate

Jane Austen's division of similar traits between Marianne and Elinor Dashwood in *Sense and Sensibility*, another of the few novels with two heroines. The sentimental heroine proved as baffling to Mrs. Radcliffe as the rational Emilia when lacking Julia's drive for independence. In *The Romance of the Forest* (1791), which Jane Austen was to burlesque in *Northanger Abbey*, the more docile Adeline La Motte can at best evoke pity for her nerves as she hides and suffers from a Gothic tyrant of an uncle in a ruined French abbey. This appeal of the author for sympathy for a passive victim shifts the task of creating emotional depth in the heroine to the reader. As a true artist, Jane Austen knew she must actually project a heroine's feelings.

The more famous Emily St. Aubert of *The Mysteries of Udolpho* (1794), also burlesqued in *Northanger Abbey*, is another passive Adeline subjected to still greater tension by her cruel Uncle Montoni. Although well endowed with conventional superiorities, Emily gains little continuing strength from them. As the quintessential passive heroine, she suffers through her cumulative trials of forced isolation, nightly visitations and threats to her person in her Uncle's lawless castle of Udolpho more like a masochistic victim than a model for self-reliant girls like Catherine Morland. Yet despite Emily the novel is memorable in the struggle of heroines for independence. The patriarchial villain Montoni glowers out of eighteenth-century fiction as the archetypal male tyrant--grasping and cruel. For Jane Austen he only exaggerates the behaviour of some English men of the time in their treatment of women, as she suggests in her everyday version of him as General Tilney in *Northanger Abbey*. The more active and self-reliant Ellena Rosalba of *The Italian* (1797) supports her aunt with sewing and stands up to tyrannical elders and clergymen. Yet she too becomes a victim of the world of men when she is kidnapped, by her cruel Uncle Schedoni, and nearly murdered. When even she cannot control her own life, she shows how improbable it was that a representative heroine could ever control the plot of a Gothic novel.

The feminine convention established the initial image of the heroine for Maria Edgeworth as well as Jane Austen, who praised the "thorough knowledge of human nature" in *Belinda* as well as *Cecilia* and *Camilla*.[17] Yet by 1801 when it appeared it would have seemed less a model to Jane Austen than a succinct epitome of a form and a theme which she had been exploring for a decade in her own Juvenilia, including the first drafts of *Sense and Sensibility*, *Pride and Prejudice*, and *Northanger Abbey*. Like Harriet Byron and Evelina, Belinda begins the story as an orphan newly arriving on the London

scene. In accord with the fictional formula, she starts life in her late teens, an acme of beauty, sweetness, virtue, openness, generosity, tender feelings and wisdom. Her story, which unlike Gothic melodrama is relevant to the required courtship plot, develops a theme out of the implications of the climactic marriage. It probes the spiritual desolation which the trivial circuit of public entertainments has caused the social leader, Lady Delacour. In this rare study of happy and unhappy marriage, Belinda learns the reason for this misery: the bored Lady Delacour has been tempted to commit the great sin of these novels, coquetry. Although slight as presented, the theme deepens the impact of the convention and prepares for Elizabeth Bennet's "philosophy" of happiness.[18] An idealized if rather insipid housewife shows Belinda that the essence of happy marriage is domestic felicity based on intelligent family conversation, a concept shared by both Charlotte Smith and Jane Austen.[19]

Besides these four, several lesser novelists added distinctive details of traits, incidents and themes to the convention as Jane Austen knew it. In the 1790's the heroine of determined independence appeared at her most forceful in a few of the novels with a cause, by Mary Hays, Clara Reeve and Mary Wollstonecraft. Clara Reeve particularly anticipates Jane Austen in *The School for Widows* (1791). There she defines true and false sensibility as Jane Austen was to do, while demonstrating the ability of women in the business world, in which men regarded them as incompetent. Her widows show the same intelligence as the late Lady Elliot in *Persuasion* as they take diligent care of family property. They also enter a series of successful careers then supposedly beyond women. One heroine other than Jane Austen's who speaks wittily appears in the first half of *A Simple Story* (1791), by Elizabeth Inchbald. Miss Milner is a young orphan who when wooed by her guardian asserts independence and tests his love with her wit. As with Mary Crawford in *Mansfield Park* it is shown to be corrupting. Then her widower becomes a "tyrant", banishes their daughter from his presence, and as a complete patriarch leaves the girl languishing in undeserved seclusion. Sarah Burney, Fanny's sister, began *Clarentine* (1796) with a girl forced into similar idleness who longs for something useful to do. Like Jane Austen's passive heroines, Fanny Price and Anne Elliot, she yearns to contribute to a society which finds little for able young ladies to do. In the same year in *A Gossip's Story* Jane West exposed love as an inadequate basis for marriage in the patriarchy. Thanks to what this otherwise conservative novelist calls "the base, ungrateful, tyrannick sex", Marianne Dudley like Jane Austen's Marianne Dashwood fails

to achieve "domestick comfort" through a courtship based on sentiment, while their rational sisters live much happier though less vivid lives by choosing husbands wisely.[20] One later, didactic novel is a useful guide to the moral principles which were conventional for them all. In *Coelebs in Search of a Wife* (1808), mentioned by Jane Austen in her letters,[21] Hannah More has Coelebs outline his preconceived image of the ideal wife before he sets out to find her. Perfect "from nature" and in "education" and "religion", she must be "pious, humble, candid, charitable".[22]

Two parodies of beleaguered heroines delighted Jane Austen the artist. In *The Female Quixote* (1752) Charlotte Lennox exposed the self-images of romantic heroines like Arabella as absurd daydreams. In *The Heroine* (1813) Eaton Stannard Barrett described a shrewd hero professing to accept a similar fantasy until his girl gets over her fit of romance. Both Lennox's Arabella and Barrett's Cherubina must learn to accept the facts of life in the patriarchal society. This means marrying their suitors on society's terms. Yet in both parodies it is the heroines who have the inventive minds and outgoing emotions, which go some way towards validating their visions of a less mercenary life than society allowed. It is the men who, like Mr. Watts in Jane Austen's juvenile story "The Three Sisters", stare in disbelief at young women who want to treat marriage as other than a business transaction. Novels like these ultimately reinforce the feminine protest against a society controlled by men who are haughty even when well-disposed towards women. To the fathers, suitors, lawyers, clergymen and husbands in the feminine novels, women are material assets to be used for their economic benefit. Their collective male image stands behind heirs like John Dashwood, who abandons his stepmother and sisters in *Sense and Sensibility*, and William Walter Elliot, whose failure to act as executor leaves the widow Smith nearly destitute in a maze of legal entanglements in *Persuasion*. Collins, waiting none too quietly to dispossess Mrs. Bennet and her daughters in *Pride and Prejudice*, is a near relative. Like all these forerunners Jane Austen developed the feminine convention as a relief for her heroines from their patriarchal society.

(iii)

The general concept implicit in the feminine novels formed the convention for a generation in both themes and techniques. As Joseph Heidler remarks, critics "had long been prone to relegate [the novel] scornfully to girls and women".[23] They were consequently free to develop it

without male interference. By stressing and then exaggerating their special concerns, they created a fictional world of their own through which they could protest against the treatment of women. Other characteristics, usually the more purely artistic ones, remained routine assumptions. All had become stylized by the time Jane Austen was starting to burlesque them in the early 1790's. Yet she was increasingly attracted to them and their theme of independence for young women. She saw possibilities behind their awkward artistry which persuaded her to devote her career to perfecting it. All the same she would fear that treating them too uncritically could beguile young women into expecting everyday men to treat *them* with the respect demanded by heroines. Because she accepted the underlying assumptions of the convention as sound, she was increasingly wary of exaggerations which might render its vision implausible. Profundity is not an obvious attribute of these novels, but they presented some aspects of their latent feminist theme with increasing insight before Jane Austen gave durable life to their convention.

The ideal of a well-educated heroine fascinated women writers in an age when little schooling was available to girls, and that mostly deplorable. As Margaret Kirkham concludes, "The first concern of feminists to emerge was, naturally for the times, Education".[24] Novelists attributed the most improbable learning to their heroines, and despite the prevailing contrary opinion showed it as no handicap in attracting worthwhile suitors.[25] A girl could hardly exceed Fanny Warley of *Barford Abbey*, at least in divinity, history and geography, for "of these studies she knows more than half the great men who wrote for past ages".[26] At a time when an open-minded man like Erasmus Darwin could propound sex appeal as the object of his curriculum for female education,[27] such an untypical education as Fanny Warley's was an indirect social protest. More often the heroine excels in the customary feminine accomplishments of the times. Music and art provided a simple choice in characterization. Ann Radcliffe praised Emily St. Aubert for lute playing but Ellena Rosalba for painting. Jane Austen used the same alternatives to sharpen the contrast between the musical Marianne and the artistic Elinor in *Sense and Sensibility*. The heroine is also said to be fluent in modern languages. Emmeline's Italian is perfect, and Anne Elliot's is nearly so at the opera in *Persuasion*, for she is able "'to translate at sight these inverted, transposed, curtailed Italian lines, into clear, comprehensible, elegant English'".[28] The storybook bride should, as Coelebs puts it, be "by education, elegant, informed, enlightened".[29] Jane Austen praised her

heroines more modestly, but after parodying their learning in the juvenile "Love and Freindship" she typically characterized them as unusually well-read and well-informed. Most novelists were content to posit erudition rather than dramatize it like Anne Elliot's at the opera. Nor did any of them before Jane Austen bother to think about its relevance, although the courtship plot really invited a philosophy of education directed towards the climactic proposal. But the repeated interest in the topic reveals a deep concern. In contrast to the routine reuse of several details of the convention, the pride in the heroine's education is stimulating both thematically and artistically. It creates a fundamental tension in her conflict with the men in her society.

Several of the writers stressed practical as opposed to formal education, for it was the more crucial to heroines in choosing suitors who respect women. Two problems recur, and both intrigued Jane Austen. Primarily rational heroines like Fanny Burney's must learn to judge new acquaintances quickly and accurately, whereas more emotional ones like Ann Radcliffe's need to moderate their excessive sensibility. Young women like Evelina, Emmeline and Elizabeth Bennet who are unrepresentative of their times in selecting husbands for themselves must quickly acquire the skill of assessing suitors if they are to marry rationally. Standards for judging are seldom mentioned, but when Mrs. Inchbald lists them in *A Simple Story* they turn out to be rather Johnsonian: virtue, sense, and beauty (perhaps as a variation on taste).[30] In practice Charlotte Smith reduced them to merit and sense in *Emmeline* and *Ethelinde*, as Jane Austen was to do in the juvenile "Catharine" and *Pride and Prejudice*. In contrast in the black and white world of Ann Radcliffe's novels any judging of character is automatic and absolute. In it excess feeling is the one defect which experience must teach an Emily St. Aubert to restrain in the Gothic world of a Udolpho. In *Emmeline* Charlotte Smith blames the seduction of Adelina on overstrong feelings, and *Coelebs* lists the subduing of passion as one of the aims of education.[31] Yet all these novelists also advocated emotional empathy as the basis of successful courting. Both problems invited a course in practical education, but no one before Jane Austen presented it in action as well as in theory.

To develop as an individual through practical education, a girl had somehow to live on her own, if only for Evelina's six months. It was the one time in her life when, as Stuart M. Tave points out, she could be placed in a position to decide her own fate: "if she makes the wrong decisions, in this place, in these months, the girl who, for all her faults, seemed to have such

potential at the start will be a defective woman by the end".³² Following Evelina's example, these novelists extended and elaborated the period of their heroines' coming out into society. The gap of time between parental and marital authority became the significant lifetime of the conventional heroine. In the patriarchy such an experience of independence rarely occurred. As J. M. S. Tompkins remarks of these novelists, "In their hands the novel was not so much a reflection of life as a counterpoise to it".³³ A young lady on her own could like Evelina centre and evaluate a group of eligible bachelors, but novelists often preferred more casual scenes set as far as possible away from adult control. Travel became their favourite device for filling and exploiting the gap. In days when the hazards of bad roads and highwaymen kept most women at home, travel itself could seem daring or even abusive for a girl like Catherine Morland. For Celestina, voluntary exile on the roads is a major "effort of heroism",³⁴ but a good many heroines are pursued and persecuted on their travels. Emmeline treks across Wales, Southern England, France and Switzerland to elude the neurotic Delamere. Geraldine Verney in *Desmond* demands sympathy as she is forced to travel alone to revolutionary France without adequate funds. In novel after novel travel provides the heroine with incidents in which she must act on her own. Jane Austen's heroines make less spectacular trips, but all except Emma travel at length and live away from home during the gap between their parents' and husband's jurisdictions over them.

The gap allowed a heroine to create a life of her own, even if it were condensed into a few months. A girl by herself could construct a congenial society by making her own women friends as Celestina and Catherine Morland both do. Fanny Price befriends her hard-pressed sister Susan and creates a positive role for herself as family peacemaker on her trip to Portsmouth. A heroine on her own could also grow in wisdom by learning to assess the men she meets. Ethelinde is "a severe observer"³⁵ and Althea Dacres of *Marchmont* "a great reader of countenances"³⁶ before Jane Austen chose the same avocation for Elinor Dashwood and Elizabeth Bennet. If necessary a girl like Emmeline could show heroism by caring for a pregnant Adelina, as Elizabeth Bennet does for her sick sister Jane. Camilla learns to overcome her impulsiveness when on her own and Belinda works out a philosophy of good and bad marriages. Jane Austen's heroines repeatedly mature in character and aspirations while on their travels. Elinor Dashwood has to take responsibility for her rude, thoughtless and dangerously ill sister

on their trip to London, and Anne Elliot gains new spheres of influence on visits to relatives and friends. Without the extraordinary time gap they could hardly exist as individuals.

One or two novelists treated the independence of their heroines as a principle, developing the theoretical implications latent in *Evelina*. In particular Charlotte Smith generalized on the freedom which the gap allowed when she described Althea Dacre's choice of rural seclusion over forced marriage in *Marchmont*:

> She was accountable to nobody; for her father seemed entirely to abandon her, and she had no other relations who had either inclination or right to direct her. Her situation, therefore was altogether different from that of a young woman directly under the protection of a parent, or of immediate friends. She broke through no duty [when corresponding with Marchmont].[37]

In such a special situation a girl like Althea or Jane Austen's Anne Elliot could claim the right to live her own life without flouting the social mores. Celestina goes further still in theorizing about her rights. Confident in "the pride of conscious worth", she asserts "that she was not born to be dependent".[38] In a scene which parallels Elizabeth Bennet's rebuff of Darcy's haughty first proposal in *Pride and Prejudice*, she snubs a suitor who demands to know if she is secretly engaged: "'However, Madam, do you or do you not deny that such an engagement does exist? Of that, I think, I have a right to enquire'". Celestina refuses the arrogant demand firmly if rather meekly: "'Forgive me, Sir, if I answer that it does not seem to me that you have any right in the world to ask that question of me'".[39] Here the novelist is positing a self-reliance for the heroine gained from experience through travel. With self-confidence went self-respect. Rosalie Lessington of Charlotte Smith's *Montalbert* more than once objects that the custom of coming out into society makes her feel "offered like an animal for sale".[40] Her claim to human dignity was an expression of this new fictional freedom of the convention and became a basic assumption of Jane Austen's heroines.

In an almost exclusively male economy women could have little freedom without financial independence. Few heroines experience the everyday agonies of Camilla, who is tempted by her new friends to overspend her allowance while shopping. Few have to earn money, although Monimia in *The Old Manor House* and Ellena Rosalba in *The Italian* support others by sewing. Following Richardson's example with Clarissa as her grandfather's

heiress, novelists sometimes allotted the heroine an initial income of her own. Cecilia can be termed "mistress of her destiny" because of her inheritance.[11] More often, like Evelina, the heroine comes into a fortune near the climactic proposal. Emmeline proves to be legitimate and the owner of some of her uncle's property, and Adeline La Motte ends up with much of the real estate in *The Romance of the Forest*. When such a fortune comes late, it adds to the heroine's prestige as a bride. After choosing wisely among suitors for a match not based on wealth or rank, she can offer the lucky bridegroom all the dowry that her society would expect of her in a marriage of convenience. In an age when few women had money of their own, this storytelling tradition may well explain Jane Austen's much remarked concern with the financial assets of her heroines. This "fantasy money", as Edward W. Copeland has called it,[41] is another conventional device used to enhance their dignity and independence. Catherine Morland becomes acceptable to General Tilney because of her unexpected dowry and Elinor Dashwood is made the agent for offering the living to Edward Ferrars that makes their marriage feasible.

Despite such inheritances these novels stress the present almost exclusively. Concern with money seldom implies planning for the future. The meaningful lifespan of heroines is confined to the gap between girlhood and the proposal. Perhaps the legal and social dependence of married women kept the novelists silent about what came afterwards. Feminine dignity could well disappear then, as it does for Rosalie Lessington when the unreasonably jealous Montalbert seizes her child and deserts her. Instead the happy ending remains an undefined dream in an environment of miserable marriages. In *Ethelinde* Sir Edward Newenden cries out like Jane Austen's Willoughby for domestic comfort from a wife as unhappy living in the countryside as he is in London.[42] Present delights absorb all the attention of Camilla and Catherine Morland, suddenly let loose at a spa. Immediate responsibilities preoccupy both Emmeline and Elinor Dashwood with their immobilized women to protect. Of them all as of Elizabeth Bennet, a Darcy might well ask, "'The *present* always occupies you in such scenes--does it?'"[43]

Even in the present, positive ideals are vague, and more often implicit than explicit. In *Marchmont* Charlotte Smith complains that it is difficult to characterize the heroism of inexperienced girls: "other virtues than gentleness, pity, filial obedience, or faithful attachment, hardly belong to the sex, and are certainly called forth only by unusual occurrences".[44] Evidently the interest of storytellers lay elsewhere than in moral ideals. All took the

virgin purity of their heroines for granted in a society in which it was more often a precept than a practice. Emily St. Aubert also expects chastity of her suitor and is ready to forsake Valancourt at the first hint of scandal. Jane Austen was as strict in the libertine years of the Regency, exiling Maria Bertram from England forever for adultery. The novelists closed their fiction to current sexual fashion, took over the maxims of the courtesy books,[45] and stylized a moral convention at odds with the manners of the times.

A resilience in emergencies such as Evelina shows when saving her brother from suicide is the one active virtue of maturing heroines.[46] Like their education it looms large because it excites novelists. In moments of sudden crisis a woman can show her exceptional presence of mind and act on it. Then a long-scorned Althea Dacres can recall Evelina's stamina by teaching fortitude to her imprisoned husband and an Anne Elliot can organize help for Louisa Musgrove, unconscious after her fall from the Cobb at Lyme Regis. In responding to such moments of drama these heroines could grow in inner strength, but more often than not suspense forestalled them. As melodrama and sentimentality became increasingly prevalent in the long generation of Gothic novels, crises more often ended in alarms and tears like Adeline La Motte's than heroic growth like Emmeline's.

The concept of evil in these novels is even more restricted than that of virtue, and more limited to the scope of the courtship and marriage convention. The social vices of worldliness, vanity and hypocrisy, which Marilyn Butler finds under attack in Maria Edgeworth's novels,[47] define the moral climate of all the novelists. No one explored so robust a facet of evil as lust. Flirting was the most conscious dread, though it occasionally leads on to sexual sin. When Miss Milner passes on from coquetry to infidelity in *A Simple Story*, Mrs. Inchbald blames her fate on an unwholesome education, that heartfelt grievance of women novelists. Others like Charlotte Smith in *Emmeline* attribute loss of virtue to excessive sensibility. Yet neither they nor Jane Austen paid much attention to seduced women. Mrs. Inchbald mentions adultery only in retrospect when Miss Milner is lying bitter on her deathbed. In *Persuasion* Jane Austen dismisses Mrs. Clay to an unmentionable future with William Walter Elliot. Charlotte Smith provides the rare exception, for Adelina has her illegitimate baby and Emmeline appears holding it, to the damage of her reputation. In view of the convention of silence, Jane Austen showed some defiance in letting Lydia Bennet appear unrepentant after living unmarried with Wickham. In an age when loss of chastity was the moral and

financial peril for unsupervised girls entering the social world in search of husbands, novelists usually ignored it. They treated coquetry as the great evil, with uncontrolled sensibility a contributory vice. So it most often is in Jane Austen's novels.

Sensibility became a deep concern of novelists in the 1790's. It offered the heroine a range of inner experiences free of the public restrictions on women, but it thwarted a rational choice of suitors. The sense of inner freedom gradually made the stronger claim. In the private world of emotions the Clarissas, Celestinas and Clarentines were on at least equal terms with men. They could compose many a sad psalm or sonnet, which the men in their stories never do. Yet novelists hesitated to accept a complete reliance on feelings, an extreme which Jane Austen satirized through Marianne Dashwood. All agreed that sensibility needed to be curbed, though they differed sharply as to the optimum amount of it and the moral seriousness of an excess. Ann Radcliffe, in the forefront of the emotional novel in the 1790's,[48] felt that overstrong feelings threaten the happiness more than the merit of Emily St. Aubert:

> this sensibility gave a pensive tone to her spirits, and a softness to her manner, which added a grace to beauty, and rendered her a very interesting object to persons of a congenial disposition. But St. Aubert had too much good sense to prefer a charm to a virtue; and had penetration enough to see, that this charm was too dangerous to its possessor to be allowed the character of a blessing.[49]

For Mrs. Radcliffe here, judging strangers by the impulse of "first impressions" became the chief danger of sensibility for a laudably "pensive" heroine, whereas in the same years Fanny Burney was blaming Camilla's impulsiveness on lack of social experience. Jane Austen satirized Emily's excess in Marianne Dashwood, but she examined the social side of first impressions in Elizabeth Bennet.

Most novelists of the 1790's, including the early Jane Austen, were more inclined than Mrs. Radcliffe to treat sensibility as a moral concern. Charlotte Smith blamed Adelina's seduction on it, condemning "the error into which her too great sensibility of heart betrayed her".[50] In the eight later novels this criticism gave way to a limited approval, for all these novelists, including Jane Austen, wrote in a generation in hesitant transition between rational and emotional outlooks. For those few who reflected on social and

moral ideals, this ambivalence led to a dichotomy in theory. In *The School for Widows* Clara Reeve analyzed sensibility into admirable and deplorable kinds:

> There is a sensibility that ennobles the heart that bears it. It is modest and secret; it never boasts itself but avoids all ostentatious display of it's feelings.
>
> False sensibility, on the contrary, is always talking of itself; it complains of it's sufferings, in order to exalt it's merits; and wonders at the hardness and insensibility of others.[51]

Jane Austen shared this position in *Sense and Sensibility*, applauding Elinor Dashwood's silent love of Edward Ferrars and condemning Marianne's voluble love of Willoughby according to this very contrast. Apparently, in this decade of ambivalence about feelings, a wise heroine matures emotionally by directing her feelings only towards gentle and placid men.

As thinkers these novelists were neither profound nor revolutionary. Those not instinctively conservative like Fanny Burney gradually came like Charlotte Smith to reject innovations that might reflect the spirit of the French Revolution. On most topics they tend to share the reactionary spirit of the anti-Jacobin novel.[52] Yet as a woman Ann Radcliffe, like Jane Austen in *Mansfield Park*,[53] scorned the double moral standard of the time and showed that feminine dignity was incompatible with the status quo. From decade to decade the feminine novelists were increasingly bitter about the humiliation and victimization of their heroines by the social leaders presented. In contrast, a longing for "rational conversation" and "permanent friendship" became a wistful hope denied women at large, in Jane Austen as in Charlotte Smith.[54] The recurring desire for rural retirement by the Ethelindes and Altheas as well as Fanny Price may partly reflect this hope. Yet after the scandal of Mary Wollstonecraft's unmarried pregnancy became public any feminine protest was muted and oblique. Few novelists were willing to contemplate even a mild revolt against the social order. Charlotte Smith sends her final heroine to North America for a happy ending in *The Young Philosopher*. Jane Austen takes her last one, Anne Elliot, out of the landed gentry to find respect in the rising society represented by naval officers. These modest breaks with the patriarchy are the ultimate protest in these novels.

(iv)

Although the feminine novelists were more routine in their storytelling craft than their social protest, they still influenced Jane Austen as artist. They stylized the framework and practices of *Sir Charles Grandison* and *Evelina* into the stereotyped model that meant the *novel* to her. It consisted of a feminine version of the courtship and marriage plot centred on a heroine who excels in the traits most valued in the convention: beauty, good temper, intelligence, virtue, fortitude, and emotional depth. Jane Austen modified the model to fit recognizable girls of her times, but she continued to reproduce it. She burlesqued it in her Juvenilia. She satirized it in her early novels as a dangerous ideal for young women longing for romance in their lives. In her later novels she perfected it in heroines who mature by reshaping it into a more attainable ideal of married well being. Jane Austen devoted her career to revising the model artistically while preserving its feminist perspective. With the searching view of wit she caricatured two extremes, an emulation of mercenary women who exploited the expectations of the patriarchy and the fantasies of girls who dreamed of independence. The latter extreme grew into a further concern of her own, a theme of the dangers of living by the example of novels.

The model heroine of the convention looks more substantial as an initial portrait than an actor in a developing narrative. She stands out in the beginning as superior to all other women, like Ethelinde "a complete idea of perfection".[55] Mrs. Inchbald dispensed with details by terming Miss Milner "lovely beyond description",[56] but most novelists filled in their vision of first-chapter perfection with the half dozen most valued traits. *Beauty* was usually confined to the face, which was regular and lovely, but also rather solemn without Evelina's humanizing fun. The more socially involved heroines shared Cecilia's intelligent countenance and eyes. For the more isolated and victimized heroines like Emily St. Aubert, only emotions playing on the face inspired more than a routine remark:

> But, lovely as was her person, it was the varied expression of her countenance, as conversation awakened the nicer emotions of her mind, that threw such a captivating grace around her.[57]

The *good temper* of the model was sweet and warm, and lively within limits. Coldness could turn away suitors, from an insipid Miss Fenton in *A Simple Story* or a too placid Jane Bennet in *Pride and Prejudice*, but too much liveliness could also lose a girl friends. In practice it had better be dainty,

like the "lively elegance and dignified simplicity" of Miss Milner,[58] and not too witty, for fear of a sneer about an Elizabeth Bennet's sharp tongue. Otherwise a girl might, as Sarah Burney's *Clarentine* puts it, be condemned as an "unformed romp", if not that dread evil "a pert coquette".[59] Like Harriet Byron these heroines also tend to have the outstanding *intelligence* of an Emmeline, who "had a kind of intuitive knowledge; and comprehended every thing with a facility that soon left her instructors behind her".[60] Fanny Price and Emma Woodhouse are not that brilliant, but both show a mental elasticity beyond that of their mentors, Edmund Bertram and George Knightley. As Florence Hilbish says of Charlotte Smith, these novelists all found their "heroines heroic" because of "their superior minds".[61]

Other initial strengths look less extravagant. Like Richardson these novelists all equated *virtue* with chastity. They envisioned neither the active innocence of a Clarissa nor the agony of a passionate Lucy Snowe. Instead they worried with Camilla and Catherine Morland about the immodesty and flirtation of an Indiana or an Isabella Thorpe. *Frankness* was less clear-cut. Camilla and Marianne Dashwood are reproached for being too outgoing, but secrecy is seldom approved. Eliza Blower's Maria condemns dissimulation even in a good cause,[62] Sarah Burney's Clarentine earns a proposal by remaining "open, unreserved and generous",[63] and Jane Austen's Knightley extols "'the beauty of truth and sincerity'"[64] If frankness fails to win a heroine peace of mind, her prized response is *fortitude*. The courtesy books praised it and heroines from Evelina to Ellena Rosalba practiced it. Jane Austen allots it to "the fair heroine" Jane Fairfax, who with"the fortitude of a devoted noviciate" decides to become a governess.[65] Finally, despite the ambivalence about sensibility, heroines share an exceptional capacity for *sentiment*, though they must strictly control it. Like Maria they have "a heart formed for love",[66] but it must prompt no physical displays. Maria condemns kissing in public as vulgar, and indeed it is as she describes it.[67] Following a century of rationalism, these novelists were locked into a tradition of not depicting emotions or dramatizing love scenes. When the superior heroine ceased to be a static model, hesitant and awkward displays of her feelings tended to weaken rather than strengthen her characterization.

As the ensuing love story displayed some of these initial strengths in action, it tended to overdramatize them in extreme situations which also became conventional. Great beauty may cause misery but never vanity, from an Emmeline who takes to the road to flee the too ardent Delamere to an

Emma Woodhouse who cares about reproducing only her friend Harriet's beauty rather than her own on canvas. An even temper may leave secondary characters like Miss Fenton insipid, but a heroic Ethelinde or Monimia can endure any amount of verbal abuse without murmur. This fortitude of silence may well look like insensitivity in a meek Jane Bennet.

Anxious to make inner tensions memorable, the feminine novelists sought to verify them externally. Avoiding both the whole-hearted sentimentality of Henry Mackenzie in *The Man of Feeling* and the avowed restraint of Elinor Dashwood, they stylized a series of physical reactions to emotional agony. Three signs of hysteria became so commonplace that Jane Austen parodied them as a girl of eleven in her earliest narrative sketches.[68] Tears are the automatic response of an Ethelinde or an Emily St. Aubert to shock and stress, without the cumulative motivation of a weeping Pamela or Clarissa. A heroine could scarcely run the gauntlet of a novel without fainting, although Monimia in *The Old Manor House* has the grace to wound herself with scissors to hide the real, emotional cause from her aunt. More extravagant still, fits were the last resort of storytellers who feared that their language was too mild and their incidents too familiar with readers to stir pity for their heroines. Even the competent Mrs. Darnford in *The School for Widows* "was either in raving, or in silent fits, for three days and three nights" on the death of her tyrannical husband.[69] Although as a teen-ager Jane Austen lampooned such excesses, she was to modify and exploit them later, for an Elizabeth Bennet reduced to tears by Darcy's first, rude proposal and a Fanny Price ready to faint at her uncle's approach.

Before Jane Austen's novels few incidents strengthen the heroine's character as a bride to be. The memorable events are seldom integrated into the love story, though the hysteria may be. Sometimes an Ethelinde or a Belinda stands aside from the story like Evelina in London and observes the infighting in the social world which she is about to enter. Sometimes an Adeline La Motte or Ellena Rosalba lives intensely for the moment as the terrors of Gothic castles and villains envelop her. Sometimes odd topics of current interest like a balloon ascent in *Maria* or a duel of women in *Belinda* would excite or revolt her. Jane Austen avoided such incidents for they neither help the heroine mature nor advance the courtship plot. They fail to establish her as significant in herself or vital as a prospective bride. Only if her experiences as an observer were relevant would Jane Austen accommodate them. When Catherine Morland peers into the bedroom of the

late Mrs. Tilney, she learns a lesson in open-mindedness from her suitor. With few exceptions outside of Jane Austen, like Monimia's days of drudgery in *The Old Manor House* (bizarrely offset by her midnight trysts with Orlando), these novelists also ignored the enforced shallowness of the everyday lives of women. Perhaps in despair that wasted lives would produce nonentities as characters, Charlotte Smith lamented, "Few girls of her age, for Ethelinde was not yet eighteen, can be said to have any decided character at all".[70] In the preface to *Marchmont* she developed this frustration into the theory that for women "circumstance" creates "character".[71] Instead, Jane Austen knew that circumstances test and deepen traits that have already been established. When the poseur Isabella Thorpe hopes for a mercenary marriage with Frederick Tilney, her voluble sensibility vanishes, but the faithful Fanny Price suffers intensely from hers during Henry Crawford's unwelcome courting.

Despite the non-amorous experiences used to make the heroine's life memorable, the courtship and marriage plot in its feminine variation provided unity for her biography. Incidents involved with courtship furthered or thwarted the climactic proposal, at first as a linear sequence of crises, but after *Evelina* usually as a triangle of a woman choosing between suitors. Earlier novelists like the Misses Minifie, who followed Richardson directly, simply provided a series of obstacles for the heroine to overcome before she could marry the man she loved. Similarly Elinor Dashwood, the only Jane Austen heroine not involved with more than one suitor, has to outlast Lucy Steele's hold on Edward Ferrars with a series of verbal duels that create a cumulative tension reminiscent of Richardson. Decade by decade between *Sir Charles Grandison* and *Sense and Sensibility* the barriers to the heroine's marriage became more and more unlikely as they grew from tyrannical parents and guardians to malicious gossip, supposed illegitimacy, possible adultery, apparent incest, kidnapping, and imprisonment in Gothic castles. By the 1790's thrills of the moment had come to replace the inner tension of a Clarissa, which Jane Austen first worked to recapture with Elinor Dashwood. Late in the century the love triangle further complicated the heroine's ordeal. At best it enabled a heroine like Emmeline to control the plot, as when she rejects Delamere in favour of Adelina's brother William. At worst it became perfunctory, as when Emily St. Aubert finds two rather obscure men wanting to woo her. When Jane Austen confined her incidents to the love story and restored it to the centre of the plot, she typically based

it on some variation of the *Evelina* love triangle. Fanny Burney also established the framework for the later courtship plots by beginning and ending them with the gap of time between the heroine's parental and married homes. It provided for a self-contained way of life for the heroine's story. Only for the odd heroine like Monimia, Camilla or Emma Woodhouse was the interval eliminated when a member of her childhood circle became her suitor.

Typically the most frustrating incident for these novelists is the climactic proposal, which provides their sense of closure for their courtship plot. Evelina's inability to recount the scene of Lord Orville's offer became a recurring difficulty for her literary offspring. Later heroines from Cecilia to Belinda look equally lacklustre when accepting their suitors, and even the witty Elizabeth Bennet is for once struck dumb by Darcy's successful second proposal. The danger of a domestic anticlimax like Jeanie Deans' in *The Heart of Midlothian* may have crossed these writers' minds. For their heroines, accepting a suitor meant losing independence. When ending with a weak climactic scene, the feminine novelists may also have been making one last protest against the patriarchy, as the gap of freedom that they had created for their heroines came to an end.

Despite the potential control of the plot offered by the feminine triangle, most of the heroines are passive rather than active. Only the occasional one initiates events in her story, although those that did were the easier to make memorable. While fending off unwanted suitors, ruthless elders and callous rivals, they could put their superior sense, warm feelings and open conduct into practice. Emmeline gains stature by rejecting the overbearing Delamere along with his haughty parents, anticipating Elizabeth Bennet's snub of the interfering Lady Catherine de Bourgh. By the 1790's few novelists were still dramatizing feminine initiative. Instead they appealed to readers for sympathy for passive heroines suffering abuse. In *Emmeline* Charlotte Smith resorted to this sentimental device only for the secondary Adelina, "the lovely lunatic".[72] In her later novels she relied on it to give body to humiliated heroines like Althea Dacres and Rosalie Lessington. Orphans now invited compassion rather than admiration as girls facing the world alone. No one, Eliza Blower seemed to trust, could avoid an outburst of sympathy for a heartbroken Maria "pressing her lovely forehead against the turf".[73] The Gothic novel in particular relied on passive heroines shocked by brutality out of any positive action. As a result they abdicated their role as the driving

force in their novels. Suffering can increase the intensity of an aggressive character but not vivify a set of static assumptions. In these passive heroines the novelists of the 1790's happened on a particularly formidable challenge in the art of the central heroine. It was to cause Jane Austen herself some difficulty in *Mansfield Park* before she mastered it in *Persuasion*.

With the heroine and her struggle absorbing most of the artistic energy in these novels, the heroes became increasingly docile. The optimum balance was hard to achieve, for novelists like Jane West complained that men in general were tyrannical, but too weak a hero could diminish the heroine.[74] Following Lord Orville's example, he typically remained the dull secondary figure needed to court but not overawe the central heroine. A gentleman with little else to do, he typically showed less physical prowess and public spirit than Grandison the prototype, and less genuine respect for women. The mentors are particularly threatening. Edgar Mandeville imposes his masculine ideals on a humbled Camilla, and several Jane Austen heroes set out to form the heroine's mind. Other suitors are flawed men who never share any of the heroines' initial strengths. No other one is so neurotic as Emmeline's Delamere, whom the young Jane Austen found a memorable absurdity,[75] but Cecilia suffers intensely from Mortimer Delvile's haughty pride, as Elizabeth Bennet does from Darcy's. Celestina is distraught at her Willoughby when he snubs her in public, just as Marianne Dashwood is at hers. To become heroes, their men must start to respect the individuality of their women. Like Jane Austen's Lord Osborne, they must learn from an Emma Watson "what was due to a woman, in Emma's [dependent] situation".[76]

The artistic dedication of the novelists to their feminist theme also appears in the sophisticated prose style that they chose. It influenced Jane Austen only obliquely. At best the elevated Johnsonian style adopted by Fanny Burney and her followers after the success of *Evelina*, although dating their novels, proclaims their high seriousness, which Jane Austen shared. Also, as with the other aspects of her art, she advanced from an early mocking of their weak wit to a judicious development of some of their practices.[77] After singling out "violently in love" as a particularly overused cliché, she offers it as an apt description of Darcy's behaviour during his second proposal to Elizabeth Bennet.[78] Norman Page has also detected the fictional convention at work in her differing use of French words between her letters and her novels.[79] The solemn style of the convention was even less suited to a heroine's speech than to general narration, as the novelists

themselves were sometimes aware. Ann Radcliffe classified conversation into the familiar and the sentimental, Charlotte Smith applauded Ethelinde for the "vivacity of her conversation", and Eliza Blower talked about the "genteel raillery, with which women of wit, acquainted with the world, usually return the effusions of common-place gallantry".[80] Yet despite the immediate example of Sheridan in his comedies of manners, they left it to Jane Austen to dramatize heroines through wit. Though possibly unrepresentative of women of the times, a witty habit of speech is more plausible than Johnsonian prose for the gossip of intelligent but informally educated women. Jane Austen knew that other language than highly structured prose would best convey the inner strength of her own heroines. Following the precepts rather than the practice of Ann Radcliffe, Charlotte Smith and Eliza Blower, she created a crisper speech to project her characters' thoughts and feelings.

An increasing attention to the environment, both social and natural, also influenced Jane Austen. As an Emmeline or a Catherine Morland fought to establish a life of her own, her indoor surroundings became more specific and her outdoor activities more localized than those of their prototypes earlier in the eighteenth century. In novels of domestic manners, which stressed the public lives of heroines, gossip could endanger the courtship of an Agnes Bennett's Anna or an Elizabeth Bennet, and social ambition threaten to impose a marriage of convenience on an Althea Dacres or a Fanny Price. For such social conflicts Fanny Burney and Charlotte Smith in particular developed a background of caricatures in the brash social-climbing Branghtons in *Evelina* and Ludfords in *Ethelinde*. Jane Austen transformed the type into more plausible toadies like the Steele sisters in *Sense and Sensibility* and Collins in *Pride and Prejudice*. In the sentimental and Gothic novels of the 1790's, more privately oriented heroines like Celestina and Emily St. Aubert found an inspiration in nature not offered them by the men in their times. Similarly, Anne Elliot turns for release to scenery and nature poetry when Frederick Wentworth ignores her. Before Wordsworth, Ethelinde found relief, and a suitor, on a moonlit lake in Cumberland, towards which Elizabeth Bennet had meant to be travelling when she came to Pemberley. Though at first scornful of an enthusiasm for wild nature, Jane Austen gradually came to share this delight of the last few of her predecessors.[81] A fondness for scenery provides a much needed interest for both a Fanny Price and an Anne Elliot left mentally idle in socially ambitious families.

While the patriarchal society was raising girls to suit its economic ambitions, the feminine novelists created a model of their own. Their new kind of heroine for their new kind of novel, as Margaret Anne Doody calls it,[82] began her adult life as the eminent example of her sex. She was superior to all other women in a set of recurring traits which required unusual circumstances to reveal them. Of her several initial assets, in beauty, temper, intelligence, virtue, fortitude, and restrained sensibility, three were most often elaborated. She was wise when men thought her frivolous, loving in a world of mercenary common sense, and resilient to the miseries inflicted on her in the patriarchy. To demonstrate these assets, the novelists took over Evelina's extended gap of independent living and filled it with incidents which became more and more melodramatic over the decades. These encouraged the host of more passive than active heroines. Increasingly novelists sought sympathy for abused women whose alleged wit could no longer keep them independent of ruthless men. Developed as well as conceived in fancy, they created a faint centre for a fictional society in which the vivid characters and actions belong to the coquettes, seducers, and tyrannical uncles. Instinctively second-class citizens, they often failed to become the most memorable character in their own novel until Jane Austen gave them artistic as well as thematic significance.

The convention of a sensitive girl of unusual independence which attracted Jane Austen also worried her. Reading the feminine novels could become the chief occupation of women with too little to do, and a substitute education when formal schooling was denigrating to girls. As Jane Austen sensed, the model young woman of novels could become a dangerous fantasy as well as a plausible vision for readers discontented with their lot in the patriarchy. Only a few heroines like Camilla and Belinda grow in wisdom as they respond to the boorishness and deceit that they meet. Many prefer to dream of a more self-reliant and exciting life than was then possible for girls. Many a heroine escapes from the drab routine of her everyday life into an imaginary world of mysterious and ennobling ancestry, adoring and respectful suitors, and unrestrained and romantic travel. Even Emmeline and Belinda with their social poise lack the humanizing embarrassments of Evelina the prototype. Yet it was *Emmeline* that first raised a concern about the dangers of living by books. Charlotte Smith condemned a young woman who "had learned all the cant of sentiment from novels".[83] This warning not to emulate the life of heroines anticipated a repeated theme of Jane Austen's.

Appearing in a novel which is prominent in the Juvenilia and belongs to the convention that it is attacking, it would give direction to her repeated satire of bookish living. The very names of Ethelinde, Clarentine, and Ellena suggest artificiality. When Jane Austen gave them over for her Catherines, Emmas and Elizabeths, she restored a perspective of everyday life to the convention. Refusing to parade their attractions before suitors, rejoicing in their inner liberty, her heroines simultaneously draw on the conventional model and expose its extravagances.

CHAPTER III

HEROINES IN TWO WORLDS--
PARODY AND PROTEST IN THE JUVENILIA

Jane Austen's great heroines belong more to the romantic world of the courtship and marriage convention than to the day-to-day life of rural domestic manners. In her juvenile fiction the literary milieu is the earlier to appear, the more basic to the artistic conception, and the more formative of the social ideals. As Jane Austen experimented with girls based on the inherited model for almost two decades, she probed and modified the extravagant traits and artificial dilemmas which amused her. Then she dramatized them as the means to independence in heroines who are sufficiently lifelike to give everyday substance to their bookish ancestry. She laughed at their delusions that worldly courtships can resemble fictional romance, but she also applauded their generous love in a world of selfish and degrading marriages. Recognizing that the convention through its stereotypes clarified problems crucial to women in her society, she made less and less fun of fictional heroines. Instead, she applauded them as resilient victims struggling to avoid social tyranny. After having mocked the hectic crises of literary courtship, she adapted them to expose the greed and loveless ambition of marriages of convenience. This double view of the convention created a vitalizing tension in her art. Perceptive in this double inheritance, her heroines earn their right to a positive happiness more reminiscent of their conventional ancestors than their social sisters.

(i)

Chronologically, the juvenile stories of young heroines fall into four major groups, one of which is now lost. All follow the feminine convention, but the earlier stories lampoon its stylized art while the later ones treat it seriously. It was the one mode of expression which for all its extravagances was making a meaningful comment on the difficulties of young women of the times. At fourteen Jane Austen burlesqued the heroines of sensibility with zestful extravagance. She exaggerated their artificiality through absurdly conventional young women like Laura Lindsay of "Love and Freindship" (1790). By sixteen she was beginning to respect the convention. In

"Catharine, or the Bower" (1792) she laughed at Catharine Percival as an orphan of too strong sensibility but approved of her learning, and her struggle as a young woman to resist overbearing men.[1] In her early twenties, according to Cassandra Austen's memorandum, she conceived of four of her mature heroines in two early versions of *Sense and Sensibility* and one each of *Pride and Prejudice* and *Northanger Abbey* which no longer survive, except perhaps as early layers in the existing novels.[2] Two of them continue the satire of heroines of sensibility, but especially *Pride and Prejudice* blends the visionary love of fictional girls with the shrewd sense of women of the world. In her late twenties in "The Watsons" (c. 1803) she stressed the social dilemma of impoverished women rather than the self-delusions of would-be heroines. In it she dramatized the plight of the grown-up Emma Watson, who returns as an unwanted stranger to her parental family after her Aunt Turner has had to turn her out on remarrying.

Along with these more serious artistic studies of heroines Jane Austen lampooned the most absurd details of the conventional model singly, often in shorter stories which belong with the first two groupings. In the three years before "Love and Freindship" she gibed at implausible traits in a dozen skits. In the following year she mocked young women with fictional fancies in "A Collection of Letters" (1791). During the prolific year of "Catharine" and the second grouping, 1792, she moved beyond parodying bookish heroines to satirizing the ambitions of girls who are totally worldly. Exaggerating their commercialism and burlesquing their mundane obsessions, she mocked the money hunger of Mary Stanhope in "The Three Sisters" (1792) and the utter devotion to cookery of Charlotte Lutterell of "Lesley Castle" (1792). Besides these stories of silly heroines, there are a few sketches outside the courtship convention which still satirize it. "The History of England" (1791) slyly confuses fact and fiction by comparing the Earl of Essex to Charlotte Smith's Delamere and defending hapless sixteenth-century queens as heroines of sensibility. By recalling Charlotte Smith's defence of the seduced Adelina in *Emmeline*, Jane Austen excused Mary Queen of Scots for the "Imprudencies into which she was betrayed by the openness of her Heart, her Youth, and her Education" (*Minor Works*, p. 146). "Lady Susan" (c. 1794[3]) describes the supreme social evil as the flirting of courtship fiction.

The great heroines of Jane Austen's mature novels represent the ultimate fusion of the conventional model with this contrary satire of its delusions. The long-lasting ambivalence which led to that fusion makes the

Juvenilia an artistic preface to her early novels, first drafted in the 1790's. Her reuse of juvenile characters and incidents in them is progressive. When Jane Austen moved on from these mostly unfinished stories to her finished novels, she was an author of twenty years' experience who was thrifty with her artistic materials. Most readers would agree with Mrs. Leavis that *Mansfield Park* reworks several characters and situations from "Lady Susan".[4] Isabella Thorpe of *Northanger Abbey* follows Laura Lindsay of "Love and Freindship" in disguising greed under a pose of sensibility. Lady Catherine de Bourgh's rude roadside visit with Charlotte Lucas in *Pride and Prejudice* parallels Lady Greville's humiliation of Maria Williams as a dependent young woman in "A Collection of Letters". A late novel may recall one of the novels proper. Anne Elliot of *Persuasion* is the same passive, unwanted, nature-loving kind of girl as Fanny Price of *Mansfield Park*, though treated with more respect in her emotional distress.

As with the Juvenilia, so with the novels of the eighteenth-century predecessors. The numerous fascinating parallels which Frank W. Bradbrook points out show that Jane Austen often reworked specific characters or scenes or themes, with the closest borrowings in the earliest work.[5] The sensational ending of *Evelina* looms grotesquely behind the scene of four young people suddenly finding the same forgotten grandfather in "Love and Freindship". In the novels proper the gentleman heroes from Henry Tilney to Frederick Wentworth belong in the Grandison-Orville line. Often wise as mentors but always placid as suitors, they help to provide a perspective from the convention on the everyday life of women of the times.

Beyond these specific parallels, the Juvenilia links the themes and artistry of the mature novels with their general source in the convention. Jane Austen adopted and explored the fictional world of her predecessors while gibing at its excesses. Parody implies a latent respect for its target. In the stereotypes which prompted parody, Jane Austen noted traits and roles which could be made to point up the heroic potential of everyday girls. While criticizing extravagances in the heroines, she preserved their self-respect and gave substance to their positive social ideal. Jane Austen was an artist who devoted herself to making pivotal and climactic scenes within the convention more natural, more concentrated, and clearer, rather than expending her energy in creating new forms. Such a reliance on the convention gives the Juvenilia continuing significance. The gay parodies of her early teens might have expressed only a child's passing delight in the most obvious absurdities

of her reading. Yet although lacking the thematic and technical depth which emerges rapidly in the middle Juvenilia, they anticipate it. They are criticisms of the convention which was to control the shape of her mature writing.

In the earliest Juvenilia, the first eleven skits in *Volume the First*, women are puppets rushed along by grossly exaggerated events rather than heroines of interest in themselves, but the assumption of the proper scope for their stories is the same as in the six mature novels. Although there are no conflicts complicated enough to involve love triangles, girls regularly have suitors and are bent on marrying them. "Jack and Alice" lampoons the temper and the sensibility of the conventional heroine by attributing them to alcohol. "Edgar and Emma" turns a heroine's tears into a way of life, as Emma pursues them to their ultimate excess: "retiring to her own room, [she] continued in tears the remainder of her Life" (*Minor Works*, p. 33). In "Frederic and Elfrida" a reputation for wit based on evidence which denies it, a mere patter on "the different excellencies of Indian & English Muslins", reveals the impatience of one of our wittiest novelists with the alleged wit of previous heroines (p. 6). One by one the traits which together form Jane Austen's image of the conventional heroine became targets of parody.

These parodies grew more comprehensive and serious during 1790 and 1791. "Love and Freindship" develops a theme in its attack on sensibility, while it continues the gibes at specific traits and adds one on the implausible education of conventional heroines. Laura Lindsay knows as much as there is to know, though indeed Jane Austen had some trouble exaggerating the claims made for a Fanny Warley or an Emmeline:

> Of every accomplishment accustomary to my sex, I was Mistress. When in the Convent, my progress had always exceeded my instructions, my Acquirements had been wonderfull for my age, and I had shortly surpassed my Masters.
> (p. 78)

Signs of a still deeper artistic perspective appeared a year later, for "A Collection of Letters" applies these gibes to the critical stages in the career of a heroine, her being orphaned, her coming out into society, and her marriage. The sequence hints at the parallel which Jane Austen was to find between heroines and the decisive events in the life of women of the times. In the early Juvenilia she was as it turned out defining the limits of the convention which she was going to explore in depth.

Jane Austen's response to the convention is most ambivalent in the fours stories from 1792. They continue to gibe at stylized details like eager suitors ("Evelyn", "The Three Sisters") and false sensibility ("Lesley Castle"), but especially one of them, "Catharine", introduces a deliberate social protest as it assesses the struggles of young women against the tyranny of the patriarchal society. No story better reveals Jane Austen's tension between lampooning the convention and adopting its themes and techniques. Although "Catharine" is often a serious study of both the humiliation of girls and the art of the heroine, it opens with a light laugh at fictional orphans: "Catharine had the misfortune, as many heroines have had before her, of losing her Parents when she was very young" (p. 192). Catharine is a heroine of the convention before she is a girl of the world, but she is both. She is soon deploring the forced marriage or grudging sustenance allotted the Wynne sisters, whose fate points up the misery of orphans in the world as it is. Her literary perspective repeatedly reveals the pettiness of the socially representative characters: their trivial accomplishments as opposed to her thought-provoking education; their hypochondria set against her love of the outdoors; their male coquetry toying with her ardent love. "Catharine" is unfinished, but its scenes open a vista on Jane Austen's modification of her literary world to the end of her career.

In the later Juvenilia Jane Austen probed the themes and therefore the art of the convention with increasing respect. After mocking the facial beauty of heroines in "Lesley Castle", she exploited it in "The Watsons" to support the heroine's self-reliance. In the earlier story a set description of the new Lady Lesley shows how the inevitable beauty and temper struck the author of sixteen:

> She ... has fine eyes, and fine teeth, as she will take care to let you know as soon as she sees you.... She is remarkably good-tempered when she has her own way, and very lively when she is not out of humour. (p. 120)

In this beauty without modesty and good temper without staying power, Jane Austen undercut the storybook perfections with precocious irony. Some ten years later, during which time the lost originals of the first three novels were written, a serious and succinct repetition of a similar beauty gives Emma Watson the independence of a heroine at her first ball: "her name was whispered from one party to another", and her "glowing" complexion, "a lively Eye, a sweet smile, & an open Countenance, gave beauty" to justify the

interest (pp. 328-329). Emma also cries like her fictional ancestors, but "her tears" of excuse for her "Uncle's melancholy state of health", though it has left her penniless, reveals the agony of a young woman who is dependent in situation but as independent as a Celestina in spirit (p.352).[6] It is the constant tension of this opposition between conventional traits and everyday misery which furnishes Emma Watson and some of the mature heroines with their force of character.

(ii)

As Jane Austen came to regard the convention more seriously, she attacked its exaggerations more harshly. Besides exposing its artistic absurdities, she ridiculed it as a delusion for young readers. In this satire, her primary target was sensibility, as it was for her fellow novelists of the 1790's. As early as "Love and Freindship", at the age of fourteen, she was considering the dangers of trying to live according to its impractical principles. At best it could only further the courtship itself, though she doubted that it did, but at worst it could destroy young brides like Laura and Sophia, who are "all sensibility and feeling" (p. 85). As when Charlotte Smith blamed Adelina's seduction on novel reading, Jane Austen opposed the "unmeaning gibberish" of "Novels" to the facts of food and shelter (p. 81). Living on love quickly leaves the married girls destitute, with the arrest of their husbands and the seizure of their house for debt. Like storybook heroines they can react in only one way to such a calamity, as Laura bewails: "This was too cruel, too unexpected a Blow to our Gentle Sensibility--we could not support it--we could only faint" (p. 89). Once done with their conventional fainting fit, they are totally unprepared to live on their own.

Jane Austen also attacked these literary heroines as wives. Their sensibility prevents their offering comfort or support to their husbands in prison: "'Oh! no, no, (exclaimed Sophia) I cannot go to Newgate; ... my feelings are sufficiently shocked by the *recital*, of his Distress, but to behold it will overpower my Sensibility'" (p. 89). Nor are they any comfort to them later, when their husbands are dying in their wrecked coach among nettles and thistles in Scotland. Instead they shriek and run mad with bookish finesse, as Laura reports:

> For two Hours did I rave thus madly and should not then have left off, as I was not in the least fatigued, had not Sophia who was just recovered from her swoon, intreated me to consider

that Night was now approaching and that the Damps began to fall. (p. 100)

Through this absurd reasoning Jane Austen derided sensibility as impractical beyond the moment of love.

This parody by extremes which continues in "Lesley Castle" anticipates the subtler satire of *Northanger Abbey* and *Sense and Sensibility*. In those novels sensibility becomes the chief threat to the welfare of Catherine Morland and Marianne Dashwood, who mistake passions nurtured by novels for true love. Even in her mid teens Jane Austen was concluding that sensibility was immoral through a logical assessment unparalleled by her predecessors. She analyzed it as selfish, dishonest, and hypocritical as well as impractical and irrational. Prefiguring Isabella Thorpe in *Northanger Abbey*, Laura Lindsay is characterized as wholly self-centred, boasting with a spurious humility that her "sensibility" is her "only fault, if a fault it could be called" (p. 78). Like Isabella she is dishonest, though more crudely so, justifying thefts of money from her Scottish host because he lacks sensibility. Two years later in Margaret Lesley Jane Austen lampooned heroines of sensibility for their alleged hypocrisy. Margaret gloats over her own and her sister's beauty while professing to ignore it: "We are handsome my dear Charlotte, very handsome and the greatest of our Perfections is, that we are entirely insensible of them ourselves" (p. 111). A year or two later, in 1793 or 1794, Jane Austen associated villainy with "the greatest sensibility" in Lady Susan, her one evil heroine (p. 250). It was only another year or so before she was drafting her first version of *Sense and Sensibility*, with its satire of Marianne Dashwood for emulating this false ideal of novels.

This parody of sensibility also became Jane Austen's point of departure when making fun of other irrational delights inspired by books: wild nature, mediaeval history, and love at first sight. These enthusiasms of readers also appear in her novels as distractions from everyday life. Soon her gibes at these various non-social delights of writers like Charlotte Smith and Ann Radcliffe grew into a comprehensive satire of the emerging Romantic outlook on life. As early as "Love and Freindship" she made fun of a joy in wild nature when Laura exults in "A Bed of full-grown Nettles", shortly after *Celestina* had introduced scenery as a major delight of heroines (p. 97). Later Marianne Dashwood's similar enthusiasm for experiencing nature at its dampest is a serious lapse of sense which leaves her desperately ill. When the banter at antique Scottish living in "Love and Freindship" and "Lesley Castle"

became focused on the poems of Sir Walter Scott after 1805, it also turned serious. In *Mansfield Park* Jane Austen has Edmund reprove Fanny Price for her disappointment that the chapel of the Rushworths is a plain room unlike her bookish vision of Melrose Abbey from the *Lay of the Last Minstrel*.[7] Similarly love at first sight, which is parodied in "A Collection of Letters", became the subject of a reasoned attack in *Pride and Prejudice*.[8] As an admirer of Dr. Johnson, the young Jane Austen deplored any apparent lapse in sense, goodness, or taste, in proportion to its degree, no matter how idealized the accompanying sensations. Emotional enthusiasms seemed to violate her principles for civilized living. They encouraged heroines to escape from their troubles rather than face up to the challenge of living their own lives in a patriarchal society.

Jane Austen's satire of living by literary models became more complex during the year or two following "Love and Freindship". Along with it she began to criticize some social practices of the times directly. "The Three Sisters" details the unfeeling greed of marriages of convenience. "A Collection of Letters" depicts the humiliation of poor dependents as well as parodying details of the convention. "Lesley Castle" sets the most mundane of women against Margaret Lesley, the bride of hypocritical sensibility. When Charlotte Lutterell finds her sister's marriage cancelled because of the bridegroom's death, she is only concerned about eating up the wedding banquet. Food was to remain a touchstone of the absurdly mundane in Jane Austen's mature novels from Henry Crawford's broken egg shells to Mr. Woodhouse's gruel.

A shift from humour at moral lapses also marks the move from pure parody to social satire. At first Jane Austen made fun of the illicit love which beset heroines of the 1790's, but soon her concern for young women entering the world of seductive men took a serious turn. In the early stories, false marriages like Laura's in "Love and Freindship", illegitimate children like Laura's cousins, and affairs like that of the first Lady Lesley are subjects of jest, as open to gibes as every other excess in the convention. From "Catharine" and "Lady Susan" on, in contrast, sexual immorality or gossip about it can damage a heroine's reputation. The earlier works separate the two satires, of bookish fantasy and everyday life, but in "Catharine" Jane Austen joined them into a single perspective of the lot of women in her time. In this combined satire sensibility remained her primary target.

As early as 1792 Jane Austen shared the ambivalence of fellow novelists of the 1790's like Clara Reeve, Charlotte Smith and Ann Radcliffe about sensibility. She recognized its merits but deplored the dangers of emotional guides to conduct in "Catharine". Although absurd when exaggerated it offered women a nobler vision than the male-oriented society of her times. Social and educational handicaps made no difference to the appreciation of nature, and its grandeur could inspirit their otherwise trivial routines. Sometimes Jane Austen glorified Catharine Percival as a heroine on the bookish model, superior both in sense to the formally educated Camilla Stanley and in sensibility to her insensitive, gossiping aunt. Sometimes she belittled her as a victim of bookish emotions. As a result "Catharine" shows particularly well how Jane Austen went about turning the art form which she derived from the convention into a study of women of her times. In conception Catharine is a heroine of sensibility sometimes taken seriously: "Her imagination was warm, and in her Freindships, as well as in the whole tenure of her Mind, she was enthousiastic" (p. 193). The "Bower" of the subtitle symbolizes her delight in the emotional and the imaginative, in solitude and nature.

Jane Austen transferred the most absurd parody to the less emotional character, Catharine's aunt, who as a hypochondriac threatens to destroy the Bower because, as she says, "'I have not a doubt but that you caught this toothake by sitting so much in that Arbour, for it is always damp. I know it has ruined your Constitution entirely'" (p. 210). Yet the transfer is incomplete and leaves both aunt and niece with a double set of traits. Aunt Percival can be devoted and kind to Catharine, "most excessively fond of her, and miserable if she saw her for a moment out of spirits" (p. 196). She can also scold her like a shrew and even ruin her reputation with the visiting Stanleys. Then she is the conventional guardian, exerting her authority over her niece with the arbitrary tyranny of a Mrs. Lennard over Monimia in *The Old Manor House*. In no other story is Jane Austen's ambivalence to sensibility so divisive.

The discrepancy between the rational and the irrational is less sharp in the heroine than the aunt, but more damaging. Rooted in fiction rather than the patriarchal society, Catharine starts out as a thinking young woman with ideas of her own, especially about the ill treatment of women. In contrast, the socially compliant Camilla Stanley trivializes her own life and that of women in general. Catharine also shows the fortitude of heroines

when she must stay home from a ball with her toothache, again in contrast to the wails of the undisciplined Camilla. Still more positively, Catharine is a keen judge of character during much of the story, with the majority of the scenes designed to develop this asset which she shares with Jane Austen's mature heroines. Yet her final estimate of her apparent suitor is solely in terms of emotions, a criterion which was deeply suspect to the Jane Austen of *Sense and Sensibility*, begun three years later:

> "And what indeed can his plans be, but towards Marriage? Yet *so soon* to be in love with me!--But it is the effect perhaps only of a warmth of heart which to *me* is the highest recommendation in any one" (p. 238)

The wording here, which for the skeptical Jane Austen would undercut itself by praising "warmth of heart" above a proposal, points to her moral indecision about the convention.

In "Catharine" Jane Austen was first confronting the dichotomy which was to continue through most of her novels. Living by books could foster a dangerous delusion, but the precepts of the patriarchy dehumanized women. A compromise was necessary to reconcile bookish postures to everyday problems, but it was elusive. In the earlier novels Jane Austen had difficulty in taking the intense feelings of her heroines seriously. As she slowly modified her distrust of sensibility and other irrational enthusiasms, her double attitude created increasing tension in her heroines. It caused an internal conflict which could be divisive in Marianne Dashwood but was eventually deepening for Anne Elliot in *Persuasion*. The distrust is sharpest in the novels first drafted in the mid 1790's, soon after "Catharine" and "Lady Susan". In *Pride and Prejudice* her refutation of the Romantic trust that first love is true love is a curiously solemn denunciation which could preserve an early layer of writing.[9] In *Mansfield Park*, the first novel entirely from the Chawton period, she still sometimes exaggerated and sometimes respected Fanny Price's emotions, as if she were resolving an active conflict in her own response to literature.

Besides the emotional reaction to life, Jane Austen thought through several other problems of women that bothered her contemporaries in the 1790's. She approached moral conduct, feminine education, discrimination against women, and marriage from the perspective of conventional ideals. They further extended the temptations and dangers of bookish principles as a guide for young women. It is a critical cliché that Jane Austen never

depicts men alone, but in not doing so she was following the concerns of her feminine predecessors. It is a corollary cliché that she ignored the major events of her times like her predecessors, but perhaps she did so because only men could engage in them. Like her predecessors she chose moral and social problems crucial to women and sought through the convention to solve them as women wished rather than men dictated. To develop their implications as a philosophy of life rather than a fantasy became her lifelong occupation.

A comparison of the mature novels with the Juvenilia shows that Jane Austen increasingly ignored any topic irrelevant to the courtship and marriage convention and its implications for women. The *Letters* of Jane Austen the woman show a lively interest in the life of the times. Jane Austen the novelist restricted discussion to the narrower range of love and marriage. After the Juvenilia she almost never allowed any development of topics beyond what is relevant to a plot within the courtship convention. The earliest stories are the loosest in range of ideas, but even they are unusually tight when compared with most other fiction. Catharine Percival discusses Queen Elizabeth, and Henry Tilney refers to the Gordon Riots in *Northanger Abbey*, but by the time of *Mansfield Park* only a glancing reference to "politics" shows that Fanny Price keeps abreast of the news.[10] Because explicit comment on social problems and abstract ideas is rare in the mature novels, the Juvenilia is invaluable for clarifying her thinking on them, and in linking them to their origin in the convention. In the later Juvenilia she also began to work out a unified compromise between the dream of heroines for independence and the subservience expected of girls of the world.

(iii)

The alternative social ideal of the convention attracted Jane Austen as offering heroines the mental and emotional stimulation denied girls in their everyday life. The literary example became a criticism of the patriarchy, for as Margaret Kirkham observes Jane Austen "learnt to define her own feminist position through a careful consideration of fiction".[11] Her heroines from Catharine Percival on gain depth as victims of a society which enervated and degraded them. They are dependents fighting for a life of their own in times hostile to feminine individuality. The plight of girls first emerges as a theme of social criticism in "Catharine". The title heroine condemns the fate of the Wynne sisters, which Camila Stanley as social spokesperson thinks fortunate. One sister is an unwanted dependent in a London family, made aware that she is existing on charity and kept from coming out into society. The other

has been exported like a commodity to Asia to be married to whoever will support her:

> "do you call it lucky, for a Girl of Genius & Feeling to be sent in quest of a Husband to Bengal, to be married there to a Man of whose Disposition she has no opportunity of judging till her Judgement is of no use to her, who may be a Tyrant, or a Fool or both for what she knows to the Contrary. Do you call *that* fortunate?" (p. 205; cf. p. 194)

Catharine's perspective in this complaint is of literary inspiration. In opposition to arranged marriages a girl needs the opportunity of an Evelina to evaluate a suitor. Judging character must become the basic skill for her to learn. It links the heroines from the courtship convention to the problem which Jane Austen saw as central for young women in her patriarchal society.

Jane Austen's concern with the plight of spinsters increased in "The Watsons". Its heroine, Emma Watson, dramatizes the misery of the unwanted female dependent. Like Fanny Price on the trip to her parental home in Portsmouth, Emma is a long absent daughter returning to her natural family, who have become strangers living in an "overstocked" house (p. 362). The theme so absorbed Jane Austen that for once she discussed a social problem in her own voice. Deploring Emma's disadvantages, she pondered the requirements of a tolerable life for women:

> The change in her home society, & stile of Life in consequence of the death of one friend and the imprudence of another had indeed been striking.--From being the first object of Hope & Solicitude of an Uncle who had formed her mind with the care of a Parent, & of Tenderness to an Aunt whose amiable temper had delighted to give her every indulgence, from being the Life & Spirit of a House, where all had been comfort & Elegance, & the expected Heiress of an easy Independence, she was become of importance to no one, a burden on those, whose affection she cd not expect, an addition in an House, already overstocked, surrounded by inferior minds with little chance of domestic comfort, & as little hope of future support. (pp. 361-362)

The misery of such women as Jane Austen saw it was fourfold. Instead of being of importance to others, they were only too often a burden, like the hapless old Mrs. Stent of the *Letters*.[12] Affection was often denied them in

arranged marriages. Poverty was an ever-present dread for daughters in large families, for their standard of upbringing would exceed their reasonable expectations in marriages of convenience made by mercenary men. Nor could they expect to find suitable intellectual companions in their husbands. Jane Austen was in effect arguing that if marriage were the fate prescribed for young women, then its principles had to be changed. In sum, a girl's prospects for usefulness, affection, domestic comfort and intelligent conversation had to become the primary considerations in her betrothal. They were so in the convention but not in the society of her times.

 The traumatic change of homes and prospects forced on Emma Watson by the remarriage of her aunt stresses a concern shared by heroines of the convention and girls of the times. Both faced the uncertain fate of leaving their girlhood home and finding another by marrying. The melodramatic loss of home by heroines like Cecilia, Celestina and Emily St. Aubert looms ominously behind Emma Watson's. It also anticipates the suddenly impoverished circumstances which girls like the Dashwoods, the Bennets and Miss Bates had to fear on the death of their fathers. It makes their insistence on nobler goals than security seem heroic. Only the rare daughter like an Emma Woodhouse could think of remaining mistress of her girlhood home and so consider living as a spinster attractive. In the mature novels an early move from home may dramatize the heroine's reduced circumstances. Elinor Dashwood loses her home after her father's death and marries into a straitened future as Mrs. Edward Ferrars. The entail of the Bennet home on Collins magnifies such a doom for the five daughters. It elevates the farce of Mrs. Bennet's husband hunting for them into a struggle for their very preservation.

 In contrast, the literary vision of marriage attracted women novelists of the 1790's, including the young Jane Austen. It offered an ennobling alternative to the threatened loss of status, security, comfort and respect. Charlotte Smith dreamed of domestic happiness as an ideal in novels like *Ethelinde*, Maria Edgeworth enlarged it into a theme in *Belinda*, and Jane Austen developed it as a self-contained protest against the mores of her society. In evaluating eligible young men exclusively by their wealth and rank, a mother like Mrs. Bennet and daughters like Penelope Watson and Charlotte Lucas were submitting to the received social standards of their times. In fundamental contrast, through Emma Watson's criticism of Penelope's

husband hunting, Jane Austen was declaring that this ambition was petty for worthwhile women like her heroines:

> "To be so bent on Marriage--to pursue a Man merely for the sake of situation--is a sort of thing that shocks me; I cannot understand it. Poverty is a great Evil, but to a woman of Education & feeling it ought not, it cannot be the greatest.--I would rather be a Teacher at a school (and I can think of nothing worse) than marry a Man I did not like." (p. 318)

This opposition of other careers to marriage as a possible future for young women verbalizes the mood of protest recurring in the mature novels in such diverse figures as Nancy Steele, Jane Fairfax and Mrs. Smith. Only the visionary world of conventional heroines offered readers of the time a positive alternative. Jane Austen accepted it as the basic social philosophy of her novels.

Like her feminine predecessors Jane Austen showed that women had to fight a hostile society to preserve their self-respect when marrying. Even the best of matches made by mercenary principles would not guarantee a woman the happiness of congenial minds or emotions, or a useful role in society. In "The Three Sisters" (1792) this opposition between social and self fulfilment takes on the gross extremes of the early Juvenilia. Mary Stanhope calculates whether or not she should marry a wealthy old man whom she hates. Jane Austen depicts this Mr. Watts as entirely indifferent as to which sister he marries. He scorns empathy as irrelevant when he rebukes a younger sister who declares,

> "I expect my Husband to be good tempered & Chearful; to consult my Happiness in all his Actions, & to love me with Constancy and Sincerity."
>
> Mr. Watts stared. "These are very odd Ideas truly young Lady. You had better discard them before you marry, or you will be obliged to do it afterwards." (p. 66)

Mr. Watts is given the stance of a man of the world when disparaging a woman's hope for happiness in marriage. Jane Austen went on to characterize the majority of marriages in her novels as unhappy while insisting on a different standard for her mature heroines. In *Pride and Prejudice* Charlotte Lucas Collins spends her days in an uninviting room to discourage her husband's presence, and in *Mansfield Park* Mary Crawford assumes that any wife would feel the same urge: "her husband away, she can have nothing

but enjoyment".[13] Only her mature heroines could, like their literary prototypes, hope to avoid an incompatible marriage because they have evaluated their suitors.

Following Charlotte Smith and Maria Edgeworth, Jane Austen developed the happy marriage of the convention into an ideal. After introducing the topic in "The Three Sisters" and commenting on it in "The Watsons", she explored its implications as the central theme of her later novels. Happiness remains the trite expectation of heroes and heroines in *Northanger Abbey*, which she offered for publication before she drafted "The Watsons". In *Sense and Sensibility* and *Pride and Prejudice*, the final versions of the other lost manuscripts intervening between the early Juvenilia and "The Watsons", it becomes a thought-provoking ambition. For the Jane Austen of the later novels, the high calling in life of "a well-judging and truly amiable woman" like Anne Taylor was to create for both husband and wife "a new period of existence with every probability of greater happiness than in any yet passed through".[14] Although a definition of *happiness* would further clarify this theme, Jane Austen would only imply her concept of the ideal marriage in self-contained novels. For her great heroines from Elizabeth Bennet to Anne Elliot it involves genuine companionship, intellectual give and take, moral equality, emotional harmony, and respect for women. She also recognized that in her society an incompatible pair like the Charles Musgroves "might pass for a happy couple".[15] Her young women become heroic by rejecting the worldly wise but fatalistic doctrine of such socially acquiescent girls as Charlotte Lucas that "happiness in marriage is entirely a matter of chance".[16] Such a view would make a joke of the effort of heroines like Catharine Percival and Elizabeth Bennet to learn to judge wisely among suitors when facing the fate of seeking a new home. Jane Austen's heroines give the convention meaning by turning the happy ending into a philosophy of marriage.

In considering the assets of a young woman for making a happy marriage, Jane Austen dramatized some strengths only posited for conventional heroines, particularly education. From the Juvenilia through *Persuasion* she repeated but also developed the standard assumption that heroines are born with minds superior to their parents'. Instead of remaining the static brilliance of a Fanny Warley or an Emmeline, this strength grows into a crucial asset of young women like Elinor Dashwood as they adjust to adult life. A sound intellect is vital to their independence, and must be

trained to help them marry wisely, not just to look polished. As a result the nature and purpose of education became a primary concern of Jane Austen's. Beginning with Camilla Stanley in "Catharine", she stressed the shallowness of the accomplishments in art, music and modern foreign languages which were the accepted aim of schooling for heroines and girls of the world alike:

> She was ... naturally not deficient in Abilities; but those Years which ought to have been spent in the attainment of useful knowledge and Mental Improvement, had been all bestowed in learning Drawing, Italian and Music, more especially the latter, and she now united to these Accomplishments, an Understanding unimproved by reading and a Mind totally devoid either of Taste or Judgement.... She professed a love of Books without Reading, was Lively without Wit, and generally good humoured without Merit. (p. 198)

In this analysis Jane Austen was giving substance to the concern of her predecessors with a woman's education. Despite the considerable asset of beauty, Camilla Stanley lacks "Wit" and "Merit". Jane Austen was repeatedly to portray these strengths of character as the two important products of a sound education, based on a solid foundation of "Understanding", "Taste" and "Judgement". Heroines like Emmeline possessed them along with the incredible knowledge parodied in "Love and Freindship". For her later heroines Jane Austen played down accomplishments but retained a credible version of an Emmeline's learning. In *Mansfield Park* education was to become a major theme.

As an educator Jane Austen like her predecessors showed social and moral conduct to be more important for young women than information. Her first concern for her heroines was their practical learning, including not only morality but also judging the characters of new acquaintance ably when their social circle rapidly widened. As the working title of *Pride and Prejudice* indicates, Jane Austen worried about the danger of "first impressions" when writing the lost manuscripts in the mid 1790's. An air and a look may help Evelina rightly choose Lord Orville over Willoughby, but they seriously mislead Elizabeth Bennet about Wickham. For Elizabeth, assessing character becomes an avocation: she regards the "deep, intricate character" as a challenge to enjoy in an effort to avoid the usual "total misapprehension of character in some point or other".[17] In a major expansion of Evelina's vague

concern, the evaluation of potential husbands became the first intellectual task for Jane Austen's heroines.

As a child of the eighteenth century Jane Austen regarded a set of fixed standards as essential for judging. Usually she developed them from some variation of the wit and merit of "Catharine". In *Pride and Prejudice* Elizabeth echoes the pair as "merit" and "sense", which she considers to be fitful in all human beings (p.135). The novel shows how an intelligent woman like her would increase her husband's happiness and her own, whereas a woman of "mean understanding" and "little information" like Mrs. Bennet would be of little help to a thinking husband and family (p. 5). Nor would Camilla Stanley. Her absorption with dress, which Jane Austen would have regarded as "frivolous", and ignorance of the geography of the places she has toured, were a criticism of society at large.[18] For heroine and woman of the world alike, accomplishments, liveliness and sweetness were secondary assets. They were no guarantee of what Jane Austen regarded as essential to a civilized life for women: knowledge, informed conversation, and merit.

(iv)

In developing this theme of protest out of the convention, Jane Austen committed herself to the art form which she had begun by burlesquing. In the later Juvenilia she worked out her techniques for dramatizing heroines on the fictional model like Catharine Percival and Emma Watson. They were the independent young women she set against the miseducated and self-satisfied Camilla Stanleys of the time. Artistically as well as thematically she compromised between the extravagant traits of literary girls and the shallow affectations of everyday women. An early frustration confirmed her in the use of the courtship plot as her basic narrative framework. In her one departure from it she began rather than ended "Love and Freindship" with the marriage of her heroines. It suited her to jest on their uselessness as wives when mocking their sensibility. Yet with the ongoing drama of a heroine's choice among suitors no longer possible, she lacked a comprehensive plot. Despite having gained independence as a widow Laura Lindsay merely drifts through the rest of the story. Jane Austen had no "ado", as Henry James would have put it, to make about her. In the plot of "Love and Freindship" the widows' future must be early death, which eliminates Sophia, or anticlimax, with Laura wiling away her time as a perpetual traveller.

Perhaps because feminine drudgery lacks artistic interest, perhaps because Jane Austen approached her heroines from the perspective of the

convention, she relied on the courtship plot to give shape, and so meaning, to everyday life in all her succeeding fiction. Although "Lesley Castle" establishes food as a touchstone of the mundane, she depended on a familiarity with the convention to give meaning to Charlotte Lutterell's agony as a cook without wedding guests. Charlotte looks vivid because her wailing over a wasted banquet at the death of her sister's bridegroom contrasts with the weeping of heroines of sensibility. Unlike romantic heroines Charlotte has been educated in recipes, not accomplishments, and has quarrelled with her sister over cooking, not suitors. As a fitting climax she would prefer a marriage feast to a marriage for herself, a gay twist of the courtship climax but of no significance without it.

The contrast between the romantic and the mundane is more restrained in the later Juvenilia. Serious heroines like Catharine Percival and Emma Watson look heroic as well as lifelike because they give credible responses to situations conceived within the world of the convention. Indeed "Catharine" seems designed as a series of scenes in which the heroine can prove herself a judge of character, first of Camilla Stanley and then of Camilla's brother Edward. Appropriately for a heroine on the bookish model Catharine probes Camilla's reading and comprehension by quizzing her on two of Charlotte Smith's novels, *Emmeline* and *Ethelinde*. Then she exposes Camilla's ignorance of geography despite having travelled as widely as most heroines. In contrast Catharine herself can take part in an informed discussion of Queen Elizabeth with her aunt and Camilla's father. Catharine is forced to conclude that neither education nor experience has prepared Camilla for a meaningful life as a woman. Camilla has not learned to weigh ideas or judge others soundly despite her much wider exposure to life, in London society and on the road. As always, Jane Austen was creating interest in a young woman by observing her from the perspective of the convention.

Similarly in "The Watsons" Jane Austen found an active occupation for Emma in her judging of her new acquaintances. At the request of her sister Elizabeth she assesses the likelihood that her brother Sam has won the love of a Mary Edwards, analyzing his chances rationally and supporting her conclusions with reasons. When she first meets her sister Margaret, she notes "the sharp, quick accent" of hypocrisy cloaked by a "tone of artificial Sensibility" (p. 351). Behind the excesses of the convention Jane Austen found an avocation for girls entering the society of her times. In the theme

of defining and achieving a happy marriage she found a meaningful purpose for their lives. In the drama of their learning how to evaluate strangers she found them a vital occupation. Inevitably the judging of suitors provided their greatest challenge. To it Jane Austen devoted much of her artistic effort.

By dramatizing incidents merely noted by her predecessors, Jane Austen characterized her heroines in credible action. Most of the juvenile stories are deliberately experimental, with only a few like "Lady Susan" leaving conventional situations undeveloped. On the page Jane Austen's one wicked heroine recalls tongue-tied wits like Evelina and Cecilia. Lady Susan rarely speaks although she claims that "the cheif of my time is spent in Conversation" (p. 268). In contrast in "The Three Sisters" Jane Austen experimented with dramatizing a girl's reaction to a proposal through five different techniques. They range from Mary Stanhope's inner feelings and outward expression of them to her boasting and quarrels with her sisters and her suitor, the repulsive Mr. Watts. In "Catharine" Jane Austen created an incident to put the heroine in control of her potential suitor when they first meet. The device of the toothache elevates Catharine into de facto lady of the house when Edward Stanley comes calling after Aunt Percival and the elder Stanleys have left for the ball. After "trembling" when coming downstairs, she forces herself to meet the challenge of her new role. After "pausing a moment at the door to gather Courage for opening it", as Fanny Price was to do in *Mansfield Park*, she assumes her new authority (p. 214). Calling on her wit, she stands up to Edward and so emerges from the scene as the dominant character. Here Jane Austen displayed Catharine's presence of mind in a simple drama beyond the reach of her predecessors, but in the rest of the story Catharine becomes the tool of Edward's male aggression. With his casual disregard for social decorum he dominates the ball despite Catharine's leading it off, and later he subjects her to a flirtation, which she assumes to be serious, merely to tease her aunt. Then the opposing worlds of the courtship convention and the patriarchy, of active heroines and passive young women, clash with one another as Jane Austen produced the double portraits of Catharine and her aunt.

With this tension between fiction and everyday life no longer disruptive, the incidents in "The Watsons" all advance the heroine's prominence. Emma Watson learns through situations developed out of the convention how to hold her own in a society of overbearing men and husband-hunting women. Her ball serves as her unheralded coming out, and

in later scenes with the ladykiller Tom Musgrave, the arrogant Lord Osborne, and her shrewish sister Margaret, she looks independent through her perceptive conversation. The most remarkable advance over "Catharine" comes in her capable handling of haughty men. She repels the flirtatious Musgrave, who is supercilious to female admirers like Margaret but toadies to the Osbornes. At the ball she declines his confident demand that she dance with him, though it is her active kindness to ten-year old Charles Blake which makes this the most memorable scene in the story. With the skill of the finished novels, Jane Austen has the heroine take the initiative and dominate this simple situation. Seeing young Charles dejected when Miss Osborne breaks her promise to dance with him, Emma asks him herself, delighting him and attracting the notice of the Osbornes. By the time Emma returns "sorrowfully" to her overnight hosts, the Edwards', from the ball, she has emerged as one of Jane Austen's most natural heroines (p. 336). The next day she forestalls Musgrave again when he is determined to drive her home to her father's house, in a situation made difficult by her dependent circumstances. Her father's "Chair" is unavailable and Musgrave has been sanctioned by her sister Elizabeth to bring her home in his carriage. Although reluctant to impose further on the Edwards, she asserts her self-respect by refusing the self-assured man. By controlling incidents conceived within the convention, Emma Watson preserves the heroic stance that Catharine Percival lost.

In these most successful scenes of the Juvenilia Jane Austen modified the bookish conventions which formed her concept of the novel into a portrait of her times, but a portrait that is carefully stylized. By intensifying her picture of domestic manners but limiting it to situations concerned with courtship and marriage, she found the final ingredient needed to give plausible depth to plots conceived within the convention. She drew on and partly presented a comprehensive picture of the life of her times, not the "ignorance of the forms, and inexperience in the manners, of the world" proposed by Fanny Burney in the "Preface" to *Evelina*. She devoted the practical education of her young ladies to learning to judge strangers. She traced their developing ideals of marriage and happiness, standards for education and living, and rational control of emotions. Once she had learned to avoid the mundane excesses of "Lesley Castle", she was able to use everyday concerns like Charlotte Lutterell's interest in food to narrow the gap between her heroines and representative young women of their times.

Catharine Percival's sensitivity over meeting a strange young man and taking him to a ball gives her a natural depth missing from the parody in "Love and Freindship". Emma Watson's distress over having to owe an obligation either to the Edwards or to Tom Musgrave creates a vital artistic tension out of the life of the times. Emma shows that a heroine can form intelligent insights into life and act on them with disinterested independence. As this effect increased from novel to novel Jane Austen became a major novelist of manners. She extended her scope to include the secondary characters and natural scenery anticipated by her predecessors but not developed in the Juvenilia. Yet she always fitted her observations of both into the framework of the convention, like her heroines, her themes, and every other aspect of her art.

Again following the feminine novelists, Jane Austen assessed the moral life of her heroines according to the dogma of the convention. Lady Susan's reputation for wickedness combined with the independent air of her letters promises a grand evil, but when it comes to definition she turns out to be merely "the most accomplished Coquette in England" (p. 248; cf. p. 256). What Lady Susan reveals is that Jane Austen thought of evil in her early fiction solely in terms of the repeated social sin in the courtship novels. It is an indictment of the society of the times, of actual rather than potential evil, for, in Leroy W. Smith's words, Lady Susan is evil "only if society itself is evil".[19] As with the vices so with the virtues. The *duty* and *principle* of *Mansfield Park* may recall the conduct books, but both the *merit* of "Catharine" and the early novels and the "beauty of truth and sincerity in all our dealings with each other" of the later novels express the moral outlook of heroines of the 1790's when contemplating marriage.[20] The characters in the novels proper seldom discuss more profound issues like those prevalent in Fielding and Richardson (from the nature of a nasty mind to the social response to rape). As conventional villains like Willoughby and Wickham later confirm, a coquetry reminiscent of Lady Susan's rather than any of the deadly sins is the repeated evil which threatens girls in the completed novels.

Jane Austen's ultimate achievement as an artist is the creation of vital central heroines out of the fanciful girls of the courtship convention. What began as a teenager's delight in mocking their excesses one by one ended in the transforming of their overall image into some of the great heroines of literature. The girl author of the early Juvenilia merely parodied details like the facial beauty of Elfrida and the temper of Alice. The teenage author of

"Catharine" assimilated them into a recognizable young woman of the times. As the orphan Catharine blends into the more socially representative half orphans of the later novels, so the striking features of the model heroine become restricted, plausible, and socially relevant. Beauty queens like Evelina give way first to the narcissistic Lady Lesley and then to an Elizabeth Bennet who is a perfect beauty only to the man who loves her. The eulogy of learning for an Emmeline, parodied in Laura Lindsay, is reduced to the reasoned conversation of a Catharine Percival, Fanny Price or Anne Elliot. The melodramatic trauma of an Emily St. Aubert when eluding violence in Udolpho is replaced by the fortitude of a Catharine at the apparent loss of a ball, which the socially trained Camilla Stanley cannot endure. The fulsome praise of a Matilda for her patience during her long confinement by her father in *A Simple Story* disappears as Lady Susan's daughter Frederica suffers abuse from her mother quietly. The parade of the miseries of an Adeline La Motte loses its sentimentality when Emma Watson accepts her loss of home with discreet sensibility.

As Jane Austen created credible alternatives to the exaggerated characters and incidents of the convention, she developed it into an artistic vision of what life could become for young women. Before her, the dream of a happy marriage had been typically a trite and extravagant fancy in a selfish world. Yet when she deepened it with the informed judging of friends and suitors, it seemed to her to offer the best hope of a civilized future for women. In this way Jane Austen made the traditional happy ending not only a meaningful artistic climax but also a criticism of her society. The art of her successive heroines, which began as parody, grew into an incisive drama of the plight of women in terms of the central crises of the courtship and marriage convention of her feminine predecessors.

CHAPTER IV

CATHERINE MORLAND AND THE DOUBLE DELUSIONS OF FICTION

Jane Austen's first completed novel recalls her contradictory view of fiction in the early Juvenilia rather than her more unified social and artistic outlook in "The Watsons".[1] For most of *Northanger Abbey* Catherine Morland is a would-be heroine parodied by two different principles. Together they reveal Jane Austen's close knowledge and complex use of the feminine literary convention. Then as a girl of the everyday world Catherine grows into a self-reliant young woman by rejecting fictional extravagances as a guide to life. At the same time she asserts her social independence by practising some of their principles. She especially looks to the happy ending for self-respect in her own future.

Northanger Abbey could scarcely exist without the convention. Its framework, incidents, heroine and her worries all have their inception in the romantic tradition. They depend on it for their form, substance and significance. Catherine owes her distinction of character to her traits as an anti-heroine, but without the novels of the preceding generation those traits would look routine and trivial. She also gains her great vitality of character from her contrast with the stereotyped heroines of earlier fiction, and the novel gains its vitality from her. Most incidents in her story depend on scenes familiar in novels. Because of the convention her frenzy over finding a roll of papers in the cabinet in her bedroom at the Abbey ceases to be mere slapstick. It probes a dichotomy in her character and the theme. Sometimes an incident may seem superficial because the convention behind it is forgotten. Catherine should not have to jostle her way through the crowd on her initial visit to the Upper Rooms in Bath. She ought to be dazzling the crowd on this her first public appearance with the beauty of an Evelina.

(i)

Echoing and exaggerating numerous such details as well as the overall convention, Jane Austen mocked it as false to life through two opposite methods of parody, both of which gain their meaning from it. Sometimes she contrasted the convention with everyday life and sometimes she showed Catherine trying to emulate it. The opening chapter introduces both

methods. Gaily opposing the girl of the world to embryo saints like Ethelinde, Jane Austen describes Catherine's childhood as anything but superior to all others. The first paragraph is a bird's eye view of a most ordinary girl of ten, but every sentence glances at the convention that the heroine ought to be orphaned, beautiful, brilliant, and sweet. Having exposed the unlikely assumptions by contrasting them with everyday life, Jane Austen then turned to parody by apparent respect for them. Suddenly they become a formal course of study for Catherine, who "from fifteen to seventeen ... was in training for a heroine" (*Northanger Abbey*, p. 15). In appearance she becomes "*almost* pretty" through the conventional beauty of "her complexion", "her features", "her figure", and the "animation" of her eyes (p. 15). By the end of the chapter the convention looks utterly irrelevant to a woman of the times. Other burlesques of it like *The Female Quixote* and *The Heroine* went no farther and took much longer to do so.

These two roles make Catherine an apt figure for parody, though they deny her consistency when she becomes a serious heroine. As an inadequate superior beauty she goes on to (half) dazzle (just two) men in Bath and endure the self-created Mysteries of Northanger Abbey. In this last sequence she casts herself as a heroine of sensibility in the tradition of Ann Radcliffe's Adeline La Motte and Emily St. Aubert. Like them she is humiliated--or rather feels abashed--by tyrannical--or aggressive--men. She also suffers from shame at her gullibility as a reader, which induces her to think of herself as a heroine.[2] In contrast as an anti-heroine behaving like an everyday girl, she acts with common sense and civility when talking to the boorish, boastful John Thorpe. As a clumsy "villain" of the day-to-day world, he is an oaf who sneers at women like his mother and sisters so as to look manly. When he parodies the traditional kidnapping of the heroine, he is similarly vulgar and undisciplined. He abducts Catherine with an ill-informed lie and guffaws when she begs out of his gig, but he turns back for fear of the dark. After praying in vain for him to stop, this everyday Catherine becomes a sulky and very substantial girl of the world as a victim.

Besides parody, the convention furthers Catherine's characterization. Neither she nor the events in her life offer a principle of artistic development on their own. Once her unpromising girlhood has been contrasted with a conventional heroine's, there is no more to say about her home life. Her parents are little more than names, for they neither abuse her nor force an unwanted suitor on her. Only Catherine's bookish expectations vitalize the

ongoing scenes--the hero on the dance floor quizzing her about heroines, the guardian worrying only about her own dress, the dismay at touring a Gothic abbey with modern kitchens. To unify scenes like these into a novel-length study, Jane Austen also depended on the convention for its courtship and marriage plot. She involves Catherine in a love triangle like Evelina's in which the heroine accepts rather than chooses the Grandisonian hero over the deceitful anti-hero. Similarly her false friend Isabella Thorpe recalls the selfish second ladies of fiction, such as Fanny Burney's Indiana in *Camilla*. The few non-parody scenes of Catherine's worldly concerns tend to be brief and lifeless even when genuinely heroic. Her trip home alone from Northanger Abbey, which was a rare and risky venture for a single woman in those days of hazardous travel, takes some twelve hours but only as many sentences. Jane Austen found the patriarchal society uninspiring for characterizing young women. The central heroines of conventional plots were much more intriguing and she soon came to respect as well as mock them.

In parodying the heroines of sensibility Jane Austen found a theme as well as an artistic model, deepening Catherine's significance. By evaluating the temptation of young readers to take novels as a guide to everyday conduct and ambitions, she gave *Northanger Abbey* a relevance lacking in the novels of her feminine predecessors, and only gradually broached in the Juvenilia, with its gibes at single bookish absurdities. Even as a teenager in the first chapter Catherine gains unprecedented depth as she tries to fit her everyday feelings to romantic sensibilities. The course of her "training for a heroine" consists largely of memorizing proper emotional responses. In a series of sample verses which would have served Ann Radcliffe or Sir Walter Scott as headings for a half dozen chapters, she looks to the poets for guidance. She turns to Pope for patience, Gray for self-confidence, Thomson for joy in thinking, and Shakespeare for jealousy, compassion, and the melancholy of silent love. Undoubtedly Jane Austen accepted these responses as valid, just as she admired the novels which she was parodying.[3] But she likely suspected that precepts alone have little impact as practical education and certainly thought them an inadequate and sometimes dangerous substitute for it.

Catherine has in fact learned to avoid life. When she enters Bath society in the second chapter, she is preoccupied with reading the romances of Ann Radcliffe rather than experiencing her new social world. She is too often

left to the luxury of a raised, restless, and frightened imagination over the pages of Udolpho, lost from all worldly concerns of dressing and dinner, incapable of soothing Mrs. Allen's fears on the delay of an expected dressmaker. (p. 51)

Tense reading has made Catherine rude to her hostess. It also distracts her from relishing her entry into the social world. Soon she is living and breathing the novel, yearning to feel the weather and see the scenery of Udolpho when she steps out of doors in Bath. By the time she visits Northanger Abbey in the second of the original two volumes, the too well-read Catherine has learned to assess life there by Gothic novel principles. She casts herself as an Emily St. Aubert opposite General Tilney as her Montoni.

Yet there are worse responses to life than avoiding it through books. Catherine is not the only girl in the novel to model her life on fiction, but she is the honest one. Isabella Thorpe is a vicious version of bookish living, for she professes sensibility while acting solely to suit her own selfish ambition. She is determined to marry by the mercenary, loveless principles of the patriarchy. She talks of feelings but pursues the richest available suitor-- James Morland if necessary, Frederick Tilney if possible. Reading is not an escape or a protest for her, but a weapon to use in her struggle for a marriage of convenience in a commercial society.

The satire of bookish values as an evasion of life includes two other pre-Romantic delights featured by Charlotte Smith and Ann Radcliffe and briefly lampooned in the Juvenilia. Like Catharine Percival in her bower, Catherine Morland enjoys the "gloomy aspect" of ancient trees, no matter how much their being "damp" may endanger her health on a raw English day (p. 179). A still greater enthusiasm is her fondness for mediaeval buildings: "Her passion for ancient edifices was next in degree to her passion for Henry Tilney--and castles and abbies made usually the charm of those reveries which his image did not fill" (p. 141). Fortunately for Henry he fills her reveries more and more fully as the novel develops. Yet by this juxtaposition of literary and lifelike emotions Jane Austen deflates her heroine's enthusiasms with an authorial wit rare in both the convention and her Juvenilia. Although Catherine looks honest as a heroine beside the hypocritical Isabella, she exposes the inadequacy of fads in novels as an unqualified guide to life. They threaten to warp her from becoming an attractive young woman of the workaday world.

(ii)

Despite parodying the convention, Jane Austen was unwilling to abandon it. While burlesquing it as a false guide to life, she used it as her point of departure when satirizing the patriarchal society of her times as degrading for young women. In no other novel did she attack male tyranny so openly and vigorously, though she continued to portray it as a central trait of anti-heroes to the end of her career. The first-page quip that Mr. Morland "was not in the least addicted to locking up his daughters" may parody fictional fathers, but it sets up a point of view. John Thorpe and General Tilney are dangerous men in and out of their parody roles. Thorpe may be more a petty liar and boor than a rake, but his sweeping lies rob Catherine of her chance to run her own life. By manipulating her affairs at a distance, he curtails her independence during her gap of freedom from her father's authority. Although she is oblivious to his role, she is his puppet for half the novel. Through his braggings to General Tilney he causes her successively to be invited to Northanger Abbey, abruptly dismissed from it, and at the climax allowed to marry Henry.

John Thorpe is partly a plot device, but General Tilney is a family tyrant who goes far to justifying Catherine's bookish assessment of him. In turn he validates the feminine convention in its assessment of male greed and cruelty. He may not be the wife-destroying Montoni that she fancies from her reading, but he is ruthless in forcing Catherine out on the open road destitute and unprotected. As a result Jane Austen accepts Catherine's conclusion "that in suspecting General Tilney of either murdering or shutting up his wife, she had scarcely sinned against his character, or magnified his cruelty" (p. 247). Phrases like "the General's cruelty" and "the General's unjust interference" carry Jane Austen's resentment up to the last paragraph of the novel (p. 252). In larger perspective she identifies his tyranny with the father figure of her society when she notes that

> The General, accustomed on every ordinary occasion to give the law in his family, prepared for ... no opposing desire that should dare to clothe itself in words, could ill brook the opposition of his son [to his abuse of Catherine]. (p. 247)

No later Jane Austen father is so domineering, but in *Mansfield Park* Sir Thomas Bertram seems so to his daughters, and Mr. Price sounds so to his. The male arrogance of later antiheroes like Henry Crawford and William Walter Elliot makes it desirable that they never become husbands or fathers

to good women. Early and late Jane Austen shared the resentment of authors in the feminine convention at the harsh treatment of young women by arrogant men.

The attitude of the hero to women is less easy to define. In suggestively negative language Jane Austen distinguished a minority of men like Henry Tilney from most of their sex:

> though to the larger and more trifling part of the sex, imbecility in females is a great enhancement of their personal charms, there is a portion of them too reasonable and too well informed themselves to desire any thing more in women than ignorance. (p. 111)

Such an equivocal defence of the most liberally minded men suggests that even the hero lacks sufficient respect for women. The long conversations which he has with Catherine show his delight in lecturing her. In principle he admits that "'in every power, of which taste is the foundation, excellence is pretty fairly divided between the sexes'" (p. 28). In practice he acts as though women have little minds and less knowledge:

> "I have no patience with such of my sex as disdain to let themselves sometimes down to the comprehension of yours. Perhaps the abilities of women are neither sound nor acute-- neither vigorous nor keen. Perhaps they want observation, discernment, judgment, fire, genius, and wit." (p. 112)

Perhaps Henry is bantering, but the jest reveals his frame of mind. He is describing the Catherine whom he is courting as he sees her. His sister Eleanor asserts that he would never "'say an unjust thing of any women at all, or an unkind one of me'" (p. 114), but she feels the need to defend him. As a gentleman in the tradition of the Grandison hero Henry is modified to look more like a man of the times. He is not so respectful to women as Lord Orville to Evelina or Montgomery to Ethelinde.

When characterized in relation to Henry, Catherine looks convincingly naive, but she also looks unheroic. She deserves admiration for reacting with pride to General Tilney's ruthless affront, but Henry dominates their joint scenes more like a mentor than a suitor. In the parody he exposes her Gothic fallacies and in the serious story he shapes her taste as his future wife on everything from flowers to art, like an Edgar Mandeville to his Camilla. Artistically Jane Austen had to use him as spokesman, for Catherine is too weak a central intelligence to take part in the play of ideas. Jane Austen

relied on him to voice her admiration for Ann Radcliffe despite the parody and to express her ideas on marriage, reading, and current attitudes to women. In doing so she was acknowledging the domination of girls by their suitors as the "deference of the youthful female mind, fearful of hazarding an opinion of its own in opposition to that of a self-assured man" (p. 48). Henry is Catherine's hero because he dances and talks with her, but she attracts him as a good listener, not a woman of ideas. He wants no central heroine in his life story. Yet if the lecturing man dominates the uninformed woman, the artistic if not the social effect was to prove useful for Jane Austen. In Henry Tilney she first experimented with the difficulties which she would have to work out for Knightley as teacher of Emma Woodhouse.

(iii)

Despite this subservience to Henry, Catherine grows into a woman of considerable independence through emulating conventional heroines. To establish her superiority, Jane Austen for once resorted to direct praise, as her predecessors regularly did when describing the initial strengths of their heroines. She applauded Catherine's positive value to the Allens as a guest "whose good-humour and cheerfulness had made her a valuable companion" (p. 154). Through Mrs. Morland she admired her self-reliance on her trip home after the General turns her out on the road. She even had Henry break out of his role of mentor to voice his delight in her innocent worry that Frederick Tilney may be flirting unintentionally with Isabella:

"your attributing my brother's wish of dancing with Miss Thorpe
to good-nature alone, convinced me of your being superior in
good-nature yourself to all the rest of the world." (p. 133)

In a sentence Jane Austen turned Catherine's naivety into an asset. Again, when satirizing Isabella as the perfect bride, Henry has Catherine in mind as his standard, strong in the frankness of the conventional heroine: "'Open, candid, artless, guileless, with affections strong but simple, forming no pretensions, and knowing no disguise'" (p. 206). In effect he is justifying his choice of Catherine over the calculating young women of the patriarchy. After all, Jane Austen did provide Henry with a sound reason for admiring Catherine the would-be heroine, though he mentions it more like a pleased teacher evaluating her progress than an ardent lover glorying in her excellence.

Of the other conventional devices which give Catherine a vital life of her own, the most crucial is the gap in her home life which constitutes the

novel. As with Evelina and Camilla, "our heroine's entrée into life" occurs at a spa (p. 20). Life there brings her into the world of assemblies and dances, eligible young men and women, and informed controversy which together expand her experience and help her to form views of her own. When the visit to Bath is nearing its end, Jane Austen prolongs the gap with a second visit more reminiscent of Ann Radcliffe's heroines than Fanny Burney's, the trip to Northanger Abbey. Removed from all her familiar surroundings, she must now respond on her own to the puzzling General Tilney, first to his toadying, and then to his tyranny. Also, like Camilla and Emmeline, Catherine makes some close women friends when by herself. Isabella is a false one, yet through her Jane Austen voiced her own concern with the social assumption that all women are so: "'The men think us incapable of real friendship you know, and I am determined to show them the difference'" (p. 40). Isabella would seem to justify the men's view, but Catherine's other new girl friend Eleanor Tilney disproves it.

To make the conventional devices effective, a heroine had to use them to generate her own independence. The gap serves Catherine well, for through it she not only learns how to think and act for herself but can be seen to be doing so. With her Jane Austen developed the rather shallow and casual judging of strangers and suitors by Evelina and Emmeline into a considered action. Through it she centred the Bath chapters on Catherine, making her thoroughly alive if not fully heroic. Although Catherine adores rather than assesses Henry and Eleanor, her judging of the Thorpes stimulates inner growth. She shows her first independent thinking in her hesitant estimate of John Thorpe, sizing him up as an empty-headed braggart on their first drive:

> Little as Catherine was in the habit of judging for her self, and unfixed as were her general notions of what men ought to be, she could not entirely repress a doubt, while she bore with the effusions of his endless conceit, of his being altogether completely agreeable. (p. 66; cf. p.65)

Later, when Jane Austen cites his condemnation of *Camilla* (which he has not read) after she has praised it in her authorial voice,[4] she implies that Catherine like Harriet Byron is the sounder thinker than the man with the university education.

With Isabella Thorpe posing as the best of friends, Catherine is at first naive in judging her, but later she matures by seeing through her. As a

newcomer to the social world Catherine would likely be deceived in her first days in Bath by Isabella's hypocritical stance as a heroine. Actually a coquette flirting with rich men, but pretending to be an epitome of sensibility, Isabella deepens the parody into satire. She shows how the social ideal of the marriage of convenience can lead a girl to manipulate the daydreams of innocent readers. Gradually Catherine comes to look more gullible than loyal to a new friend, as Isabella flaunts her greed when toying with James Morland's proposal while pursuing Frederick Tilney. Catherine's change for the wiser comes late in the Northanger chapters. In her first positive thinking after her "visions of romance were over", she analyzes Isabella's letter about the broken engagement with James as a "shallow artifice" of "inconsistencies, contradictions, and falsehood" (pp. 199, 218). Like Charlotte Lennox's Arabella in *The Female Quixote*, she has learned to see the world as typically shallow and sordid. She then must adjust to its meannesses as much as a heroine can.

Along with these sound insights in judging the Thorpes, Catherine exudes an inner zest which gives force and continuity to the actions and emotions of conventional heroines. She is at her most spirited in repelling the Thorpe's inroads on her conduct, but she can if necessary also assert her independence with Henry. When he asks "'What are you thinking of so earnestly?'", her retort "'I will not ["tell"]'" is more direct than Celestina's similar refusal, and more forceful.[5] Dramatic moments like this give Catherine an individuality beyond that of her literary ancestors. It is a strength which increases markedly when she takes the initiative from the Thorpes and her brother James as they try to bully her into cancelling a walk around Bath with the Tilneys. Finding her "agreement was demanded" and her "acquiescence expected", she withstands the pressure of Isabella's alternating affection and reproach, James's angry charge that she is "obstinate", and John's lie in her name, with an energy that is heroic:

> "I will go after them," said Catherine; "wherever they are I will go after them. It does not signify talking. If I could not be persuaded into doing what I thought wrong, I never will be tricked into it." And with these words she broke away and hurried off. (pp. 97-101)

This little scene of ordinary life shows an unparodied Catherine in command of an everyday incident, living her own life as she thinks right.

Then as Catherine marches off to apologize to the Tilneys for John's unauthorized lie, Jane Austen deepens the sense of her individuality with an inner drama not anticipated by her feminine predecessors. It looks forward to the device which Henry James was to advocate for characterizing a central heroine like Isabel Archer. As Catherine "walked, she reflected on what had passed" and a conflict develops inside her mind (p. 101). Her pain at disappointing her friends clashes with her conviction of being in the right, while her own desires pull her both ways. This simple decision has turned into an inner battle in which the heroine becomes actively independent as she works out her own decision. Internal drama had been one of the potential artistic distinctions of the novel since its inception by Richardson, but none of his followers exploited it before Jane Austen. In this first experiment she was hesitant enough not to leave Catherine's conduct to speak for itself. She has the wise Mr. Allen sanction it, like an elder spokesman on the ethical view of her conduct.[6]

After a lapse into Gothic fantasy in the early chapters of the visit to Northanger Abbey, Catherine continues to grow in individuality there as Jane Austen adds two variations in the inner drama. At bedtime in the Abbey Catherine only parodies Adeline La Motte when she rifles the ebony cabinet in her quest for some lost romantic manuscript. In this scene Jane Austen notes only the same external signs of tension used by the predecessors whom she was parodying--blushes, trembling, a "flushed" cheek, an eye "straining with curiosity" and "an unsteady hand" (pp. 165, 169). But when the dawn exposes Catherine's folly, the action turns wholly inward. It is a preview of the self-criticism which was to give Elizabeth Bennet and Emma Woodhouse their intense inner depth:

> Could not the adventure of the chest have taught her wisdom?
> A corner of it catching her eye as she lay, seemed to rise up in judgment against her. Nothing could now be clearer than the absurdity of her recent fancies. (p. 173)

Here the outward actions of eyeing the chest and replacing the laundry bills in the cabinet are of moment only as they stimulate an inner response. As the parody turns serious, Jane Austen abandons the conventional blushes and trembling and develops her own artistic techniques. Catherine on her own, without the patronizing Henry, has emerged as the centre of another scene in which she grows inwardly.

The familiar tears, when they are tears of undeserved humiliation, can also establish inner depth. Catherine's "tears of shame" when she is caught spying for a corpse in Mrs. Tilney's room continue the parody of conventional heroines (p. 198). Instead her tears on being sent home in unexplained and unmerited disgrace are the stunned response of an abused woman:

> Catherine's swelling heart needed relief. In Eleanor's presence friendship and pride had equally restrained her tears, but no sooner was she gone than they burst forth in torrents. Turned from the house, and in such a way!--Without any reason that could justify, any apology that could atone for the abruptness, the rudeness, nay, the insolence of it. (p. 226)

This weeping is a moving protest against the General's tyranny. It is the reaction of a mature Catherine to a humiliation for which she can find no explanation. But the attempt to find one leads her into a process of reasoning, still another of Jane Austen's techniques for deepening the conventional heroine through internal conflict. These dramatized traits create a character of inner dimensions out of the everyday girl who has daydreamed of a more challenging world than the one she knows.

(iv)

Although Catherine matures during her visits to Bath and Northanger Abbey, her double purpose weakens the climactic effect of the courtship plot. Her story ends with the traditional proposal, which gives it its forward movement, its climax, and its sense of fulfillment. Artistically the convention has to be taken seriously. At times Catherine remains the inadequate heroine of the parody, but in the end she becomes a mature woman. By means of her private weeping on leaving Eleanor, Jane Austen deftly turns her humiliation into evidence of her fortitude, a heroic if conventional trait; but her dismissal from Northanger is her high point as a serious character. After passing over the simple heroism of Catherine's solitary, unprotected journey home, which impresses Mrs. Morland, Jane Austen parodies her arrival as inadequate for a heroine. Catherine is not "returning ... in all the triumph of recovered reputation" but slipping "home in solitude and disgrace" (p.232). Again, at the climactic proposal, Jane Austen explains that Henry loves Catherine not for any conventional superiority of hers, but because of "a persuasion of her partiality for him" (p. 243). In the closing pages she was more incensed at General Tilney's male "cruelty" than inspired by Catherine's climactic marriage (pp. 247, 252).

With Catherine ultimately becoming a serious heroine, the courtship and marriage convention also has to be respected. It is crucial to the novel whether the climax is amusing or not. Despite the parody Jane Austen relied on the traditional love story for overall unity. It coincides with the scope of the story from Catherine's meeting with Henry in the first days in Bath, through the customary dances, outings and visits with him, to the final proposal. By means of John Thorpe she even develops a slender love triangle of the *Evelina* type, which proves to have been crucial when it instigates the General's opposition to Henry's courting of Catherine. The discussion of marriage gives the plot thematic depth, though it is not continuous, and also divided between social criticism and parody. Henry defines an everyday ideal when discussing "a country-dance as an emblem of marriage", with "fidelity and complaisance ... the principal duties of both" (p. 76). By contrast, Mrs. Allen's inferiorities as a bride who "had neither beauty, genius, accomplishments, nor manner" simply reverse the conventional superiorities of heroines (p. 20). Like Catherine the plot wavers between mundane situations and absurd extravagances. The themes of bookish living by Gothic fancies and of feminine independence from false friends are left peripheral to courtship and marriage in this novel. In the end Jane Austen dismisses Henry's proposal in a jest at conventional moral precepts:

> I leave it to be settled by whomsoever it may concern whether the tendency of this work be altogether to recommend parental tyranny, or reward filial disobedience. (p. 252)

The artist could only smile at herself when she fell back on the plot of the convention to round out her realistic alternative to a parody of it.[7]

Northanger Abbey is a novel which looks two ways and barely glances at a third. In one direction it parodies the convention as an absurd guide to life. In the other it satirizes the patriarchal society as degrading for women. Artistically, the zestful Catherine of the parody scenes becomes pallid as a girl of the world when stripped of her bookish perspective. Her fate is not a match arranged by her parents but the happy marriage of the convention, which Jane Austen could not yet take seriously. The parody, which is itself divided between an inadequate emulation of bookish heroines and a contrast between them and reality, belittles the convention to which the plot belongs. The social environment of male tyrants, patronizing suitors and greedy marriages exposes the humiliation of women in the existing social order. Consequently the artistic effort to give Catherine prominence through praise

by others, her judging of strangers, and inner drama has a divided purpose. It teaches her to give up the visions of conventional heroines but also not to replace them with the principles of a society contemptuous of women and often cruel to them. As Warren Roberts says, "Throughout *Northanger Abbey* Austen used literary device as a way to reach behind illusion and reveal the real world".[8] In the closing jest on the proposal Jane Austen was not only mocking her own frustration as an artist but also expressing dissatisfaction with the two views of life. She was anticipating a third, intermediate position of compromise for women of independent minds, a modified conventional ideal, which she was to develop and define in her later novels.

CHAPTER V

ELINOR AND MARIANNE DASHWOOD: SOCIAL PROTEST AND SENSIBILITY

In *Sense and Sensibility* (1811) Jane Austen exposed the abuse of women of independent minds by the patriarchal society, but she still found the emotional ideal of the feminine convention an absurd alternative. When the Dashwood sisters are forced to leave their paternal home on their father's death, Marianne seeks to escape from the oppression of women in her times by living out her fantasy of a storybook love in which she is the central heroine. Although Jane Austen satirized this extreme response as potentially suicidal, as it is for Sophia in "Love and Freindship", she was less certain about a positive alternative, which she started to establish through Elinor. As with Catherine Morland, the convention satirized in Marianne helps to make her a solid and vigorous character, but when denied the same model Elinor is less vivid as a heroine and less effective as a social critic. Yet despite the satire of one heroine and the pale image of the other, they both win through to a final self-respect outside the normal expectations for such women in their day. Like the heroines of the preceding generation they are an implicit protest against the patriarchal society of the times.

(i)

No other novel of Jane Austen's creates such a strong sense of women beleaguered in a man's world. All the characters who matter are outside the established, anti-feminine society with its unhappy marriages of convenience. They are either widows like Mrs. Henry Dashwood and Mrs. Jennings or impoverished young ladies like the Dashwood sisters and the Steeles. On entering the social world the latter must make their own way in a repressive society not envisaged by *Evelina*. Although Elinor and Marianne lose only one parent in the first chapter, their fate gives new depth to the orphan convention. It may free them from subservience to a father, but it severely reduces their financial status both for their current living expenses and for the dowry which men of anywhere near their previous social status would expect of them. Like Ethelinde they face such a degrading future because of the loss of a father and the selfishness of a brother. Their too trusting father may have wished them well, but he has left them, without legal recourse, to the

bounty of the "rather cold hearted, and rather selfish" John Dashwood, who is quickly persuaded by his still more "selfish" wife to pocket their promised legacy (*Sense and Sensibility*, p. 5). Then they find decent shelter only through the charity of another man, Sir John Middleton. In the patriarchal society depicted a man's help seems crucial to their welfare, as it does also for the widowed Mrs. Smith in *Persuasion*.

Empty-headed and uncongenial though the Middletons prove to be, Sir John with his "good heart" provides the Dashwoods the help which was denied Eliza Williams in Colonel Brandon's inset story (p. 33). A tragic victim of the patriarchal society, Eliza is a conventional "orphan" with the traditional "warmth of heart" and "eagerness of fancy and spirits" who has lacked only the "fortitude" of heroines to elope into a storybook courtship with Colonel Brandon (pp. 205-206). Ill-matched by social pressure to "a husband to provoke inconstancy", she dies "worn down by acute suffering of every kind", ruined by arrogant men, just as her daughter is seduced and deserted by the sham "hero" Willoughby (pp. 206-207, 43). Set against a society which is so ruthless to sensitive women, the convention offers the great attraction of an alternative order which would have saved Eliza if she had eloped with Colonel Brandon. In its strong appeal to Marianne it is more than a daydream; it is the one evident means to civilized living.

The male society looks particularly dehumanizing in *Sense and Sensibility* because it is nearly faceless. As Leroy W. Smith remarks, "the system" of the patriarchy is the "enemy" in this novel.[1] It features no male tyrant like Montoni, Schedoni or General Tilney to concentrate its brutality and cruelty. The men in this novel are too little to be actively villainous. They are insignificant people taking advantage of the luck of their sex to live at their ease and patronize women. John Dashwood wants anyone but himself to "do a great deal" for his sisters (p. 228). Sir John Middleton feels that "in settling a family of females only in his cottage, he had all the satisfaction of a sportsman" (p. 33). Mr. Palmer lapses from "his Epicurism, his selfishness, and his conceit" only to make constant fun of his wife and mother-in-law (p. 305). Robert Ferrars treats all women including his mother as fools, until Lucy Steele makes a fool of him. The suitors, who are presumably the best of the men, are anything but heroic. Only Colonel Brandon acts openly and without deceit, and he is the most faceless man of all. The seemingly ardent Willoughby seduces Eliza's daughter and daydreams of romance with Marianne, but when a rich Miss Grey appears he

settles for her money along with her spite. Edward Ferrars is an enervated hero: he is a little man who opts out of the approved masculine careers like law and the army but longs rather than strives for domestic happiness with Elinor. He does nothing positive about it until Lucy Steele discards him. The most strident social voice is no man's, but the domineering Mrs. Ferrars'. As patriarchal as most women of the convention when in a position of power,[2] she commits her fortune and ambitions for her sons wholly to the principles of the male society. Beset by its aloofness, greed and contempt, a self-respecting women can only withdraw from it and seek other ideals.

The situation of single young women in this male-oriented society is desperate. Marriage on its terms is unlikely to make them happy, but they must marry to have a tolerable future. As Elinor tells Edward, it is "better for her [Lucy Steele the woman] to marry *you* than be single" (p. 367). The Steele girls look crass in their frantic search for security through husbands, but they are in fact responding to social conditions in the most direct way. The need of the Dashwood girls is also urgent, but like their predecessors in the feminine novels they refuse to marry just for a price. A financially comfortable marriage still confronted a young woman with a depressing future. Those who have married as they were expected to do--the Mrs. John Dashwoods and Lady Middletons--have nothing "worth hearing" to say (p. 233). Seen from the dignified perspective of conventional heroines, they show several deficiencies "for being agreeable--Want of sense, either natural or improved--want of elegance--want of spirits--or want of temper" (p. 233). The sad truth for Jane Austen is that the society based on these women is insipid without men:

> When the ladies withdrew to the drawing-room after dinner, this poverty was particularly evident, for the gentlemen *had* supplied the discourse with some variety--the variety of politics, inclosing land, and breaking horses--but then it was all over.
> (p. 233)

In *Pride and Prejudice* Jane Austen was to propose a flow of rational conversation between a man and a woman as the chief domestic joy in marriage, and hence the measure of its success. It was not to be found in the patriarchal society of these little men and women, which, as P. J. M. Scott assesses it, is not "worth the pains they ["who are intelligent, sensitive and just"] have to take to live with it".[3] No wonder that thinking men like Edward Ferrars and John Willoughby dream of a different ideal of "domestic comfort"

(p. 16; cf. p. 332). No wonder Marianne looks to the convention for happiness.

(ii)

While attacking the life allotted women by the patriarchal society as empty and degrading, Jane Austen rejected the simple alternative of her story-telling predecessors as fantasy. Through Marianne the specific parodies of the Juvenilia and *Northanger Abbey* widen out into a comprehensive satire of the romantic way of life envisioned for women in the courtship convention. In *Sense and Sensibility* Jane Austen was enlarging the attack on emotional enthusiasm as a guide to living that she had begun in "Love and Freindship" and repeated in "Lesley Castle" and *Northanger Abbey*. Initially drafted in 1795 as the epistolary "Elinor and Marianne", *Sense and Sensibility* reflects its decade. It echoes the ambivalence of novelists of the 1790's like Clara Reeve, Charlotte Smith and Ann Radcliffe, who sought to distinguish between a good and a bad sensibility.[4] Like Charlotte Smith, Jane Austen linked the excess--the bad sensibility--to the delusion of trying to live life according to novels, but the satire is subtler than the parody of Catherine Morland for trying to memorize emotions for various occasions from precepts in poems. Although "passages were idolized" by Marianne and Willoughby, their good sense makes their reliance on bookish ideals more sophisticated than Catherine's (p. 47). It also makes it more dangerous, for it entices these enthusiasts to waste their great talents.

Jane Austen also tried to distinguish feelings which she could admire, as her ambivalent predecessors had done. She developed Elinor as a woman who feels deeply but privately, recalling Clara Reeve's "true" as opposed to "false" sensibility. Yet for her ambivalent predecessors and herself, for Elinor and the reformed Marianne, the larger question must be whether rational and emotional responses to life can coexist in one person, or whether one must dominate the other.

Marianne Dashwood represents open or "strong sensibility" in its most admirable form (p. 201). To assess its potential danger with increased objectivity, Jane Austen set aside her former suspicion that it is the hypocritical and selfish "cant" charged by Charlotte Smith and implied in the Juvenila through Lady Susan. It may be a mask for greed in sister Margaret in "The Watsons" and Isabella Thorpe in *Northanger Abbey*, but Marianne Dashwood is sincere. Her one defect is that "her sorrows, her joys, could have no moderation" (p.6). Even at best, Jane Austen was convinced that

there are reasons aplenty"to call for the ridicule so justly annexed to sensibility" (p.49). First, if not selfish, it seemed self-centred in contrast to the eighteenth-century standard of disinterested social behaviour. Marianne can eagerly accept Mrs. Jenning's invitation to come to London for a prolonged visit, but she so dislikes the woman that she is unwilling to talk to her even as her guest. Second, she neglects social obligations, as Elinor complains of her: "'all the charms of enthusiasm and ignorance of the world cannot atone for setting propriety at nought'" (p. 56). Third, in the family circle, which is the primary social unit in Jane Austen's novels, she adds to the misery of her mother and sisters by openly bemoaning her own sorrows and loudly bewailing theirs. She repeatedly embarrasses Elinor by publicly defending her from the gossipy Mrs. Jennings. Finally, she injures her own health almost on principle by encouraging fits of feeling and refusing to exert herself to overcome them:

> Marianne would have thought herself very inexcusable had she been able to sleep at all the first night after parting from Willoughby....She got up with an headache, was unable to talk, and unwilling to take any nourishment; giving pain every moment to her mother and sisters, and forbidding all attempt at consolation from either. Her sensibility was potent enough!
> (p. 83)

Although in this novel *sensibility* may partly mean estimating the proper degree of emotional response, Jane Austen seems chiefly to equate it with excessive feelings, which if uncontrolled can lead to moral as well as social evil. As W. A. Craik has pointed out, Marianne courted her "moments of precious, of invaluable misery" and "rejoiced in tears of agony" to the brink of suicide.[5]

As usual Jane Austen also widened her criticism to include some other Romantic enthusiasms. When summarizing her attack in the last three paragraphs of the first chapter, she opposed "sense" to "Marianne's romance" as well as her "sensibility". In context *romance* seems to mean a reliance on fancy rather than sense as a guide to life. This wider satire makes special fun of three of Marianne's favourite delights. Through Edward, Jane Austen mocks her passion for a wild scenery reminiscent of Charlotte Smith in *Celestina* and Ann Radcliffe in *The Mysteries of Udolpho*:

> "I do not like crooked, twisted, blasted trees. I admire them much more if they are tall, straight and flourishing. I do not

like ruined, tattered cottages. I am not fond of nettles, or thistles, or heath blossoms. I have more pleasure in a snug farm-house than a watch-tower--and a troop of tidy, happy villagers please me better than the finest banditti in the world." (p. 98)

As with sensibility, Jane Austen valued the rational, the practical, the useful, approving with Edward a nature that "unites beauty with utility" (p. 97). She also satirizes Marianne's fondness for places divorced from people. She mimics her sad rhapsody on her childhood home of Norland when moving from Sussex to Barton in Devonshire. She mocks her "great pain" on leaving Mrs. Jennings' London house despite disliking both her hostess and the City (p. 301). Here, she would feel, Marianne's enthusiasm has led her emotions into self-contradictory behaviour. A third notion, a reliance on feelings as a guide to right conduct, would have seemed a non sequitur to Jane Austen. The irony is implicit, for events contradict Marianne's claim that "'if there had been any real impropriety in what I did, I should have been sensible of it at the time, for we always know when we are acting wrong'" (p. 68). Oblivious to Willoughby's hints of seduction, she has accepted his gift of a horse, given him a lock of her hair, and visited a strange house alone with him. Since Jane Austen's time the acceptance of Romantic assumptions has left this ridicule of emotional morality looking archaic. Consequently the specific satires here help to clarify the gentler mocking of the same delights in two later heroines, Fanny Price and Anne Elliot.

The differing artistic success of the two heroines explains the comparative failure of this satire of open or "false" sensibility and allied obsessions. Although Marianne the enthusiast is the secondary heroine, she is an artistic miracle. In her Jane Austen deftly created a vivid character out of a figure who is purely conventional:

her face was so lovely, that when in the common cant of praise she was called a beautiful girl, truth was less violently outraged than usually happens. Her skin was very brown, but from its transparency, her complexion was uncommonly brilliant; her features were all good; her smile was sweet and attractive, and in her eyes, which were very dark, there was a life, a spirit, an eagerness which could hardly be seen without delight. (p. 46)

Marianne shares these details with the heroines of a generation, and each is praised with the trite epithet--the *lovely* face, the *sweet* smile, the eyes full of

life. Naturally Jane Austen gave her a "hero of a favourite story" for a lover (p. 43). Reactions familiar with conventional heroines appear in most of her scenes with Willoughby. She "burst into tears" over his sudden departure from Barton (p. 82). She staggers "faint" after his public snub of her, and again on reading his cruel letter (pp. 177, 185). She even works herself up into a "hysterical" fit in which she fights physically with her sister (p. 191).

Yet like Catherine Morland Marianne lives so vitally through the satire that she looks heroic in spite of it. Her bouncing openness to Willoughby shows the energetic faith of a heroine in human nature. She is generous in spirit to her mother and sisters, as Elinor coolly calculates in asking her to give up Willoughby's gift of a horse. During the early chapters, which are the most important in establishing a character as memorable, she shares in the vitality of great heroines. Perhaps sensing the artistic danger to Elinor, Jane Austen had her deny Marianne the full liveliness of conventional heroines: she "'sometimes talks a great deal and always with animation--but she is not often really merry'" (p. 93). Jane Austen had to doubt that romantic enthusiasts were "really merry", for she strove through Elinor to show that young women could achieve a happy marriage rationally in spite of a hostile society.

In essence Marianne is another parody heroine. Jane Austen was inclined to dismiss her feelings as childish fads and her adult character as routine. At the immature age of sixteen she would have struck Charlotte Smith as too young to have any settled character.[6] Through Elinor, Jane Austen likewise argued that only the four years starting with nineteen matter much in practical education.[7] In Marianne she was equating Romantic enthusiasm with the emotional inconsistencies of the young teenager, in contrast to the mature self-control of Elinor. Artistically she showed no interest in experimenting with Marianne as a character study. She created no inner drama in her, or any scenes to put her in charge of social groups, both of which she did with Elinor. Marianne becomes an increasingly static and remote object of sympathy as Jane Austen tells the latter half of the novel from Elinor's point of view. Yet her early impact keeps her memorable to the end. Jane Austen may also have created unintended sympathy for her by overmocking such natural wishes as her urge to get out-of-doors at Cleveland on the trip home from London: "an heavy and settled rain even *she* could not fancy dry or pleasant weather for walking" (p. 303). Also, Marianne may seem appealing because she is made to abandon her most endearing

principles. To grow up, she has to learn to control her emotions through "reasonable exertion", "enter on a course of serious study", repent her neglect of Elinor, and confess her "series of imprudence", her "want of fortitude" and her "ungrateful contempt" for "the unceasing kindness of Mrs. Jennings" (pp. 342-346). Elinor has naturally become her model, for as a final penance she has to engage in the social proprieties. By doing so Marianne may preserve all the independence that was then practical, but she tends to look humiliated and invite sympathy. Elinor's ideal of outward propriety and inner freedom is dated, and artistically she is the less vivid heroine.

(iii)

In simple contrast Elinor Dashwood is designed to achieve true independence by keeping her equally strong feelings to herself. With her Jane Austen set out to demonstrate that sense and sensibility are not mutually exclusive by having them coexist in one person. During the virtual essay on the defects of Marianne's sensibility late in the first chapter, she praises Elinor's quiet response to her father's death as a heroic fortitude: "Elinor, too, was deeply afflicted; but still she could struggle, she could exert herself" (p. 7). Similarly her near betrayal by Edward Ferrars is developed to show that she suffers as great a misery as Marianne without parading it. To argue the point, Jane Austen resorted to the only homily in the finished novels. On learning of Edward's secret engagement to Lucy Steele, Marianne displays the open distress: "'Four months!--and yet you loved him!'"; "'So calm!--so cheerful!--how have you been supported?'" (p. 262). In an austere reply Elinor expounds on her "duty" of not having others "'suffer on my account'" and her innocence of "'any imprudence of my own'" (pp. 262-263). These are the words of a lecture, not intense feeling, and Marianne knows it: "'If such is your way of thinking,... your resolution, your self-command, are, perhaps, a little less to be wondered at'" (p. 263). Fortitude is a heroic trait, but unless it is dramatized it must remain static and abstract, as unconvincing for Jane Austen as for previous writers in the convention. In all of Elinor's struggles for inner independence Jane Austen faced the difficulty of somehow bringing out the deep feelings of a heroine who was required by the theme not to display them.

Nor did the artistic difficulty stop with reproducing buried feelings. To round out the theme that sensibility is admirable if restrained, Jane Austen had to provide a positive alternative to her four objections to Marianne's too open sensibility. She had to show that Elinor's feelings are not self-centred

but disinterested, not antisocial but courteous, not inflicted on her family but thoughtfully concealed from them, not self-fed but fought down as a duty. To provide a goal for these aims, she set up Elinor's civility in social intercourse as the positive ideal. It is Elinor's one early reason for distrusting Willoughby, that he slights "too easily the forms of worldly propriety" (p. 49). Jane Nardin rightly relates "true propriety" to morality in Jane Austen, but adds that this early novel also advocates "conventional propriety narrowly defined".[8] Jane Austen herself recognized the shallowness of the ideal when she had the reformed Marianne call "the civilities, the lesser duties of life" (p. 347). At best Elinor's goal in life is not grand. It becomes petty when it has to include a show of friendliness to the Steele sisters:

> Marianne was silent; it was impossible for her to say what she did not feel, however trivial the occasion; and upon Elinor therefore the whole task of telling lies when politeness required it, always fell. (p. 122)

A searching criticism of a Romantic distaste for unfelt social courtesies would have been possible, but this attack on Marianne is not it. When Jane Austen opposed honest personal feelings to a narrow propriety, she made them subject to the sham of outward appearances, and in a society which she condemned as arrogant to women.

Elinor looks heroic not through her restrained sensibility but in the few scenes which dramatize her feelings when she is under attack. With propriety a standard of behaviour she appropriately fights Lucy Steele for Edward in social situations. In their first encounter, when Lucy springs the news of her long-standing secret engagement on Elinor, she comes the closest to shattering the heroine's feminine dignity. While suffering intensely, Elinor struggles to control the shock that even Edward is not a trustworthy man:

> What felt Elinor at that moment? Astonishment, that would have been as painful as it was strong, had not an immediate disbelief of the assertion attended it....and though her complexion varied, she stood firm in incredulity and felt in no danger of an hysterical fit, or a swoon. (p. 129)

While denying the conventional fit of sensibility, Jane Austen stresses that internally as well as externally Elinor is "forcing herself to speak, and to speak cautiously" with "a calmness of manner, which tolerably well concealed her surprise and solicitude" (p. 130). Most of the chapter (XXII) alternates this self-exertion with new and increasingly strong inner bursts of emotion. Hope

surges briefly when Elinor speaks "with revived security of Edward's honour and love, and her companion's falsehood". Then as her inner conflict wavers through "a most painful perplexity" she concludes that Lucy's claim is correct: "Elinor's security sunk, but her self-command did not sink with it" (p. 131). Faced with the factual evidence of the miniature of Edward's face and the letter in his handwriting, Elinor could hardly bear her emotions: "she was almost overcome--her heart sunk within her, and she could hardly stand, but exertion was indispensably necessary, and she struggled" (p. 134). As a result of an inner effort that is heroic she has won time to enlarge her emotional capacity so that it can now encompass and sustain this new despair. When Lucy caps her evidence with the claim that the lock of hair in Edward's ring is hers, asking ruthlessly if Elinor has noticed it, Elinor speaks like a heroine of true sensibility: "'I did;' said Elinor, with a composure of voice, under which was concealed an emotion and distress beyond any thing she had ever felt before" (p. 135). In the contrast with Marianne's open sensibility this increase in Elinor's ability to sustain shock must be the chief evidence that her sensibility is equally strong.

Neither this "true" inner sensibility nor its outward propriety is presented as an end in itself, but the means to a better life than society offered women. If "false" sensibility distracts Marianne from estimating Willoughby's intentions objectively, everyday life is disheartening if not unbearable. As Raymond Williams remarks, Jane Austen looked for "social improvement" through "a morality which is in the end separable from its social basis".[9] Social marriages like the Palmers' suffer from the "strange unsuitableness which often existed between husband and wife" (p. 118). Elinor's somewhat shallow ideal is Jane Austen's first attempt to develop the happy ending of the convention into a philosophy of positive living. By marrying Edward, Elinor retains a dignity not usually accorded women in her times, a success more practical and sociable than the self-centred sensibility of the convention. It is civilized life at its best, based on tolerance and understanding, of which the best propriety is an expression. It is also the plausible means for a woman to control her fate and prove heroic. For Edward a happy marriage is the purpose of life for men as well as women, for he opposes it to the masculine careers that he rejects: "All his wishes centered in domestic comfort and the quiet of private life" (p. 16; cf. pp. 102-03). This ambition of his gives the central heroine the chance to dominate the hero.

If the object of life is domestic happiness, Jane Austen suggests that a truly "amiable woman" is indispensable to it (p. 5). Edward's great wish becomes that of the heroines in later novels: "'I wish as well as every body else to be perfectly happy; but like every body else it must be in my own way. Greatness will not make me so'" (p. 91). In further verification, Willoughby the seducer of women and their happiness finally laments to Elinor that in marrying for money he has sacrificed "domestic happiness", which he then recognizes as the great loss of his life (p. 332). As a social observer Jane Austen recognized that many people can be satisfied with a trivial happiness, ranging from the Middleton's partying to the John Dashwood's miserliness, but she envisioned an ideal for right-thinking women of independent mind and their men. In the process she achieved a unity that had eluded Fanny Burney: she related the manners of the times to the basic theme by having Elinor observe and evaluate the marriages around her. Elinor sees that civilized living depends on the quality of the woman. A miserly wife like Fanny Dashwood accentuates rather than alleviates her husband's chief weakness. A silly wife like Charlotte Palmer turns her husband cynical and thwarts a flow of rational conversation. How the self-serving hypocrite Lucy Steele may influence Robert Ferrars the silly coxcomb had better not be contemplated. But a woman of sense like Elinor or the reformed Marianne would guarantee the happy ending of the convention, made practical by being modified.

(iv)

The theme of an ideal marriage derived from the feminine convention but made plausible by a more discreet sensibility imposed artistic difficulties on Jane Austen. Elinor has to feel deeply, think independently and act responsibly while avoiding Marianne's open emotions. As an epitome of self-control she has to be that most difficult of characters, an introvert who lives an intense inner life without showing it outwardly. At the same time she has to dominate extroverts like her mother and sister. For Marianne Jane Austen had only to intensify the conventional image of a heroine, but Elinor required the much more challenging creation of a new image, and it lacks the full substance of Marianne's conventional one. When detailing Marianne's beauty, as cited above,[10] Jane Austen describes Elinor in one brief sentence of generalities: "Miss Dashwood had a delicate complexion, regular features, and a remarkably pretty figure" (p. 46). For the later heroines a more detailed conventional beauty and enthusiasm like Marianne's help provide the

vivid initial image that Elinor lacks. Nor is Elinor necessarily more lifelike than Marianne. As John Odmark feels, "Elinor seems at times more like a principle than an individual".[11] The parody in *Northanger Abbey* required that Catherine Morland be realistic rather than conventional when first coming to Bath, but the theme of *Sense and Sensibility* imposes no such demand. Elinor has only to embody a set of abstract neoclassical standards like sense and propriety to provide the rational contrast to Marianne's Romantic fancies. She was an artistic challenge to which Jane Austen responded by experimenting with devices latent in her predecessors and first tried in *Northanger Abbey*.

In characterizing Elinor, Jane Austen was piecing a new model together, for the later heroines develop as much from Elinor's more original image as from Marianne's traditional one. Although mostly developed outside the detailed conventions for heroines of the preceding generation, Elinor shares a few of their attributes, which Jane Austen elaborates and illustrates much more than her predecessors had done. Sense is her central strength, as Jane Austen notes in her initial praise: she "possessed a strength of understanding, and coolness of judgment, which qualified her, though only nineteen, to be the counsellor of her mother" (p. 6). Extended examples reminiscent of Clara Reeve's competent widows justify the praise. Through good business sense Elinor performs what was then the man's task of ensuring that her mother move wisely to a new home. With insight she insists on explaining Willoughby's sudden departure rationally rather than emotionally. When Mrs. Dashwood scolds her for doing so, Jane Austen steps into the novel to snub the overly enthusiastic mother: "common sense, common care, common prudence, were all sunk in Mrs. Dashwood's romantic delicacy" (p. 85). Finally, near the climax Jane Austen has Mrs. Dashwood confess a "mother's imprudence" to Elinor and obey her "eager sign" for silence when talking to the dangerously ill Marianne (pp. 352, 350). By sense she controls the scenes in which Lucy tries to humiliate her over Edward, thinking as well as acting reasonably instead of emotionally, as befits so outwardly calm a woman. It is her theory as well as her practice to do so, for her first requirement of character is "sense", "the foundation on which every thing good may be built" (p. 263).

Along with good sense Jane Austen exploited a major structural device of the convention to dramatize Elinor's independence, while assigning the more stylized traits and techniques to Marianne. The gap in parental

authority when the sisters visit London and Somerset with Mrs. Jennings is developed wholly to Elinor's advantage. Marianne degrades herself as a woman then by dunning Willoughby with love letters, and sulking and making herself ill when he fails to reply and snubs her in public. It is Elinor who takes advantage of this period of freedom to act with dignity, responsibility and wisdom. She alone takes an interest in customs of the urban society which, like Evelina, the Dashwoods are first experiencing. Only she enters positively into its social life. In a succession of scenes she repulses Lucy Steele again, assesses the domineering Mrs. Ferrars and her toadies, teaches and later nurses Marianne, and interviews Willoughby. Here Jane Austen also continued to develop techniques introduced in *Northanger Abbey*, particularly the heroine's judging of strangers and her inner characterization.

Elinor's able judging of friends and new acquaintances gives dramatic force to her independent stance and provides a measure of her growth. It is another of Jane Austen's original developments of conventional assertions. Elinor first appears as a thinking woman when she reasons out the error in Marianne's criticism that Edward has "'no taste for drawing'". She analyzes his "'natural taste'" into its essential parts, "'innate propriety and simplicity of taste'" and evaluates each separately (p. 19). Later she makes quick and penetrating estimates of simple people like the Middletons, Charlotte Palmer and Robert Ferrars. She enjoys tackling devious ones like the aggressively rude Mr. Palmer. She encounters the dread Mrs. Ferrars with a "lively" "curiosity to know what she was like", though she is not given the same chance to rebuff this virago as Elizabeth Bennet is with Lady Catherine De Bourgh (p. 230). In Elinor, Jane Austen turned a latent strength of traditional heroines into an avocation.

The theme of a rational approach to life and the character of the independent thinker merge as Elinor with her mental bias works out a theory for judging. When Marianne charges that her "doctrine" is to make "'our judgments ... subservient to those of our neighbours'", she distinguishes between courteous "'behaviour'" and "'the subjection of the understanding'". She wants Marianne "'to treat our acquaintance in general with greater attention; but [not] ... to adopt their sentiments or conform to their judgment in serious matters'" (p. 94). Marianne is dangerously her inferior in assessing newcomers like Edward Ferrars, John Willoughby, Colonel Brandon, and the pivotal Mrs. Jennings, who emerges as the touchstone for testing Elinor's neoclassical standards of sense, goodness and taste. If two of them, here

"good-breeding and good nature", produce contradictory assessments, then Mrs. Jennings tests which is absolute, for she has no taste but great kindness.[12] At first Elinor is inclined to share Marianne's harsh criticism of her, but she keeps her opinion private and her mind open, to the benefit of both sisters. After Mrs. Jennings staunchly sides with them against the rapacity of Mrs. Ferrars, the John Dashwoods and Lucy Steele, and especially after she sacrifices herself to nurse Marianne, Elinor sees that she is truly admirable. Mrs. Jennings is in fact no slave to the patriarchal society but instinctively a free woman who indignantly condemns its cruelty to dependent girls like Lucy and Marianne. With Mrs. Jennings, Elinor's open mind and courtesy have won a rich reward. Such a person forces standards to be altered and goes a long way towards humanizing the novel as a whole and Elinor as its heroine.

Elinor looks most like a heroine for women exploited by the male society in her three private scenes with Lucy Steele. In them Jane Austen expanded the external as well as the internal drama introduced in Catherine Morland's most effective scenes. Elinor's inner growth during her first agonizing interview about Edward's secret engagement, as described above (p. 85), gives her a dimension of depth never afforded the simply conventional Marianne. Although not revealing as much inner agony in the later scenes with Lucy, Elinor looks heroic in them through external action when she rebounds from her shock to initiate a second tete-a-tete in Chapter XXIV. Adopting a close point of view which was unique to her own novels for most of another century, Jane Austen traced Elinor's inner and outer drama simultaneously during this skilful in-fighting. With irony Elinor needles Lucy for having revealed her engagement to a stranger. With sense she exposes the fallacy of Lucy's plea for her help in securing Edward the living of Norland from his brother-in-law. With integrity she refuses to advise her about continuing the engagement. Meanwhile internally Elinor is "guarding her countenance" and tone of voice more successfully than Lucy, though she finally decides to break off the encounter "lest they might provoke each other to an unsuitable increase of ease and unreserve" (pp. 147, 150).

Elinor again behaves like a heroine for independently minded women when the two meet in London and Lucy sallies "to the charge" (p. 218). Then Lucy is striving to conform to the offensive social atmosphere of the John Dashwoods and Mrs. Ferrars. In a scene reminiscent of Catharine Percival in the Juvenilia, Jane Austen contrived to have Elinor acting as the

lady of the house when Lucy and Edward overlap when calling at Mrs. Jenning's house (Chapter XXXV). With a heroic fortitude Elinor forces herself to behave naturally to Edward despite Lucy's "narrowly watching her": "almost every thing that *was* said, proceeded from Elinor, who was obliged to volunteer all the information about her mother's health, their coming to town, &c, which Edward ought to have inquired about, but never did" (p. 241). Jane Austen is in fact demonstrating that Elinor will be an effective minister's wife, though this future role of hers remains unexplored. Elinor has vanquished Lucy for good and they never meet again. When Lucy takes a last petty revenge from an impersonal distance by sending warped news of her marriage to a Mr. Ferrars, Jane Austen dismisses her as a combination of "malice", "ignorance" and "want of liberality" (pp. 366-367). In marrying Robert Ferrars, Lucy has revealed her secret engagement to Edward to have been a calculated coquetry. Although the great evil in the feminine novels, it is the obvious way for a woman on her own to achieve a marriage of convenience, "with no other sacrifice than that of time and conscience" (p. 376). In contrast Elinor has shown heroism by refusing to engage the patriarchal society on its own terms.

To strengthen Elinor's impact, Jane Austen adapted the courtship plot of the convention to this new type of central heroine. The theme that overt sensibility is neither a sure sign of feeling nor a safe ideal for women in a commercially and class minded society required two very similar plots. Each leading lady had to be shocked to the limit of her endurance by devious lovers and then learn to suffer with feminine stoicism. Because Jane Austen wrote comedy, each also had to marry a man who respects her as a woman. For Elinor's story Jane Austen fell back on the age-old love triangle of a man's choosing between two women, but she left the man enervated. She drew Edward as a passive Grandison waiting for the women to settle his future. For the sub-plot she adopted Fanny Burney's love triangle based on a woman's choosing between two lovers. By means of a variation on it through a time lapse, Marianne accepts Colonel Brandon after finally freeing her heart from Willoughby. In the main plot Edward with "his natural shyness" seems designed to be a suitor whom Elinor can dominate (p. 15). His long secret engagement to Lucy makes his near courting of Elinor almost as reprehensible as Willoughby's desertion of Marianne. When teasing Marianne over wild scenery he can recall Henry Tilney poking fun at Catherine Morland, but Jane Austen never lets him jest with Elinor. Jane

Austen also refuses to let him make his own way in his career or his courtship. She contrives to have Elinor offer him a living of Colonel Brandon's and allows him to propose only after Lucy deserts him.

Elinor also dominates the sub-plot, for it gives her the advantage of an Emmeline over an Adelina. She guards and nurses her sad sister while Marianne is languishing as Willoughby's victim, and she encourages her to repent and become a "reward" for Colonel Brandon (p. 378). It is also Elinor, not Marianne, who hears Willoughby's confession, though this incident may ultimately slight her central role. Many a reader may feel with W. A. Craik that "Marianne's illness and Willoughby's confession are the climax" of the novel.[13] Unfortunately for both the theme and the heroine this incident from the sub-plot rather than the main plot and involving its seductive antihero rather than its hero is the emotional high point of the late chapters.

As in *Northanger Abbey* Jane Austen refrained from dramatizing the climactic proposals: Edward and Elinor settle their future offstage in two whimsical sentences; Colonel Brandon and Marianne seem to come together only by default. Perhaps Jane Austen was avoiding a scene difficult for a representative woman of her times to dominate. Perhaps she shared Elinor's reluctance about open feelings. Perhaps she regretted that the proposal brought the heroine's gap of freedom to an end. Probably she distrusted love along with sensibility. She laughed at the "needless alarm of a lover", mocking the subjection of sense to feeling:

> though a very few hours spent in the hard labour of incessant talking will dispatch more subjects than can really be in common between any two rational creatures, yet with lovers it is different. Between *them* no subject is finished, no communication is even made, till it has been made at least twenty times over. (pp. 305, 363-364)

Although more genial than satiric, this humour shares the ambivalence of novelists of the 1790's towards feelings. In one mood Jane Austen has Elinor deride Marianne for denying that an older man like Colonel Brandon can feel love because he suffers no "'flushed cheek, hollow eye, and quick pulse of a fever'" (p. 38). In another mood, when the satire of open sensibility requires that Marianne marry Colonel Brandon, Jane Austen insists that this is no marriage of convenience but a true love, in which a man open to "ridicule" for his "sensibility" is "giving way to irresistible feelings" with an "irrepressible effusion" (pp. 49, 336, 337).

Despite the ambivalence of storytellers of the 1790's a strong emotion--love--is essential to their convention. They assume that the climactic proposal is the decisive moment in the life of a woman of independence. Then at least a couple marrying for love rather than convenience need to express their feelings. Yet to Jane Austen, at least in this novel, love is suspect in men and women of sound sense, who would oppose "the reality of reason and truth" to "the rapturous profession of the lover" (p. 361). Long hostile to open feelings she lacked practice in communicating them. She talks about Elinor's love rather than reproducing it. Elinor's feelings look vital during her first interview with Lucy because the inner drama brings them to life, but without it they look placid and tame. As Elinor bravely forgoes family sympathy because of her principled silence, Jane Austen describes rather than projects her sorrows. This "greater fortitude" than Marianne's in keeping her suffering to herself, another conventional heroism, also remains hidden (p. 356). At the climax conventional tears serve Elinor no better than her weeping forerunners. When Edward suddenly arrives to announce that he is single and free, she cries to express the turbulence of her sudden joy: "Elinor could sit it no longer. She almost ran out of the room, and as soon as the door was closed, burst into tears of joy, which at first she thought would never cease" (p. 360). Yet in thoughtlessly cutting up a scissors' case Edward shows the more convincing inner excitement. Most of the time the contribution of Elinor's controlled sensibility to the ideal marriage remains theoretical.

Elinor's weak initial image and reticent feelings show how thoroughly Jane Austen relied on the conventional model in developing her heroines. Without the familiar assumptions which establish Marianne so effectively, Elinor lacks her sister's initial solidity to stand out as a heroine of independence, and only slowly acquires it. Despite the constant artistic effort to show her dominating her mother, her sister, and Edward, and growing in inner stature through judging them, she remains more stolid than forceful. The plot is constructed to give her a prominence that is latent but not often exhibited, just as the theme is developed to support her as a principle more than a portrait of rational sensibility. In effect, like Catherine Morland, Elinor is bound by the bookish model which she is attacking; but with her theoretical conception she lacks the down-to-earth zest which makes Catherine vital. The convention must restrict Elinor as well as Marianne because it shapes not only her plot but also her aim in life and the scope of her behaviour. With the happy marriage her ultimate ambition, she must gain

force from vitalizing the essence of the courtship convention. She can try to avoid its extravagances, but ultimately she cannot do without it. Jane Austen never again developed a novel around two central women. For all later heroines she was to retain and perfect the old model as her basic artistic image. They are characterized fully within the convention, but they enlarge Elinor's principles for marriage.

As the heroine of true sensibility Elinor is meant to establish a compromise state of marriage on the border between the mercenary society of the patriarchy and the fantasy land of romance. She must marry without the greed of social marriages, but she must also marry credibly. While avoiding the irrational enthusiasms of love for its own sake, she must love when she marries. In effect she enlarges the ambivalence of novelists of the 1790's to encompass wedded love as the end of sensibility. She establishes this combined attitude as a third alternative in marriage, which she supplies with a unifying principle of its own. Her future with Edward will be none too affluent, but she will ensure its domestic comfort. In a man's world Elinor can plausibly attain her limited ideal of inner freedom whereas Marianne must abandon her fantasy of a new life for feeling women. The later, reformed, sensible Marianne reinforces Elinor's ideal of rational love. Although Jane Austen was to characterize all her later heroines fully within the convention, in theme they continue and clarify Elinor's midway position between the daydream of feminine independence and the submissive life of the times for women.[14] Through Elinor she began to define her ideal marriage as a modified form of the convention.

CHAPTER VI

ELIZABETH BENNET AND THE GOLDEN WORLD OF PEMBERLEY

The quest for a meaningful life for women in Jane Austen's first trio of novels culminates in *Pride and Prejudice* (1813). Its stately home of Pemberley modifies the romantic escape of the feminine novels of the preceding generation into a more plausible haven. It differs from the other two novels first drafted in the 1790's in not satirizing bookish minded heroines, but it continues to insist on their ideal of respect for worthwhile young women. Less extreme than *Northanger Abbey* and *Sense and Sensibility* when opposing the marriage of convenience to fictional romance, it repeats the same conflict. No man in this novel is actively a tyrant like General Tilney or an unnatural brother like John Dashwood. Yet silly men like Collins prosper while able young women dread an impoverished future. No girl longs for the Gothic adventures of Mrs. Radcliffe's Adeline La Motte or Emily St. Aubert. None emulates the enthusiasm of Charlotte Smith's Ethelinde and Celestina for the sensibility and wild nature of poetry. Yet Mary Bennet wants to order life by familiar quotations and her sister Jane finds solace in a storybook romance. The Bennet, Lucas and Bingley girls live in a very ordinary society in which the odd married couple like the Gardiners may be happy, but most older people leave the younger generation longing for a different life. A giddy girl like Lydia Bennet looks for immediate thrills among the soldiers at Brighton. A shrewd woman of the world like Charlotte Lucas hunts for a secure home no matter how uncongenial it may be. In contrast young women with larger minds like Jane and Elizabeth Bennet envision a harmony of feeling and intellect with men who respect them. Lydia and Charlotte react to society on its own terms, Jane sees only its good-natured half, but Elizabeth learns to look at it from a wider perspective which she then teaches to Darcy. Hers is an outside view of the times developed from a tempered version of the courtship and marriage convention.

(i)

The five Bennet daughters face a desperate financial future, but it only emphasizes the degrading prospects for any girl hampered by a small dowry. With their parental home of Longbourn entailed on Collins as male heir, they

must expect to marry into a much lower and less comfortable social level than the one they have known as children. Their contrived plight is itself deliberate feminist criticism. Though more socially representative, it parallels that of Fanny Burney's Cecilia, who must marry without a dowry unless her husband will change his name. Silly Mrs. Bennet may be a caricature of a mother hunting husbands for her daughters, but she is reacting to a real and serious threat in the most direct way. The entail virtually dooms her daughters to a humiliating if not a tragic future because they are women rather than men. Lady Catherine de Bourgh denounces the practice of entails in her usual self-centred language and Mrs. Bennet responds in too obvious a way to succeed, but each stresses the theme that society victimizes women. They are both prepared to accept its rules under protest, but the thinking Jane Austen heroine, like her fictional prototypes, is not. When Elizabeth rejects a financially sound proposal from Collins which socially subservient women like her mother and Charlotte would applaud, she shows the independent thought and action of a true heroine.

Daughters like the Bennets also suffer from a more common misery than the conventional cruelty of conscious male tyrants. They have been raised by mismatched parents. In a patriarchal society the effect can be equally devastating if less obvious. The gloomy review of the Bennets' home life in the opening paragraphs of Chapter Forty-Two is a short essay on the breakdown of family life and "the disadvantages which must attend the children of so unsuitable a marriage". Barred from intelligent conversation by "a woman ... [of] weak understanding and illiberal mind", Mr. Bennet has long allowed his sharp wit and sharper tongue a "highly reprehensible" relief: he has ruined the family's "domestic happiness" by "exposing his wife to the contempt of her own children" (*Pride and Prejudice*, p. 236). In every other way indolent, he is the traditional tyrant in reverse, and just as dangerous. He is a man with power and ability who refuses to apply "talents which rightly used, might at least have preserved the respectability of his daughters" (p. 237). As a result all five girls are as desperate to get away from "the real gloom over their domestic circle" as Emily St. Aubert is to leave Udolpho. Even the naturally contented Elizabeth looks forward to her trip with the Gardiners "for the commencement of actual felicity" (p. 237).

Among the younger women Caroline Bingley and Charlotte Lucas are the slaves of social marriage who devote their energies to the subservient and loveless goals of wealth and class status. One is the spokeswoman for the

marriage of convenience and the other its philosopher. Like Camilla's heartless cousin Indiana in Fanny Burney's novel and the wicked Lady Susan of the Juvenilia, they recall the anti-heroines of the convention. With the belittling perspective of irony Jane Austen exposes them, and through them the patriarchy, as bankrupt in emotions and moral ideals. They and the society that they represent are sacrificing the potentials of civilized living to physical well-being and greed. Elizabeth scorns Caroline Bingley for subjecting every generous urge to rank and fortune. Caroline sacrifices her friendship for Jane to keep her brother from an unprosperous but very happy match and strains her fragments of wit to entice Darcy from Elizabeth. Friendships between women prove as fickle with Caroline as they were reputed to be except in the convention. With her hypocrisy she can deceive the trusting Jane, but her sneers only add to Darcy's admiration for Elizabeth: "He listened to her with perfect indifference, while she chose to entertain herself in this manner, and as his composure convinced her that all was safe, her wit flowed long" (p. 27). Such a self-contradictory "wit" must deny her wisdom as well, and impress Darcy all the more with Elizabeth's independent mind and manner.

As the more intelligent of the sordid pair Charlotte Lucas vocalizes the wit and poses the philosophy which Elizabeth must refute to establish her own social position as convincing. Early in the novel Charlotte is built up in opposition to the too sanguine Jane as Elizabeth's practical sparring partner. She exactly catches the public impact of Darcy's stance with her class conscious witticism on his "*right* to be proud" when he casually scorns Elizabeth's beauty at a first glance (p. 20). What she misses is the underlying reason for his pride, the contempt of a superior mind for women who think too little and toady. She also proves a sounder judge than Elizabeth of the probable reaction of strangers like Bingley to Jane's apparent complacency about love. She looks a formidable rival to Elizabeth, but her decline begins as early as Chapter Six. Her goal in life sounds practical, but it is only short-sighted. She looks on the most serious event in the life of women as a gamble: "'Happiness in marriage is entirely a matter of chance'" (p. 23). Her aim in marrying is security at any price. It is a doctrine fit for her society, but compared to Jane Austen's ideal of mental and emotional happiness it is a mean and mercenary ambition: to her, marriage

was the only honourable provision for well-educated women of small fortune, and however uncertain of giving happiness, must be their pleasantest preservative from want. (pp. 122-123)

In this epitome of Charlotte's expectations in marriage Jane Austen was defining the social position which she was striving to refute. It was in effect sham marriage. In its place she developed a third option out of Elinor Dashwood's midway position between the social and conventional extremes. To make her compromise sound plausible, she had to prove Charlotte's philosophy false, work out a new one for Elizabeth, and demonstrate its domestic superiority. Charlotte's error is the easier to refute because her marriage to Collins stunts her intellectual growth. Jane Austen devoted the rest of the novel to showing how Elizabeth's wit, when denied its old outlet of repartée with Charlotte, thrives in contests with Darcy's independent wisdom. With Darcy Elizabeth achieves a union which combines their wit and wisdom as extensions of one another. It will confirm and expand their mental happiness as a rational ideal for a marriage of equals.

(ii)

The social critics are more varied in *Pride and Prejudice* than in the earlier novels, but their complaints are more precise and less extreme. Those with a positive alternative recall the feminine convention, but Mr. Bennet is only negative. This intelligent but indolent head of the family sees that society is degrading, but he does nothing to provide an attractive future for his daughters. In laughing at the follies of his family and neighbours, he establishes a critical perspective to open the novel. He exposes the most vociferous of socially acquiescent men and women as fools. He is also a credible source for Elizabeth's social insight and wit, and he singles her out as perceptive in the opening chapter. His own wit proves sterile, however, for it is more a belittling irony than a constructive satire. Embittered at having married a fool of a wife, he has made it his whole philosophy to enjoy the troubles of others: "'For what do we live, but to make sport for our neighbours, and to laugh at them in our turn?'" (p. 364). He is willing to laugh at predicaments which are held to be too serious for humour. He treats Jane's anguish over Bingley's desertion as amusing and is soon laughing at Lydia's forced marriage to Wickham. Indirectly his philosophy that irony is the end of life has ruined Lydia, for he has encouraged her to be headstrong by scorning his wife in front of his children. Ultimately he must put up with the aims of social marriage, for he has no others to offer. Gradually the

conventional superiority of the heroine to patriarchs emerges, but never so convincingly as here. Elizabeth has to lecture him on his duties as a parent when he lets Lydia visit Brighton alone. After it is too late, he admires her "greatness of mind", which Lydia's fate has revealed (p. 299). By this late time in the novel Elizabeth has become the driving force for good in the family. It is she who has him answer her uncle's urgent letter about Lydia's marriage, and after her own wedding she undertakes the re-education of Kitty.

Jane Bennet lacks her father's probing intellect, but her outlook is at least positive. Like Miss Woodley in *A Simple Story* she sees only the good in society, as Elizabeth notes with loving laughter:

> "Oh! you are a great deal too apt you know, to like people in general. You never see a fault in any body. All the world are good and agreeable in your eyes. I never heard you speak ill of a human being in my life." (p. 14)

As the complete optimist Jane represents the same naive extreme as earlier book-blinded heroines, but with a new social relevance. Her misery when Caroline Bingley snubs her is an exposé of that social climber's ruthless ambition. Jane scarcely belongs in the same world as her, and in fact she comes from another. In a sly but artistically significant twist, Jane Austen developed Jane out of a prototype by identifying her with the conventional heroine, "five times as pretty as every other woman in the room" (p. 14). A young woman of "great sensibility", Jane is a close if mature relative of Marianne Dashwood's, although the "constant complacency in her air and manner, not often united with great sensibility", keeps her from preaching on the topic (p. 208). Her determined optimism serves a similar thematic purpose to Marianne's enthusiasm: it is false to life. In her, but only in her, Elizabeth is willing to admit that open sensibility can be admirable: "'to be candid without ostentation or design--to take the good of every body's character and make it still better, and say nothing of the bad--belongs to you alone'" (pp. 14-15). Applying this slanted principle, Jane has curtained herself off from the darker corners of society. Only by doing so has she been able to counter Elizabeth's shrewd judging of friends and strangers with her own idealized estimates of them.

The contrast between the two principles of judging character makes Elizabeth's stance look practical as the sisters try to account for Caroline Bingley's sudden coldness and puzzle over Wickham's slander of Darcy. The

objection to Jane's sensibility is not a list of specific flaws like those attacked in Marianne Dashwood, but a comprehensive probing of its impracticality. Naive, single-minded, dependent on the good will of more perceptive people, Jane shows that the unmodified convention is as self-defeating a response to the social world for her as it was for Evelina. Her romantic idealism makes Elizabeth's sharp wisdom sound true to life in contrast, while their sisterly love sets them both apart from the self-centred society of the times. Elizabeth is never more memorable than when seething in loyal fury at Darcy for halting Bingley's romance with Jane. Ironically, he himself loves Elizabeth all the more for this affection, which closely resembles his own for his sister Georgiana. Perhaps too they are both inclined to admire Bingley's courtship as a show of independence against social marriage.

Unlike the determinedly cheerful Jane, Darcy deliberately stands aloof from the life of his times. Although he is another hero in the Grandison-Orville line, Jane Austen enlarges him from the gentleman of the convention into a social critic. He condemns the society of his times for the mindless courting "to the exclusion of all conversation" which it shares with "the less polished societies of the world" (p. 25). He resents wasting time with women like Caroline Bingley who read books only to impress him, and admire his wealth and stately home rather than his mind. As a critic of time-serving women, he is a ready pupil for a rebel like Elizabeth, who envisions a marriage of good minds as the basis of "connubial felicity" (p. 312). He is a worthier verbal partner than Edward Ferrars because of his integrity, his strong if solemn intellect, and his shy pride in it. In scene after scene at Netherfield, Rosings, Pemberley and Longbourn, Elizabeth begins by teasing him, but she soon finds herself involved in a mental combat which taxes her talents. Her wit combines with his wisdom to transform abstract topics like education, humour and marriage into lively discussions of the situation of women. At Netherfield they define the accomplishments, graces, and reading desirable in a wife. At Lady Catherine's they ponder how impersonal wit can be. At Hunsford Parsonage, when she needles him about separating Jane from Bingley, he is soon remarking on the hazards of a marriage of convenience.

These conversations show Darcy that Elizabeth is a woman with a mind of her own, and he deserves credit for wanting to marry her. He admires her as an intelligent woman whose independent thinking frees her from the ambitions he scorns in society. Yet she is right as both a woman

and a heroine to resent his first proposal in Hunsford parsonage: "'In vain have I struggled. It will not do. My feelings will not be repressed. You must allow me to tell you how ardently I admire and love you'" (p. 189). A central heroine must demand the respect of the hero. Elizabeth refuses him for two stated reasons, his separation of Bingley from Jane and his alleged injustice to Wickham, but she also rebels instinctively against his male arrogance. From now on a Jane Austen hero must learn to respect a worthwhile woman as his mental equal. So far in his life Darcy has accepted the dogma of the patriarchal society that any woman will marry any eligible bachelor who asks her. As a result when he sneers that his frankness has given the real offence, Elizabeth can take charge of this pivotal proposal with a feminist anger:

> "You are mistaken, Mr. Darcy, if you suppose that the mode of your declaration affected me in any other way, than as it spared me the concern which I might have felt in refusing you, had you behaved in a more gentleman-like manner." (p. 192)

Elizabeth still has to teach him that her mind is as good as his, and that it is quite as skeptical of social values. She has already begun, by forcing him to think deeply to refute her two charges against him, and in moral rather than social terms. In his analytic letter of explanation he gives the lie to the more serious charge, that he has ruined Wickham's career, but he acknowledges his lack of openness with Bingley in a manly apology.

The new respectful Darcy seen here and at Pemberley reflects partly a change in Elizabeth's stance towards him, but also his effort to learn from her critical wit. The praise from his housekeeper, Mrs. Reynolds, the devotion of his sister Georgiana, and the approval by Mrs. Gardiner show that he can earn the respect of worthwhile women. He soon realizes that a woman of intelligence may well be qualified to laugh at his foibles. Late in the novel, when his latent heroism can only reinforce Elizabeth's independence, Jane Austen plays up his active manliness, which is the chief asset of Sir Charles Grandison as opposed to Lord Orville. When he rebuffs Caroline Bingley's sneers about Elizabeth at the uneasy Pemberley tea party, he adds his own voice to that of his future hostess. Joining their mental strengths, they defend the stately life of Pemberley against a social spokesperson. When he vigorously pursues Lydia and Wickham, having them marry, he earns her change of heart towards him. William Westhaven served Emmeline no better.

Elizabeth has a lively, generous, outgoing concern for worthwhile people such as the reformed Darcy which ensures that while more down-to-earth than Jane she will not think or act with the selfishness characteristic of the patriarchal society. As a thoughtful daughter of Mr. Bennet she is willing at first just to laugh at the foibles of her family and neighbours. She smiles with some indulgence at the mindless urge of Kitty and Lydia to dance with any soldier in a red uniform and enjoys observing the gossip of friends like the Lucases. Her ordeal as a social critic comes later, when Charlotte Lucas marries Collins, Caroline Bingley snubs Jane, and Wickham proves villainous. Shocked to find that laughable foibles can mask degrading motives, she has to change her view of a society that can accommodate greed, hypocrisy and snobbery. Her analysis to Jane of Charlotte's socially sound marriage is a condemnation of that society:

> "You shall not defend her, though it is Charlotte Lucas. You shall not, for the sake of one individual, change the meaning of principle and integrity, nor endeavour to persuade yourself or me, that selfishness is prudence, and insensibility of danger, security for happiness." (pp. 135-136)

Her old friend's mercenary marriage has brought on a wave of pessimism in which her own values seem to flounder. She wonders whether she as well as Jane has been too idealistic in judging others. She may even feel that her father is right to be utterly cynical about society when she says,

> "There are few people whom I really love, and still fewer of whom I think well. The more I see of the world, the more am I dissatisfied with it; and every day confirms my belief of the inconsistency of all human characters, and of the little dependence that can be placed on the appearance of either merit or sense." (p. 135)

The standards of merit and sense are durable, but the despondency is momentary. Optimistic at heart and espousing a "philosophy" of "pleasure", Elizabeth is not a negative critic like her father (p. 369). When she sets out on her travels, she hopes to find a more equitable and civilized society than she has found at home in Meryton. Like Charlotte Smith's heroines she looks for a society in which merit and sense prevail.

(iii)

How thoroughly "First Impressions" was "lop't and crop't" in revision can never be known, but the influence of writers of the 1780's and 1790's

remains strong in the mature version.[1] Although *Pride and Prejudice* invites no recollection of the convention through parody, its advance is in subtlety, not new directions. A. Walton Litz rightly describes it as "the discovery of new possibilities within a traditional form".[2] Its insights into the life of the time develop out of a flexible use of the feminine convention. In both character traits and social attitudes Elizabeth inherits the ancestry of a generation of heroines. The great beauty of her "uncommonly intelligent" eyes, a repeated asset of theirs, becomes unusually plausible by seeming so only to Darcy her suitor (p. 23). Collins' proposal and Wickham's confidences give the impression of the customary flock of suitors, but Collins would propose to any attractive girl and Wickham turns out to have been flirting casually. Even when she is the social critic, "her temper to be happy" recalls a traditional trait of heroines to underlie her philosophy of pleasure (p. 239). Above all, her continual wit, through which she defines the qualities of her visionary social order, at last gives substance to an alleged strength of heroines. It also exposes the inadequacies of the two extreme attitudes to life which she opposes, one of which is the social mores of the times. Her opinions and hopes look practical beside the bookish ideals of her sister Jane. Beside the mercenary ambitions of her mother, Charlotte Lucas and Caroline Bingley, who automatically accept the social expectations of the marriage of convenience, they look generous and far-sighted. Poised between the improbably romantic and the mundane, Elizabeth makes a modified conventional world seem a plausible compromise between extremes.

When Elizabeth laughs at Jane's sensibility and Charlotte's social subservience, her wit gives force to her independent social philosophy.[3] Time after time she establishes her views as sound in scenes with the dreamers and social schemers because she is a conventional wit in action. For women denied a rigorously intellectual education, it could be used to demonstrate their innate mental strength. When suspicious like Elinor Dashwood of feelings as a guide to life, Elizabeth uses it to reject love at first sight as irrational.[4] In an epigram she also suggests that the romantic ideal is anti-social: "'Is not general incivility the very essence of love?'" (p. 141). As a woman of the world she knows that an ennobling happiness is rare in everyday courtship and must be earned. She is also a searching critic of her own perspective when she sums up the central dilemma of her courtship, as to which of Darcy and Wickham is just and honourable:

> "There is but such a quantity of merit between them; just enough to make one good sort of man; and of late it has been shifting about pretty much. For my part, I am inclined to believe it all Mr. Darcy's." (p. 225)

By coming to prefer Darcy, she chooses another social onlooker like herself. He will not commit himself to society as it is, but his humourless criticism has made him stolid and disdainful. "'I dearly love a laugh'", she warns him, as she makes fun of his solemn pretensions (p. 57). Her humour gives her independent philosophy the force and authority which Elinor Dashwood lacks. Through it she dominates the vivid company of Mr. Bennet the ironist supreme, Mrs. Bennet the too voluble matron, Collins the joyous toady, and Lady Catherine the absurdly aggressive woman of power. Together they animate a world which never overshadows her. With the still greater exuberance of her wit Elizabeth grows in stature as the critic of this lively society.

As Elizabeth's social weapon her wit is as moderate as her ambitions and ideals. Reluctantly she comes to recognize that her father's total abandonment of life to humour, though refreshing, is destructive. She pinpoints the dangers of a total and indiscriminate irony when Darcy makes the charge against humour one evening at Netherfield:

> "The wisest and the best of men, nay, the wisest and best of their actions, may be rendered ridiculous by a person whose first object in life is a joke."
>
> "Certainly," replied Elizabeth--"there are such people, but I hope I am not one of *them*. I hope I never ridicule what is wise or good. Follies and nonsense, whims and inconsistencies *do* divert me, I own, and I laugh at them whenever I can."
> (p. 57)

Like Darcy she knows that humour can belittle the good as well as the evil, though if controlled it can be an effective means to a laudable end. With wisdom she strenuously balances her hope for a rational future against her latent bitterness at social greed and folly to achieve a typically mild satire that eases off into banter with those of good will. None but a stupid Collins, a conceited Lady Catherine or a false wit like Caroline Bingley would regard her as shrewish or pronounce her humour to be "a mixture of pride and impertinence" (p. 35). Wit appeals to great minds, so that Darcy looks open-minded when he loves her for it and denies her alleged "impertinence" by

redefining it as "'the liveliness of your mind'" (p. 380). Elizabeth shares the gentleness and humility of a generation of heroines: "there was a mixture of sweetness and archness in her manner which made it difficult for her to affront anybody; and Darcy had never been so bewitched by any woman as he was by her" (p. 52). As a result her happy wit solves the problem of characterizing the heroine as a social critic who while frank still retains her feminine delicacy.

As Elizabeth learns to judge complex strangers, she dramatizes another strength claimed for conventional heroines but seen clearly before only in Jane Austen's own heroines, starting with Catharine Percival. Assessing others has become her avocation, as Bingley notes when he calls her "a studier of character" (p. 42). From the first she can easily size up simple characters like his. With more "intricate" characters like Charlotte Lucas, Wickham and Darcy she errs badly at first, but they provide her a course in self-education (p. 42). She mistakes Charlotte's calculated shrewdness for a disinterested argument because she assumes that a close friend must think like her on so fundamental an issue as the marriage of convenience. Before leaving home she also lacks sufficient objectivity to judge an ingratiating hypocrite like Wickham or an austere critic like Darcy. Taken in by Wickham's slander, she fails to realize that his claim that he will not "'be driven away by Mr. Darcy'" from the Netherfield ball has been an empty boast (p. 78). Her twin standards of "merit" and "sense" cannot easily penetrate his deceit, and she recognizes his "indelicacy" only in retrospect (p. 207).

Although Elizabeth no longer lists the propriety of Elinor Dashwood along with merit and sense as an absolute standard, she makes it more vital and significant as a factor in social living and judging. When she writhes in "agonies" of "shame and vexation" at the "total want of propriety" of her family at the Netherfield ball, she gives social embarrassment an impact only faintly anticipated by Evelina's awkwardness at her first ball and Elinor's unease with Lucy Steele (pp. 100, 198). For the Bennet girls, gossiping and rudeness affect not just passing customs but basic human issues, and ones in which women can play a heroic role. Impropriety raises a further barrier than relative poverty to their eligibility as brides. It also jeopardizes their moral assessments. When Elizabeth mistakes the impropriety of Wickham's allegations about Darcy for righteous indignation, she commits a more serious error in judging than Marianne Dashwood with Willoughby. Marianne mistakes Willoughby's romantic flirting for sensibility, but Elizabeth

misinterprets Wickham's slander as a plea for justice and so condemns Darcy's good conduct as evil. When she realizes and corrects her errors in judging, she qualifies for entry into Pemberley society. For this heroine judging has become a practical course in discerning the true worth of potential husbands, as befits both the courtship convention and the life of the times.

On the visit to Kent in the second volume Elizabeth continues to mature, now through an internal drama which is more pervasive and significant than Elinor Dashwood's. It shows that a heroine of the convention can reason analytically and objectively. Earlier, an omniscient point of view in the first volume helps create the effect of a stage play for her great scenes of wit with Jane and Darcy on judging character and marrying wisely. In them she reacts fondly though perhaps too leniently to her destructively brilliant father, her generously minded elder sister, her worldly wise friend Charlotte, and the gossiping society of Meryton. Then as all but Jane disillusion her, Elizabeth suddenly doubts her own critical ability and good cheer in her wave of pessimism about "the inconsistency of all human characters" which opens the second volume (p. 135). By means of a new limited point of view Jane Austen now explores her mind as she reassesses herself and her values.

In particular Elizabeth's reading of Darcy's letter of explanation after his first proposal becomes a voyage of discovery into her own sense and merit. As she reads his rational defence of his actions for Bingley and against Wickham, her fight for an impartial perspective becomes the new, inner drama in the novel: she "weighed every circumstance with what she meant to be impartiality" (p. 205). Emotion struggles with reason as she blames herself for having "often disdained the generous candour of my sister" (p. 208). She matures as she works through the dilemma in judging as to whether Wickham or Darcy is the honourable man. Then she turns relentlessly on herself for having betrayed the ideals which she has professed: "How despicably have I acted....Till this moment, I never knew myself" (p. 208). The reading of Darcy's letter has turned into a struggle for self-discovery beyond Elinor Dashwood's experience. As Robert K. Wallace observes, Elizabeth's "is a very special kind of anguish, for it derives from her own character, at the same time that it helps to clarify that character".[5] This siege of self-criticism gives Elizabeth a depth of personality and a potential for independence not seen in any previous heroine in the English novel except Clarissa. As Elizabeth

withstands Lady Catherine's inquisitions and Darcy's first proposal, her wit grows more profound too. It now becomes a series of verbal reports on her original social thinking.

Without a skilful use of the conventional gap between the heroine's parental and marital homes this inner growth would scarcely be possible. Even a relatively aggressive woman like Elizabeth had, as Susan Peck MacDonald explains, to behave with rare discretion because of the social mores.[6] In *Pride and Prejudice* Jane Austen fills the time gap with the usual trips, to visit Charlotte in Kent and Darcy's estate of Pemberley in Derbyshire. Besides learning to judge intricate characters more clearly than she had done at home, Elizabeth comes to realize how mentally impoverished a way of life she has endured with her parents. In Kent she enjoys a new level of intelligent and civilized conversation with Darcy and Colonel Fitzwilliam, though not with her hostesses. Lady Catherine talks chiefly to herself, and Charlotte Collins reveals the emptiness of social marriage by discouraging her husband's presence as much as possible. Returning from this trip more aware of the family disharmony at Longbourn and knowing "how materially the credit of both [Jane and herself] must be hurt by such impropriety of conduct, she felt depressed beyond any thing she had ever known before" (p. 209). Only the prospect of the further absence of a second trip could "console" her (p. 237). That second trip, to Pemberley, shows her an epitome of as civilized living as seems practical. It inspires her to return to her original social outlook with a positive but judicious optimism.

(iv)

Pemberley changes the character of the novel and Jane Austen's use of the convention. On first reading, *Pride and Prejudice* looks dualistic from the title page to the climax. When the Netherfield men first arrive in Meryton, "Bingley was sure of being liked wherever he appeared, Darcy was continually giving offence" with the pride which prejudices Elizabeth against him (p. 16). After the climactic proposal the Gardiners are welcome at Pemberley but Wickham is barred. The novel is riddled with simple oppositions in characters, themes, and techniques which give the initial impression that life consists of scores of absolute choices. The wit thrives on them, and so does the satire of extreme views of life. Jane sees life as bookishly perfect, while Charlotte has no ideals at all. Jane tells Elizabeth, "'my confidence was as natural as your suspicion'", for to her life does consist of opposites (p. 148). The early Elizabeth would have to agree, for she

opposes the "amiable" Wickham to the "unsocial" Darcy, and then in Kent she abruptly reverses the assessment (pp. 81, 91, 208). Yet as the working title implies, First Impressions are deceptive. Bingley causes the Bennets great anguish whereas Darcy salvages their reputation. Jane judges Darcy correctly when Elizabeth misjudges him. With the perspective of ironic insight Jane Austen dissolves the simple contrasts, including the title itself. Darcy's pride encompasses prejudice, and Elizabeth's prejudice goads on her pride. With a flexibility not found in *Sense and Sensibility*, *Pride and Prejudice* develops the theme that life need not be bound by such oppositions.

The quest for a compromise between the degrading society of the Charlotte Collinses and the dream world of the Jane Bingleys ends at Pemberley. Darcy's estate is a potential model of Elizabeth's restrained ideal.[7] To function it needs only her active contribution as a woman of civilizing insights. It restores and releases her natural optimism with the evidence that her hope for a rational marriage is practical. Seen through the double perspective of inner and outer drama, the tour of Pemberley becomes a voyage of twin discoveries for Elizabeth. She learns the dimensions of Darcy's merit and sense and finds an outlet for her own feminine talents. Her old anger at Darcy and shame for her relatives turn into happy pride in both as she listens to the Gardiners' sensible conversation with him. After the disruptive news of Lydia's disappearance with Wickham, that conventional seduction forces the heroine to fight to regain the ideal she has just glimpsed. Marooned back in the family discord at Longbourn, she hears of Darcy's efforts to make Wickham marry Lydia and the Gardiner's confidence in his love for her, but she sees his old forbidding mien when he comes calling there. To realize her rational society at Pemberley, she has to recover her own vision, clarify it to him, and teach him to share it with her.

Besides gaining this view of marriage, Elizabeth at Pemberley expands through Jane Austen's increasing sympathy and skill with the emotions of conventional heroines. Elizabeth looks more substantial than Elinor Dashwood partly because she is more vivacious. Though again expressed dramatically rather than directly, strong feelings humanize her mental conflict. She is truly a heroine in love. With her active sympathy she cannot be aware of having misjudged Darcy without brooding over her treatment of him. Her former "hatred" changes through mental drama to "respect", "good will" and "gratitude ... for loving her still well enough, to forgive all the petulance and acrimony ... accompanying her rejection" (p. 165). As Elizabeth's love for

Darcy grows, Jane Austen shows herself more receptive to this crucial sentiment of courtship heroines. When Darcy comes calling with Georgiana and Bingley at the inn near Pemberley and the Gardiners search Elizabeth's face for signs of love, the perspective of inner drama focuses the scene on the heroine's seething emotions as she struggles to appear calm. As a result her half hour of tears over Darcy and her trembling knees at the news of Lydia's disappearance carry a conviction beyond the conventional fits they replace.[8] After Lydia's debacle, when Darcy seems more a friend than suitor on his return to Longbourn, she sets herself pathetic little tests to quiet her frustrated love: "'If he does not come to me, *then* [after dinner],' said she, 'I shall give him up for ever'" (p. 341). She is in fact feeding her emotions, as Jane Austen points out with a humour that is more banter than satire: "Elizabeth walked out to recover her spirits; or in other words, to dwell without interruption on those subjects that must deaden them more" (p. 339). Jane Austen could hardly avoid smiling at the feelings she had so vigorously satirized in Marianne Dashwood. The tone here is more genial, but Jane Austen still hesitated to commit her heroines fully to love.[9] She was reluctant to display it during the scene of the climactic proposal.

The second proposal, at Pemberley, rounds out the plot thematically more than emotionally. Despite the continual oppositions, a strong sense of over-all unity in *Pride and Prejudice* radiates from the third, middle world of Elizabeth's. Through it the conventional love story seems more true to life than the grasping marriages which represent the actual society of her times. Free of the artistic clash in Jane Austen's earlier novels between parody and a serious use of the fictional mode, the courtship plot strongly reinforces the happy ending. In the process several automatic assumptions gain a new flexibility and significance. In a love triangle reminiscent of Evelina's, Elizabeth feels she is choosing between Darcy and Wickham, the male flirt of the convention. Wickham's villainy is worldly although his appearance and role are bookish, for Jane Austen probes behind his "charm of air and address" to the self-centred fortune hunter (p. 206). He strives for a marriage of (his) convenience with a single-mindedness unsurpassed by Gothic tyrants like Montoni and worldly matrons like Mrs. Bennet. Perhaps Mrs. Bennet instinctively senses the connection when she dreads his bookish challenge in the form of a duel for her husband. After Elizabeth realizes her error in judging Wickham, she silences him with a wit which reveals her growth in wisdom when he tries flirting with her again as Lydia's husband. Having

dispatched her former favourite, she is ready to take command of the plot, and with it her future. Determined to thank Darcy for his salvation of Lydia, she initiates the proposal scene without looking less feminine or leaving Darcy less manly, for he declares that he "'was not in a humour to wait for any opening of your's'" (p. 381). It is here that Jane Austen avoids a fully emotional love scene. At the moment of climax she gives the voluble Elizabeth nothing to say. Although Elizabeth's emotions might well subdue her wit as she accepts Darcy, Jane Austen only summarizes rather than reproduces her reply. Instead she explores the happy ending as a perspective which gives a new depth of meaning to marriage.

The stately home of Pemberley, where the married Elizabeth lives, becomes a working model of civilized life. There she can make a positive contribution as a woman to its success. In the proposal scene Darcy has stressed her value to him in rounding out his practical education. As a result the couple form a marriage which transforms the trite happy ending of romance into a new way of life in which the heroine has a unique role. Her wit provides the leavening agent to raise his stolid thought into the active intelligence needed to complete her ideal. Then the climactic marriage of the convention can produce a plausible vision of the good life. It may even, as she once dreamed, "teach the admiring multitude what connubial felicity really was":

> It was an union that must have been to the advantage of both; by her ease and liveliness, his mind might have been softened, his manners improved, and from his judgment, information, and knowledge of the world, she must have received benefit of greater importance. (p. 312)

Despite Charlotte's view of marriage as a lottery, Jane Austen has shown that the highest happiness can be planned and achieved. During the earlier visit to Pemberley, the novel provided a glimpse into Elizabeth's future career as a wife inspiring civility in her household and guests. When Caroline Bingley needles her about Wickham at the tea party, she protects what is more Georgiana's humiliation than her own with a forceful composure. Her wit becomes a mask for her heroic struggle to preserve the dignity of the stately home. It dramatizes her qualifications to be mistress of Pemberley. It makes the climactic proposal seem the fulfilment of this expectation and an induction into a proven ideal. Yet vivid and positive though her new life is, it depends on a certain abstraction from reality. Pemberley is a self-contained

world which banishes those social mores which are most degrading to women. It is an epitome of the secluded estates to which the Altheas and Emilys retire, an ideal modified from the convention but still of the convention, set up to offer a plausible alternative to society as it is.

Elizabeth and Darcy in fact define the happy marriage of the convention in their life at Pemberley. He appreciates her wit and values the lessons she teaches him: "'dearest, loveliest Elizabeth! What do I not owe you! You taught me a lesson, hard indeed at first, but most advantageous. By you, I was properly humbled'" (p. 369). With him Elizabeth will be able to continue her witty conversations, knowing that he will come to appreciate them more and still more: "She remembered that he had yet to learn to be laught at" (p. 371). With her he will no longer spend his weekends wrapt in the old grim solitude which Bingley dreads: "'I declare I do not know a more aweful object than Darcy, on particular occasions, and in particular places; at his own house especially, and of a Sunday evening when he has nothing to do'" (pp. 50-51). Pemberley can fulfil its potential for civilized living only under the guidance of an able woman like Elizabeth. In turn it will ensure her independence. There for once a central heroine will not lose her stature when she marries, and shrink into a domestic oblivion like Scott's Jeanie Deans. Her wit is a feminine strength which she will be able to enlarge in marriage. She promises to be an even more vital woman than ever after the novel ends. The feminine novelists all assumed that the climactic marriage is a unique happiness which sets the heroine and her husband apart from ordinary society. Elizabeth makes it so, justifying the convention as she transcends it. In her, the satire of Catherine Morland and Marianne Dashwood for trying to live like heroines in the everyday world gives way to a hope that their dream is not impossible but only extravagant. By taking the convention seriously in Elizabeth, Jane Austen turned it into a critical perspective of the life of her times.

CHAPTER VII

FANNY PRICE: THE PASSIVE HEROINE AS SOCIAL OUTSIDER

With *Mansfield Park* (1814) Jane Austen began a second trio of novels which continued to modify her use of the feminine convention. Uneasy that she had been "too light, and bright, and sparkling" in *Pride and Prejudice*,[1] she turned away from witty extroverts like Elizabeth Bennet and radiant bridal homes like Pemberley. Instead she chose less exuberant heroines who marry less brilliantly. Two of the three later heroines are passive women who endure rather than resist the patriarchal society, more like a Monimia than a Camilla. The perspective of society is wider and its presence gloomier in these novels. The men are more thoughtless or misguided than tyrannical, but the careers of the heroes are more vital for their wives. Pressing this social impingement still further, Marilyn Butler comments that in the last three novels "the heroine's choices no longer solely affect her private happiness in life, but are subtly interlinked with the stability and well-being of her society".[2] The romantic life of the convention continues to offer a dangerous relief for young men and women, but in its shallow, extreme version it looks more remote from the life of the times and less positive as an alternative system. The later heroines are no longer seen as individuals who can achieve their own independence without close reference to the world at large. Society encroaches on their lives when they marry, so that they must live more fully within its limitations. Yet they are heroines conceived within the feminine convention, which still determines their characters and ambitions.

(i)

The emotional longings of the younger generation at Mansfield Park suffer from the insensitivity rather than the arrogance of the patriarchy. Sir Thomas Bertram presides over society there with an austerity which is as damaging as General Tilney's tyranny or Mr. Bennet's wilful neglect of the moral and emotional education of the young. He neither senses their basic needs nor shields them from the misery of loveless marriages of convenience. Although kindly and earnest, "a truly anxious father, he was not outwardly affectionate, and the reserve of his manner" erects a barrier between him and

his family which blocks his communication with them and blinds him to their utter boredom (*Mansfield Park* p. 19). As a patriarch he looks for an unquestioning obedience from his daughters and niece, denouncing "'that independence of spirit ... which in young women is offensive and disgusting beyond all common offence'" (p. 318). With his supine wife neglecting the family and his sister-in-law Mrs. Norris interfering capriciously, his daughters grow desperate. At best "the usual resources of ladies residing in the country" leave young women "very much in want of some variety at home" (p. 41). A parasite like Lady Bertram with her endless fancy needlework may feel cosy in the subservient role allotted her, but most women must find something demanding to do, and those without a sound practical education find mischief.

Aunt Norris, to whom Sir Thomas unwisely delegates the raising of his daughters and niece, is a self-centred dependent trying to occupy the vacant position of maternal power. By toadying to his daughters Maria and Julia, she spoils rather than liberates them, turning Maria especially into a dangerously discontented bride. Over the dependent niece Fanny Price, who seems to her of no consequence socially, she tyrannizes like the cruel aunt of the convention, as epitomized by Mrs. Lennard in *The Old Manor House*. In practical charge of the household when Sir Thomas is away on his trip to Antigua, she promotes Maria's loveless match with the silly but wealthy James Rushworth and encourages the private theatricals, which leave the young Bertrams less than ever willing to return to the old uninspiring life with Sir Thomas. When he returns, Maria and Julia are so desperate to escape that each marries the first man who will take her away from home. For them the conventional gap between their childhood and married homes never exists, and they experience no period of independence.

While society stifles young people at Mansfield, elsewhere it actively degrades them, particularly the women. The life of the Prices in Portsmouth is brutalizing, with food spoiling on the tea-board, the children uproarious, and the father swearing and threatening them physically. Life in London is more elegant, but it is still more demoralizing. It destroys all generous and affectionate feelings, including domestic comfort. Coming to Mansfield from London, Mary Crawford rejoices in finding a society there in which individuals at least matter:

> "You have all so much more *heart* among you, than one finds in the world at large. You all give me a feeling of being able

to trust and confide in you; which, in common intercourse, one knows nothing of." (p. 359)

At Mansfield a woman like Mary could marry both wisely and affectionately, even though she feels disappointed that Edmund is not the elder son and so plans to enter the ministry. In contrast "the most desirable" London match leaves a Mrs. Fraser "'about as unhappy as most other married people'" (p. 361). Made on "'the advice of every body connected with her, whose opinion was worth having'", it represents the best (or worst) of social marriages (p. 361). Edmund is really condemning the mores of society at large when he writes Fanny that Mrs. Fraser "is a cold-hearted, vain woman, who has married entirely from convenience" (p. 421). Fanny, who puts the criticism in her usual moral terms, thinks "the influence of London very much at war with all respectable attachments" (p. 433). The sad truth is that Mansfield offers women the least degrading life shown in the novel. Other societies suppress feelings, misdirect ambitions, and destroy happiness. Mansfield may be uninspiring, but Sir Thomas respects individuals and with a more humane example like Fanny's they can grow in empathy, wisdom and good will.

This social analysis brings *Mansfield Park* the closest that Jane Austen came to writing a novel of ideas, but its precise theme is not easy to pinpoint. Exactly what can make life more positive than insipid at Mansfield, and how progress there depends on Fanny, are hard to explain. Critics have long puzzled over the implications of topics like the moral condemnation of the private theatricals, the sense and merit of Fanny's rejection of Henry Crawford, and her dogma of "duty" and "principle". Almost every commentator has had a new theme to suggest. For R. W. Chapman it is environment,[3] for Andrew Wright education,[4] for Lionel Trilling security,[5] for Lord David Cecil a contrast of worldliness and unworldliness,[6] for Marvin Mudrick a defence of genteel social conventions,[7] for Howard S. Babb integrity.[8] Later critics note the increased social awareness. W. A. Craik and Avrom Fleishman suggest the breakdown and reform of society, while others search beyond the nature of the social decadence for a theoretical explanation of it.[9] Julia P. Brown stresses the impingement of the drift of history, P. J. M. Scott the impossibility of escape from the world as it is, and Alistair Duckworth the "inherited culture endangered".[10] The critics only agree that the novel is not about Jane Austen's avowed topic, "ordination".[11] Yet the wider implication of this uncertainty is clear. Whatever the precise reason,

there is fear of an imminent social breakdown that threatens the integrity of the young, especially young women.

On more clearcut issues like the heroine's choice of suitors and the author's attitude to her, critics merely divide into opposing groups. Chapman and Wright see Henry Crawford as a rake whom Fanny must reject.[12] Cecil and R. Brimley Johnson feel that she ought to have married him, as do the callous Mary Crawford and Aunt Norris in the novel.[13] Jane Austen herself also declared the marriage likely and under some circumstances inevitable.[14] Critics who dislike the idea must feel that she is smiling at Fanny to say so, although like Wright most are convinced that she has "presented [her] straightforwardly, without contradiction of any kind".[15] Mrs. Craik can find no humour at her expense, and Mudrick and Duckworth no irony.[16] In contrast Cecil has glimpsed a moment of satire when Fanny feels sorry for the poor horse when Mary Crawford is riding instead of herself, Norman Page notes a "hint of ironic comment" in Fanny's raptures on harmony in nature, and Margaret Kirkham attributes the irony to her too "submissive role" as a woman.[17] P. J. M. Scott refuses to stop with single instances, remarking that "Austen ... regularly teases her heroine", and I find both occasional satire and frequent banter at Fanny.[18] Bewildering though these critical differences are, their very contradictions are significant. They suggest both Jane Austen's increased concern with ideas and the severity of her artistic challenge. They also imply the value of a linked study of Jane Austen's novels as a guide to her purpose in any one. A comparison of Fanny with her earlier heroines and those of her predecessors shows that civilized marriage, respect for intelligent women, and the dangers of romance-inspired daydreams continue as central concerns.

The major thematic contrast to earlier heroines is that Fanny crucially affects the hero's career by marrying him. In *Mansfield Park* Jane Austen was unwilling to ignore Edmund's preparation for the ministry as she had Henry Tilney's and Edward Ferrars'. When Edmund plays Anhalt the chaplain in *Lovers' Vows*, Mary Crawford as Amelia can forget his career, for the stageplay ignores Anhalt's everyday duties and isolates the love story from the man's total life in the old conventional way of the Lord Orvilles. Instead, starting with this novel, Jane Austen refused to do so, and held the hero's occupation up to unprecedented scrutiny. When Edmund lives and loves at Mansfield, his career and his marriage combine to determine his future life: he was

to receive ordination in the course of the Christmas week. Half his destiny would then be determined--but the other half might not be so smoothly wooed. His duties would be established, but the wife who was to share, and animate, and reward those duties might yet be unattainable. (p. 255)

In other words, half of Edmund's "destiny" depends on his wife. Perhaps for this reason Jane Austen still characterized her hero not through his career but through his behaviour to eligible young women. By that test his conduct is less sound in practice than in principle. He rationalizes away his objections to acting so that he can play Anhalt opposite Mary as Amelia. He cannot give her up, although he senses that she would be an unsuitable wife for a clergyman when he reproves her wit on family prayers: "'Your lively mind can hardly be serious even on serious subjects'" (p. 87). She continues to infatuate him despite her jests on ordination. He lacks Fanny's wisdom and intuitive principle in personal relations, never threatening to overshadow her superior common sense as Henry Tilney does with Catherine Morland. As the novel ends he still has to learn a clearer appreciation of duty and principle from Fanny. When he marries her on the rebound after rejecting Mary, Jane Austen mocks his blindness rather than crediting his perception. Looked at from the feminine point of view, as a contrast of worldly and unworldly young women in love with a clergyman, and of clerical wives and widows, ordination is in fact an eligible "subject" for the novel, if not quite its theme (*Letters*, p. 298). *Mansfield Park* opens with the selfish Mrs. Norris in arrogant charge of the vicarage, continues with her epicurean successor Mrs. Grant ignoring its responsibilities beyond the dining room table, and ends with the charitable and well-principled Fanny ready to set a good example from its door. Yet in Fanny, Edmund has married the chief critic of society instead of its most representative and eligible young woman.

As Edmund's rival for Fanny, Henry Crawford puts her role in still clearer perspective. Although she knows what is right, she is passive, not active, in confronting Edmund and Henry with her views. Landed and well-to-do, Henry is as eligible a bachelor as the patriarchal society can offer, but lacking a purpose in life he drifts disastrously as landlord and spouse. Superficial in all things, he is oblivious to all but surface impressions. He catches the delivery rather than the substance of the liturgy when reading it aloud and the poses rather than the essence of characters when declaiming *King Henry the Eighth*. He admires "the glory of heroism" in William Price's

naval career, but he neglects his own estate of Everingham (p. 236). His concept of marriage is equally shallow before he courts Fanny. With women he poses as "the hero of an old romance", but he wants to humiliate rather than please them or treat them seriously (p. 360). He must gratify his image of heroism not through a manly career but by conquering every female heart around him. He flirts with Maria at the very altar of the chapel in her future home of Sotherton as well as during every rehearsal of *Lovers' Vows*, delighting in the agony he causes. It is his pose as flirt supreme that raises Fanny's ire as a woman: "'I cannot think well of a man who sports with any woman's feelings'" (p. 363).

Ironically when Henry tries to flirt with Fanny he succumbs himself, falls in love, and pursues her in earnest. As Mary points out, Fanny becomes the beloved of the beloved of all, but Jane Austen makes no attempt to turn this conquest to the heroine's artistic advantage. Fanny's impulse to do "works of charity and ingenuity" could have made her the saviour of Everingham and its neglected tenants had she married him (p. 151). An active heroine like Emmeline or Elizabeth Bennet would have thrived on such a challenge, but it is beyond Fanny's ambitions and abilities. When Edmund suggests that she reform Henry, "'I would not engage in such a charge,' cried Fanny in a shrinking accent--'in such an office of high responsibility!'" (p. 351). Born and bred to be timid and self-effacing, she can influence society only passively.

Suited by nature to be Edmund's good example and confidante rather than Henry's active reformer, Fanny is a despised girl not educated for a social life and so free to work out her own code of duty and principle. As a poor relative she grows up unwanted in the society of her times and, like Sarah Burney's Clarentine, desperate for something useful to do. One of the many indigent young women of the period ignored by most authors, she is "'dependent, helpless, friendless, neglected, forgotten'" (p. 297). The dread of life-long uselessness throbs in her lament "'I can never be important to any one'" and her cry, "'it would be delightful to feel myself of consequence to any body!'" (pp. 26, 27). From the homesick little girl who "crept about in constant terror of something or other" to the overlooked woman who "alone was sad and insignificant", Fanny is the victim of her Aunt Norris's bad temper and the drudge of Lady Bertram (pp. 15, 159-160). Yet Lady Bertram puts Fanny's dull but busy life in its contemporary perspective, for with her yards of decorative needlework Lady Bertram is a satire of the social

expectations of the times for ladies. Fanny, who is retiring by nature and upbringing, is no active critic of society, judge of character, or reformer of men like Elizabeth Bennet. As Jane Austen notes, perhaps with a storyteller's regret, her lot is silence: "Few young ladies of eighteen could be less called on to speak their opinion than Fanny" (p. 48). Longing to be useful rather than prominent as a woman, she gives those few who heed her quiet example and commonsense a direction lacking in society at large.

(ii)

To give literary substance to the "overlooked" young woman of the times, Jane Austen again used the feminine convention as a model, but not the active, witty heroine of the Evelina, Emmeline or Miss Milner tradition (p. 176). She turned instead to the passive heroines of the 1790's featured by the later Charlotte Smith and Ann Radcliffe. Like that prototype Fanny is an enthusiast. She is as fond of nature, places and poetry as Marianne Dashwood was, "rhapsodizing" about the "wonderful" evergreen, the "dear" East Room and the mediaeval chapel of the *Lay of the Last Minstrel* (pp. 209, 152). In contrast to the robust Elizabeth Bennet she is also "somewhat delicate and puny", soon given a headache by cutting roses for Aunt Norris (p. 11). In sum, Jane Austen drew Fanny as a heroine of sensibility appealing to the reader's sympathy rather than an active wit commanding attention. By doing so she eliminated the need for a new basic image of a heroine which had frustrated her with Elinor Dashwood. Instead she combined a "good sense" and "sweet temper" reminiscent of Elinor with the "sensibility" of a Marianne (pp. 399, 26, 79). Fanny's appearance, like Marianne's, is also hauntingly conventional: "very pretty" with a "complexion", "countenance" and "figure" which catch Sir Thomas's eye and set Henry Crawford raving about "'that soft skin of her's, so frequently tinged with a blush'" (pp. 197-198, 229). Although *Mansfield Park* is the first novel wholly from the Chawton period, the mature author is still relying on the courtship convention for the form and much of the essence of her art of the central heroine.

Jane Austen apparently chose the passive heroine as an artistic challenge. She denied herself the well-proved techniques that she had gradually evolved with Catherine Morland, Elinor Dashwood and Elizabeth Bennet and would return to for Emma Woodhouse. In characterizing Fanny she avoided the external drama of judicious conversation with which Elinor fends off Lucy Steele, and Elizabeth stands up to Lady Catherine De Bourgh. She boldly transferred a distinctive wit which recalls Elizabeth's to Mary

Crawford, the anti-heroine, who like Mr. Bennet misuses it. The dramatic moments occur, but they pass by undeveloped, as when Fanny "felt too angry for speech" at Mary Crawford's wit on family prayers, or thought she ought to "reproach herself for loving him [Sir Thomas] so little" (pp. 87, 178). Jane Austen also abandoned the inner drama which she had perfected in *Pride and Prejudice*, working instead to project the emotional depth claimed by her predecessors for their passive heroines. She likewise curtailed her use of the heroine's point of view, telling the story of Fanny's childhood omnisciently and scarcely entering her heroine's mind before the trip to Sotherton. Apart from one session of self-criticism in the East Room she made no use of a close point of view to trace Fanny's tension during the rehearsals of *Lovers' Vows*. Only two interviews with Sir Thomas dramatize her deep involvement during Henry's siege of her heart. Nor is Fanny an eager and confident judge of character like Elinor and Elizabeth. Although she makes some sound estimates of Henry Crawford and Julia Bertram, she sizes up most people emotionally rather than rationally, looking on Edmund "as possessing worth, which no one but herself could ever appreciate" (p. 37). She defends him illogically, as he points out, and professes herself "'not competent'" as a judge (pp. 109, 269). Nor does she criticize herself much, as Elizabeth and Emma do repeatedly and memorably. An "angel" is not likely to doubt her conduct (p. 344). Such a complete avoidance of familiar techniques can only be conscious. It means that Jane Austen was deliberately experimenting with Fanny as an artistic departure from her proven successes.

Instead of dramatizing Fanny's inner life, Jane Austen appealed like her predecessors for sympathy for her. Fanny is an outwardly insignificant girl whose inner life is emotionally intense rather than mentally active: her "mind...had seldom known a pause in its alarms or embarrassments" (p. 35). She looks forlorn rather than astute as the lowly companion of Lady Bertram at Mansfield and the forgotten daughter stunned by the family squabbles at Portsmouth. At Mansfield she is repeatedly scolded and humiliated by Aunt Norris or isolated in the unheated East Room, the closest thing to a turret there. Timid and tense as she is, "not even innocence could keep [her] from suffering" during "the dreadful duty of appearing before her uncle" to welcome him home from Antigua: "after pausing [like an Ethelinde or a Catharine Percival] for a moment for what she knew would not come, for a courage which the outside of no door had ever supplied to her, she turned the lock in desperation" (pp. 176, 177). Abused like the heroines of the 1790's,

she shivers in the frigid East Room and expects to trudge to the Parsonage for dinner because Aunt Norris has denied her a fire and transportation. Sir Thomas's kind orders for a daily fire and a carriage for her invite further sympathy for a girl who lacks the spirit to rise up and snub the female tyrant herself. When visiting the Prices at Portsmouth the unwanted Fanny comes to her childhood home longing to be loved and needed, but her mother embraces her absentmindedly and her father overlooks her in the dusk. Her more active sister Susan has helped bring some order to the household with an authority which Fanny with her "more supine and yielding temper would have shrunk from asserting" (p. 395). Drawing on the passive convention of the 1790's, Jane Austen worked to evoke sympathy for a humiliated heroine, and in doing so she probed behind the fictional image to the poor female relative of the times.

Fanny gains her intensity of character from a sensibility reminiscent of Marianne Dashwood's but now more acceptable. It is Fanny's first as well as her most constant trait, appearing at its most extreme in her early life at Mansfield, when "she really grieved because she could not grieve" at Sir Thomas's departure for Antigua: "'it was a shameful insensibility'" (p. 33). Despite the irony of such self-contradictory remarks, they show a latent sympathy for a child left by her uncle's misjudgement at the mercy of the callous Aunt Norris.

An apt opposition of moods reveals Jane Austen's lingering but lessening doubts about sensibility. She created an inner tension in the older, teenage Fanny by juxtaposing her rapture at her brother William's visit to Mansfield with her misery over Henry's unwelcome wooing:

> It was a picture which Henry Crawford had moral taste enough to value. Fanny's attractions increased--increased two-fold--for the sensibility which beautified her complexion and illumined her countenance, was an attraction in itself. (p. 235)

Fanny is never more vital as a character than during the running opposition between her joy at the news of William's promotion (secured by Henry) and her anguish at Henry's proposal, which she understandably takes to be "mere trifling and gallantry" (p. 301). Simultaneously experiencing some of her happiest and sorriest moments, she is "feeling, thinking, trembling, about every thing;--agitated, happy, miserable, infinitely obliged, absolutely angry" (p. 302). This banter prevents any of the sentimentality which left feelings seeming absurd in the works of Richardson's followers. To Jane Austen it is

one of life's little ironies for Fanny that the "concurrence of circumstances...[should] give her so many painful sensations on the first day of hearing of William's promotion" (p. 303). With William and Henry leaving Mansfield together, Jane Austen made fun of Fanny's conflicting emotions with an incongruous combination of feelings and food:

> After seeing William to the last moment, Fanny walked back into the breakfast-room with a very saddened heart to grieve over the melancholy change; and there her uncle kindly left her to cry in peace, conceiving perhaps that the deserted chair of each young man might exercise her tender enthusiasm, and that the remaining cold pork bones and mustard in William's plate, might but divide her feelings with the broken egg-shells in Mr. Crawford's. (p. 282)

Yet Fanny gains sympathy from this banter, for in contrast Jane Austen satirizes the cold worldly wisdom of Sir Thomas calculating the effect of her misery. Fanny grows in independence and heroic stature because her "agitation" at William's arrival is "of a higher nature" than her frightened "agitation" over social visits (p. 233). This approved equation of feeling and moral outlook, which Jane Austen had attacked in Marianne Dashwood, reveals that a basic change was taking place in her artistic values. It shows a new tolerance to emotional responses to life and an urge to develop techniques for presenting them.

For Jane Austen, the passive heroine was artistically a departure which she still had fully to accommodate. To describe Fanny's emotions, Jane Austen often echoed the devices of conventional novelists for externalizing inner tension, but she found it difficult to treat them seriously. She showed signs of artistic unease at elaborating emotional responses which before she had only parodied. Certainly she sympathized with the waif who arrives at Mansfield as a shy girl of ten, though even then words like "forlorn" and "the despondence that sunk her little heart" are a unique linguistic extravagance for the adult Jane Austen (p. 14). Fanny's "swimming eyes", "nearly fainting" and "terror" are described in more extreme language than she had used since the early Juvenilia (pp. 284, 176, 15). When the older Fanny cries like this, Jane Austen could not refrain from smiling at her. As her huge thorn in the flesh leaves Mansfield to live with the disgraced Maria, "not even Fanny had tears for aunt Norris--not even when she was gone for ever" (p. 466). Although Fanny never actually swoons, Jane Austen mocks her as a heroine

who "fancied herself on the point of fainting away" (p. 399). The news of Maria's seduction is too serious for banter, but the language describing Fanny's reaction is more violent than any Jane Austen had used after "Love and Freindship": "She passed only from feelings of sickness to shudderings of horror; and from hot fits of fever to cold" (p. 441). The stylistically alert Jane Austen would have been acutely aware of such verbal extravagance in a description of a conventional fit. It is the language of a former critic of sensibility who felt some discomfort at being solemn about feelings which she had previously only satirized.

A Fanny who is so sensitive and self-effacing that she is unwilling to fill the conventional role of a central heroine repeatedly amused Jane Austen. Occasionally the humour is satiric, as when Fanny's feelings run away with her honesty as she parts too fondly from Mary Crawford: "her feelings could seldom withstand the melancholy influence of the word 'last.' She cried as if she had loved Miss Crawford more than she possibly could" (p. 359). More often it is a friendly banter, as when Fanny is the reluctant leading lady at the Mansfield ball. From the moment when Edmund asks her for two dances and "she had nothing more to wish for", she looks like a parody heroine (p. 272). Finding "that *she* was to lead the way and open the ball", she gains a desperate courage--not to perform but to escape from the traditional role of heroines:

> To be urging her opinion against Sir Thomas's, was a proof of the extremity of the case, but such was her horror at the first suggestion, that she could actually look him in the face and say she hoped it might be settled otherwise. (p. 275)

After an evening of agitation Fanny rounds out the burlesque with a bookish pose reminiscent of Marianne Dashwood. She retires from the ball in the spirit of *The Lay of the Last Minstrel*, pausing

> at the entrance door, like the Lady of Branxholm Hall, "one moment and no more," to view the happy scene,...and then, creep[s] ... slowly up the principal staircase, pursued by the ceaseless country-dance, feverish with hopes and fears, soups and negus. (pp. 280-81)

As with the tears over William and Henry's pork bones and egg shells, Jane Austen was associating food incongruously with feelings as she had first done with Charlotte Lutterell in the juvenile "Lesley Castle". Like most novelists of the 1790's she was ambivalent about sensibility and all emotional responses

to life. Fanny bemused her as a passive heroine who indulges in extravagant feelings and also is enraptured by poetry and nature.

(iii)

In *Mansfield Park* Jane Austen probed her repeated theme of the dangers of bookish living with a range of typically unfavourable assessments. They range from a satire of Henry Crawford's flirting while acting, through a mocking of Edmund's more honest delusions, to a banter at Fanny's enthusiasm for poetry, nature, and places. For young men and women dismayed by their drifting, heartless society, fictional living seemed to offer the positive life they desperately want. To Henry the rehearsals of *Lover's Vows* appear in retrospect as the height of "'exquisite pleasure'": "'I never was happier'" (p. 225). For the despised Fanny in her enforced silence books occupy many a vacant hour, fill a mind barred from most pleasures, and provide a positive ideal to counteract her negative life. In sum, the visions of romance offer the young people relief from social degradation, damaging though the escape can be for hypocrites and triflers.

In this novel *Lovers' Vows* provides the most prominent example of modelling life on literature, for it beguiles the amateur actors into a fantasy world of their own. Fanny alone struggles to avoid the seductive illusion which destroys rather than fosters inner independence. The other young people encourage it, lose their grip on everyday life during the rehearsals, and injure themselves permanently. Although Edmund at first demurs at producing a play when Sir Thomas is absent and Maria about to marry,[19] he has two more telling complaints. He objects to the confusing of real and bookish roles and the fictional evil of flirting when he explains to Fanny why "'They have chosen almost as bad a play as they could'" (p. 153). He sees the temptations of an unhappy bride-to-be like Maria playing Agatha opposite Henry Crawford as her grown-up bastard Frederick. Their roles become still more dangerous because Henry's acting is a deliberate flirtation. He likes causing jealousy between Maria and Julia over the casting of Agatha, but still more he enjoys making sham love to Maria during the rehearsals. It may be the great happiness of his life, as he later tells Fanny, but to Maria it is a disaster. He teases her into so confounding her real and acting roles that she expects the flirting Frederick to propose to her in his own person as Henry; when her father returns,

> Henry Crawford's retaining her hand at such a moment, a moment of such peculiar proof and importance, was worth ages

of doubt and anxiety. She hailed it as an earnest of the most serious determination.[20]

For Maria the error of confusing fictional romance with actual courting leads to life-long misery. It hurries her on the rebound into a loveless marriage of convenience with James Rushworth in her desperation to leave home, and it banishes her into permanent exile with Henry, and later Mrs. Norris, through adultery and divorce. Reviewing her fate, Tom Bertram blames it on the mixing of roles when he was temporarily master of Mansfield, in his "self-reproach arising from the deplorable event in Wimpole Street, to which he felt himself accessory by all the dangerous intimacy of his unjustifiable theatre" (p. 462).

For the more sincere Edmund and Mary the play is simply a delusion. It entices them into a love for one another which makes them forget their incompatability--her distaste for marrying a clergyman and his distress over her unrestrained wit, "blunted delicacy and ... corrupted, vitiated mind" (p. 456). The immodest language of Mary as Amelia to Edmund as Anhalt the chaplain almost guarantees their personal involvement in the play's courting: "The whole subject of it was love--a marriage of love was to be described by the gentleman, and very little short of a declaration of love be made by the lady" (p. 167). Even the sophisticated Mary announces that the decision as to who will act Anhalt--Edmund or a Charles Maddox--is going to determine whether she speaks Amelia's lines without alteration. Edmund also loses his perspective as he is caught "between his theatrical and his real part" (p. 163). He admits that he plays Anhalt to avoid the "'excessive intimacy which must spring from'" having Maddox cast in the role (pp. 153-154). In truth he cannot bear Mary's playing Amelia opposite any Anhalt but himself. For him the rehearsal becomes a vortex of ever-increasing involvement. It tempts him to abandon his objective and principled resistance to the play and leaves him bewildered until the second-to-last chapter of the novel.

Although Fanny avoids the fantasy land of *Lovers' Vows*, she too seeks refuge from the oppressive society in books, and their version of the outdoors. Poetry, nature and places were an attractive resource for an underoccupied and isolated woman. Jane Austen sympathized with the need and increasingly respected it, but she still smiled at her heroine's enthusiasm with an ambivalence reminiscent of her earlier parodies and satires. Like *Lovers' Vows*, much other "reading offers important scope for vicarious role-playing", as Tony Tanner remarks.[21] In Fanny, Jane Austen in fact fulfilled her wish to

include "solemn specious nonsense" in the novel, even implying "a critique on Walter Scott" (*Letters*, pp. 299-300). When "Fanny's imagination" is most extravagant, she looks to a more recent Romantic bestseller, the *Lay of the Last Minstrel*, for the escape Catherine Morland found in *Udolpho*. Fanny poses as a Scott heroine both when retiring from the ball like the Lady of Branxholm Hall and while touring the chapel at Sotherton:

> "I am disappointed," said she, in a low voice, to Edmund. "This is not my idea of a chapel. There is nothing awful here, nothing melancholy, nothing grand. Here are no aisles, no arches, no inscriptions, no banners. No banners, cousin, to be 'blown by the night wind of Heaven.' No signs that a 'Scottish monarch sleeps below.'" (pp. 85-86)

"'You forget, Fanny'", says Edmund. What she forgets is life as it is. In 1814 Jane Austen was still reluctant to admire Sir Walter Scott and had to smile at this enthusiasm of Fanny's.[22]

Even when echoing Jane Austen's favourite authors Fanny recalls Marianne Dashwood's delusion of thinking and acting according to books. The scheme for an improver to beautify Sotherton makes Fanny "'think of Cowper ... "Ye fallen avenues, once more I mourn your fate unmerited"'" (p. 56). Edmund could only have "smiled" at such an automatically bookish response. Later a comparison of her father's house in Portsmouth with her uncle's stately home tempts her to misapply "Dr. Johnson's celebrated judgment as to matrimony and celibacy, and say, that though Mansfield Park might have some pains, Portsmouth could have no pleasures", although if applied relevantly this analogy would define her central concern as a heroine (p. 392). She must even recall "a line or two of Cowper's *Tirocinium*" when she is agonizing over the propriety of referring to Mansfield as "home" when visiting her parents, a qualm mocked by their complete indifference (p.431). When she instantly rejects Henry's love forever, Jane Austen slyly accepts the existence of such "unconquerable" stances, "or one should not read about them" (p.231). Nevertheless this humour is not strident like the satire of Marianne, but rather a friendly banter. Fanny is a passive heroine driven to books by her loneliness and instinctively looking at everyday trials from their perspective.

A similar light humour undercuts some of Fanny's raptures on nature. Although Jane Austen was more tolerant of this delight than she had been with Marianne Dashwood, she still revealed a lingering suspicion of its

relevance to human life. She mocked Fanny for her fantasy on it during a walk with Mary Crawford in the parsonage shrubbery,

> venturing sometimes even to sit down on one of the benches ... till in the midst of some tender ejaculation of Fanny's, on the sweets of so protracted an autumn, they were forced by the sudden swell of a cold gust shaking down the last few yellow leaves about them, to jump up and walk for warmth. (p. 208)

More often a hesitant praise like Edmund's suggests the more friendly smile of an author not quite in accord with Fanny's fondness for "inanimate nature":

> "I like to hear your enthusiasm, Fanny. It is a lovely night, and they are much to be pitied who have not been taught to feel in some degree as you do--who have not at least been given a taste for nature in early life. They lose a great deal." (pp. 81, 113)

Once in a while there is complete sympathy. Jane Austen joins with Fanny in lamenting the loss of "animation both of body and mind" in Portsmouth caused by missing the rural springtime, "that season which cannot, in spite of its capriciousness, be unlovely" (p. 432). When Fanny arrives back at Mansfield, Jane Austen rejoices with her in the budding trees, "when farther beauty is known to be at hand, and when, while much is actually given to the sight, more yet remains for the imagination" (pp. 446-447). This range of attitudes shows Jane Austen's increased understanding of those who find nature more attractive than society. It is one more aspect of Fanny's oblique protest against social oppression.

Likewise Jane Austen found some of Fanny's joys in inanimate things more appropriate than others. The beloved East Room may deserve her tears, for it is really Fanny's best friend: "The room was most dear to her, and she would not have changed its furniture for the handsomest in the house" (p. 152). In it Fanny gains an inner dimension of independence from the extroverts who hound or despise her. In it she worries out her agonies over her lonely opposition to *Lovers' Vows* and Henry's proposal. Yet even this "nest of comforts" can amuse Jane Austen, for it features a Romantic extravaganza which sandwiches Wordsworth between the Italy of *Udolpho* and the Lake District of *Ethelinde*:

> three transparencies, made in a rage for transparencies, for the three lower panes of one window, where Tintern Abbey held its

station between a cave in Italy, and a moonlight lake in Cumberland. (p. 152)

Ironic language and details like these capture the girl's emotional response to her loneliness, giving her a substantial life of her own. What they fail to do is make her heroic. Jane Austen's quizzical perspective frequently denies Fanny the verve that unimpeded emotional experiences would produce.

Of all the emotions featured in the courtship convention, love still frustrated Jane Austen the most, but she strove with some success to catch Fanny's anguish. Her most extended attempt creates an intensity reminiscent of Richardson's, and likely inspired by his. To a Fanny in love with Edmund the anguish of watching him and Mary rehearse their courting in *Lovers' Vows* would be nerve-wracking. Jane Austen made it excruciating by steadily increasing the tension with shock after shock in the Richardson manner. At first Fanny dreads the morrow merely as an unwilling spectator of the scene in which Amelia proposes to Anhalt. Her anxiety proves too mild, for the morrow brings Mary-Amelia to the East Room asking her to represent Edmund-Anhalt being courted, and then Edmund himself arrives to have her criticize the rehearsal of his love making. Even the task of prompter proves too much for a Fanny "agitated by the increasing spirit of Edmund's manner" to Mary (p. 170).

More often, humour weakens the impact of Fanny's intense love. Her devotion to Edmund is potentially heroic, but it is so extravagant that Jane Austen could only wonder at Fanny's "heavenly flight" as

> she seized the scrap of paper on which Edmund had begun writing to her, as a treasure beyond all her hopes.... The enthusiasm of a woman's love is even beyond the biographer's.... This specimen, written in haste as it was, had not a fault; and there was a felicity in the flow of the first four words, in the arrangement of "My very dear Fanny," which she could have looked at for ever. (pp. 262, 265)

This banter at such a "fond indulgence of fancy" establishes a distance between Jane Austen and her heroine which can turn to satire, as in this joy over "the arrangement of 'My very dear Fanny'", a mere salutation in a letter (p. 267). Again, Fanny may treat Mary's jealousy of the Miss Owens "calmly", but she shares it, asking Edmund, "'The Miss Owens--you liked them, did not you?'" (pp. 288, 355). Jane Austen also mocks Fanny's agony at Henry's wooing as the stance of a bookish heroine. It weakens as he comes to

Portsmouth and offers her a hope of escape from the squalor of life among the Prices. Yet Jane Austen as well as Mrs. Inchbald had to come to terms with love. *Lovers' Vows* may well have intrigued Jane Austen because like her own novels it explores love and the meaning of marriage. Its lush metaphors and its theme that first love is true love, which she had denounced in *Pride and Prejudice*,[23] would have struck her as cogent but also absurd. With love crucial to both her own and Mrs. Inchbald's alternatives to marriages of convenience, she had to commit her heroines to experiencing it fully. Before she finished with Fanny she had started to do so.

(iv)

As a shy and overlooked menial seething with a vital inner life, Fanny has an independent social stance. Being an outsider, she suffers contempt and loneliness but gains moral insight and intellectual strength. In the first of the original three volumes--as a child, on the trip to Sotherton, and during the controversy over *Lovers' Vows*--she is an onlooker like the early Evelina. She not only watches the social courting of the Bertrams and Crawfords but also notes its greed and deceit. Then she turns into a sharp if mostly silent social critic, to Mary Evans offering perhaps the most "radical critique of bourgeois patriarchy, its norms, and values of behaviour" in fiction.[24] But Fanny is no active reformer. Jane Austen could have shown her standing up to Aunt Norris and her cousins over *Lovers' Vows*, like a Catherine Morland to John and Isabella Thorpe, but Fanny is far too passive to do so. "Shocked to find herself at that moment the only speaker in the room, and to feel that almost every eye was upon her", she cannot bring herself to voice her heartfelt objections to the acting (pp. 145-146). She can show the conventional fortitude of a heroine only passively, like an Adeline La Motte in *The Romance of the Forest*. As she becomes unhappily aware of the general mixing of real and acting ambitions and feelings in the rehearsals of the play, she has repeatedly to resist being given a role herself. In effect she is fighting to keep free from a society which is morally callous and emotionally cruel. She loses the struggle in practice but not in principle, for she never rationalizes away its delusions. She agrees to take a part just before Sir Thomas returns and ends the theatricals, for she is aware that as a dependent she owes her cousin a debt of self-abnegation.

When Maria and Julia leave home soon afterwards, Fanny becomes the leading young lady in Mansfield society, at Mrs. Grant's dinner and during the ball in her honour. Then, in accord with Charlotte Smith's theory,

circumstances bring out if they do not create her character.²⁵ As a passive heroine she gains no prominence through her own exertion, but she gradually moves into a position to maintain her own ideals with those who want to please her. Ironically, Fanny's new prominence as centre of social interest in Volume Two first attracts the attentions of the rake Henry rather than the morally minded Edmund. As the astute philanderer recognizes her unique virtue and determines to marry her, he helps to define her independent ideal, which gives her "the heroism of principle" (p. 265). Based on "true merit and true love", it clarifies the moral standard prized but not defined by previous heroines in the convention:

> Henry Crawford had too much sense not to feel the worth of good principles in a wife, though he was too little accustomed to serious reflection to know them by their proper name; but when he talked of her having such a steadiness and regularity of conduct, such a high notion of honour, and such an observance of decorum as might warrant any man in the fullest dependence on her faith and integrity, he expressed what was inspired by the knowledge of her being well principled and religious. (pp. 473, 294)

In sum, Jane Austen was saying that a "well principled and religious" heroine is characterized by moral reliability, honour, propriety, loyalty, and self-honesty.

A critic like A. C. Bradley would see evidence here that Jane Austen's mind was deeply rooted in Christianity, as it undoubtedly was.²⁶ Yet Jane Austen excused herself from explicit religious commentary as too "presuming" (p. 468). The feminine novel was an alternate and secular source for the same values. Although she frequently mentions *duty* and *principle*, she slants them towards courtship and marriage in keeping with the drift of the convention. The "hard duty" of being introduced to strangers, which Fanny dreads at the ball, is simply part of a heroine's entry into society (p. 273). Henry even seems to speak from the convention when he values her "good principles" and calls her unique, possessing "'qualities which I had not before supposed to exist in such a degree in any human creature'" (pp. 294, 343). Like her predecessors Jane Austen has given her heroine a virtue which is exemplary rather than typical. As a young woman at odds with society Fanny is as extreme in her moral principles as in her enthusiasm for books, nature and love. Although unrepresentative of the social practices of the Regency,

she represents the large class of neglected poor female relations who had plenty of time to brood on moral ideals and attend church or chapel. In her the passive heroine of the convention becomes their literary reflection.

Despite Fanny's firm principles, in practice the moral outlook in *Mansfield Park* shows a new flexibility. In this novel Jane Austen was no longer willing to be as dogmatic as her predecessors about her heroine's duty. In particular, two incidents leave Fanny wondering what is morally right. Her opposition to *Lovers' Vows* causes her a lively inner debate rare for this heroine. As she ponders "what should she do?" about the demand that she take a role in the play, her sense of duty pulls her both ways:

> she had begun to feel undecided as to what she *ought to do*; and as she walked round the room her doubts were increasing. Was she *right* in refusing what was so warmly asked, so strongly wished for?.... Was it not ill-nature--selfishness--and a fear of exposing herself? (pp. 150, 152-153)

Other heroines--Elizabeth Bennet and Emma Woodhouse--find fault with their own behaviour, but they know what is right and what is wrong.

Fanny's second doubt concerns Henry's proposal, leading to the critical conflict as to whether she could, would, or should accept it. Jane Austen as author sounds unequivocal in declaring that Fanny would have married Henry had her heart been free--in "only ... a fortnight"--and if Edmund were to marry Mary would indeed do so "very voluntarily" and with "every probability of success and felicity for him" (pp. 231, 467). Love would have had to develop, but Henry's invaluable help to William "was always the most powerful disturber of every decision against Mr. Crawford" (p. 364). As Juliet McMaster observes, his courting "comes close to touching her heart".[27] The chance of becoming "the friend of the poor and oppressed" at Everingham and of giving Susan a home there also appeals to Fanny (p. 404). Jane Austen's words are so definite that it seems perverse not to credit them. They likely suggest a practical possibility for a writer who in her last novels implies that nothing in life can be absolute for mature people. Fanny may sound inflexible in rejecting Henry because she is so young. Like Marianne Dashwood she is younger than the beginning of the four-year span which Elinor regards as the crucial period in life for education.[28] When Edmund tells Fanny of his love for Mary, he soon says "enough to shake the experience of eighteen", but her dismay that Mary's character is "nearly desperate" "may be forgiven by older sages" (pp. 270, 367) When Henry pursues her, "She

could not, though only eighteen, suppose Mr. Crawford's attachment would hold out for ever" (p.331). Perhaps echoing Charlotte Smith's *Ethelinde*, Jane Austen seems to have looked on Fanny as a girl of absolute moral principles who will turn into a more human wife when experience has tempered her bookish inflexibility and given her an adult character of her own.

Fanny experiences the second half of the novel's standards of "true merit and true love" in her devotion to Edmund (p. 473). In a fundamental shift Jane Austen superseded the sense as well as the propriety of her earlier novels with this emotional criterion. Sometimes in her lingering ambivalence she could, as noted above, smile at Fanny's love. She could capture the spirit of a rhapsody that is amusingly bookish, as when Fanny asserts that

"there is nobleness in the name of Edmund. It is a name of
heroism and renown--of kings, princes, and knights; and seems
to breathe the spirit of chivalry and warm affections." (p. 211)

In contrast, Fanny feels laudably exalted when she can bring together the gifts from the two people whom she deeply loves. In a rare symbolism Jane Austen catches this feeling as Fanny joins Edmund's chain with William's cross, "those memorials of the two most beloved of her heart, those dearest tokens so formed for each other by every thing real and imaginary" (p. 271).

In the third volume there is less banter at Fanny's love, which is basic to her happy marriage. Lady Bertram mouths the social "advice" that "'it is every young woman's duty to accept such a very unexceptional offer'" as Henry Crawford's. but Jane Austen links the social marriage of convenience to evil: "a good man must feel, how wretched, and how unpardonable, how hopeless and how wicked it was, to marry without affection" (pp. 333, 324). After the "vice" of Maria's seduction and the "folly" of Julia's elopement, Sir Thomas comes to share this nonsocial view with Fanny (p. 452). "Sick of ambitious and mercenary connections", he applauds the "domestic felicity" Edmund finds with her (p. 471). For Jane Austen it is "true love". Edmund has always found the solace and advice he needs in chats with her rather than in the dream of *Lovers' Vows*: "'You are the only being upon earth to whom I should say what I have said'", he tells her when consulting her about Mary (p. 270). Fanny has always appeared to her best advantage in tête-à-têtes with him. In them he has found a principle and integrity lacking in society, and she has found an audience for her joys in poetry and nature, which the other Bertrams have driven her to by their neglect.

Jane Austen again drew on the courtship convention for this alternative to her contemporary society, though more obliquely and less buoyantly than in her earlier novels. The new society which finally centres on Fanny gains depth from the happy ending of fiction, although Mansfield Park offers no joyous vision like Pemberley. The best "happiness" in this novel is "very much à-la-mortal, finely chequered", more like life than romances, but by no means identical with it (p. 274). Receiving no useful example from elders, young people can be "merry" only with their own generation; Fanny has dreamed of settling down in a "little cottage" with William (pp.197, 375). All the young Bertrams and Crawfords hope to escape from their aimless, joyless social world into the happy marriages of fiction, but only Fanny has the emotional experience and moral insight to know the limitations of bookish living. Mary and Henry sense a pleasure in *Lovers' Vows* and a worth in Fanny outside their previous experience, but they lack the determination and self-discipline to achieve a feasible version of it. Their selfish happiness serves best to show off Fanny's worth by contrast. True to Edmund and devoted to anyone who has real affection and use for her, she offers a domestic happiness which if not exuberant is reliable in a fluid world. When Edmund, who has been blinded but not perverted by *Lovers' Vows*, realizes that Fanny offers an attainable version of the play's ideal, he joins with her in creating a marriage which will approach the happiness of the convention:

> With so much true merit and true love, and no want of fortune or friends, the happiness of the married cousins must appear as secure as earthly happiness can be.--Equally formed for domestic life, and attached to country pleasures, their home was the home of affection and comfort. (p. 473)

By marrying Fanny, Edmund is in fact accepting standards and ideals from the courtship convention, and in turning away from Mary he is rejecting the social mores of his times.

In the passive heroine of the courtship convention Jane Austen found both an alternative social ideal for neglected women and a new artistic challenge. She condemned the selfish and superficial world of the early Mansfield for scorning the quiet but devoted young woman who could give it the ideal it needs. *Mansfield Park* is not an optimistic satire of a few foibles in a fundamentally sound world, but a trial of the whole social system of the patriarchy, especially in its devaluing of poor women. Jane Austen was not yet ready to seek a cure for social malaise outside the gentry, though as David

Monaghan remarks she "began to lose confidence in England's landed society"; "survival of the old order depends entirely on" Fanny.[29] At the end the heroine withdraws into Mansfield Park and, as Barbara Hardy remarks, makes the "home ... a communal place".[30] It is a refuge of "country pleasures, ... affection and comfort" which retains what Mary Crawford has longed for but abandoned (p. 473).

Fanny may sometimes have too much sensibility for Jane Austen, but only it and her moral integrity set a positive direction in the variously time-serving and indolent world of Aunt Norris and Lady Bertram. Through true love and true merit Fanny shows that if emulated with sincerity and moderation the convention could give meaning to the lives of young couples stifled by society. Extravagant fancies pervert the ideal, but Fanny's hopes, though amusing, essentially come true. The chapel at Sotherton may fall short of her poetic fancy, and the chilly November winds may belie her rhapsody on a warm late autumn, but she marries her hero with the chivalric name for better, not worse. Jane Austen would have completely met the artistic challenge of the passive heroine if in addition she could have shown Fanny infusing him and his community with a revitalizing enthusiasm. But Fanny herself lacks the spirit to do so. Without the wit, shrewd judging, inner drama and self-criticism of an Elizabeth Bennet, Fanny is not a magnetic character. She is a thoroughly convincing woman who fails to project a heroic image of herself. In her Jane Austen was defining the difficulties of portraying the passive heroine. She would have to surmount them to turn Fanny's passive successor, Anne Elliot, into an artistic triumph.

CHAPTER VIII

EMMA WOODHOUSE: THE ACTIVE HEROINE AS SOCIAL LEADER

Emma Woodhouse is a woman born into a position of power which she learns to exercise wisely by deepening her insight into the feminine convention. Unlike Fanny Price she is an influential and outspoken young woman who can improve society by action as well as example, but she lacks an adequate model as social leader. Like Fanny she must look outside her society for inspiration. At first she assumes that strangers and newcomers to her town of Highbury must have led more significant lives than hers and would arrange futures for them according to the extravagant principles of romance. Superficial and damaging though her early efforts at matchmaking are, they have positive implications. They are a protest against the littleness which society has forced on women like her and a search for a better alternative. She has still to learn the sad truth that the drifting male selfishness that depresses her in Highbury society makes it a microcosm of society at large. Yet although *Emma* (1816) follows *Mansfield Park* in dramatizing the discontent of the young in such a society, its mood is more optimistic than pessimistic. An expansive renewal is possible if Emma is willing to undertake the task and learn to do it well. Hope arises from the public implications of the heroine's own marriage, which gives new meaning to the spirit of the feminine convention. Although examining the central heroine in a new situation, as a woman with social power, Jane Austen once again developed the double potential she saw in it. She used it as a theme as well as an artistic framework for the account of a heroine seeking a more influential life as a woman.

(i)

Life in Highbury is hard on young women, especially if they are poor. As with the Thorpes, Dashwoods, Steeles, Bennets and Lucases in the earlier novels, marriage is their only escape from insecurity, but here there is a more visible degradation facing them. Emma puts their plight bluntly when she tells Harriet Smith, "'A single woman, with a very narrow income, must be a ridiculous, disagreeable, old maid!'" (*Emma* p. 85). Miss Bates with her universal "good-will" may be a partial exception, but as George Knightley

notes, her future looks bleak: "'She is poor; she has sunk from the comforts she was born to; and, if she live to old age, must probably sink more'" (pp. 21, 375). Anne Weston is happy with her new husband, but again Knightley points out that only a lucky marriage has allowed such a Miss Taylor "to be secure of a comfortable provision" (p. 11). Marriage offers poor women their one hope of a tolerable future, as the bachelors in the novel well know. Perhaps most poignant of all, Jane Fairfax looks doomed for most of the novel to the worst miseries facing a poor young woman. Returning to Highbury from her friends the Campbells, who cannot provide for her indefinitely, she feels that her pleasure in life must end before she has much more than entered the social world:

> With the fortitude of a devoted noviciate, she had resolved at one-and-twenty to complete the sacrifice, and retire from all the pleasures of life, of rational intercourse, equal society, peace and hope, to penance and mortification for ever. (p. 165)

It is a future which appals her, and in her resentment she voices the most strident protest in Jane Austen's novels against the lot of women:

> "There are places in town, offices, where inquiry would soon produce something--Offices for the sale--not quite of human flesh--but of human intellect." (p. 300)

These words resound with a bitterness that Jane Austen seldom revealed at the society of her times and its treatment of women.

As in *Mansfield Park* social oppression is generalized, not concentrated in single tyrants like General Tilney. None of the three men in a position of power in Highbury deliberately represses women, but together they control their fate. Mr. Elton is only a self-centred man who knows the good things available to eligible bachelors and wants to enjoy them. He would not think of offering himself to rescue a schoolgirl like Harriet Smith from poverty. He humiliates her in public for thinking he might marry her, and instead acquires a Mrs. Elton who offers both "substance and shadow--both fortune and affection" (p. 182). Mr. Woodhouse is courteous to women, but he so enjoys his life of "gentle selfishness" while playing cards with them that he wants to preserve them all from such a dire change as marriage (p. 8). Knightley speaks of the "excellent wife" as "submitting" her "own will" to her husband's, but he is a responsible landlord of his estate of Donwell Abbey, and he does think of ways to help poor women like Miss Bates and Jane Fairfax (p. 38).

To put his benevolence fully into practice, he needs a wife to help implement it.

These men may not use their power tyrannically, but like Mrs. Ferrars in *Sense and Sensibility* some women are eager to replace them as social dictators of the patriarchal society. The dread Mrs. Churchill directs some Highbury lives from afar through her influence on Mr. Weston and his son Frank Churchill. She has made certain that Captain Weston had "much the worst of the bargain" when he married her sister-in-law (p. 16). Frank fears that she will do the same by him if she hears of his secret engagement to Jane Fairfax. Mr. Weston's first wife was also the poorer because she was a woman, for "her fortune bore no proportion to the family-estate" (p. 15). A similarly repressive power threatens Highbury when the new Mrs. Elton arrives in town ready to act like a female patriarch. She divides the community into factions, creates a favoured inner circle, and patronizes Jane Fairfax. Unless Emma can exert an overriding influence, and exert it benevolently, Highbury will continue to resemble the general society of the times in its oppression of women. She must teach herself to do so, for she can find no admirable example in the behaviour of those women already exercising some power.

For the rare woman born into an affluent and affectionate home with no male heir, Highbury is a comfortable place to live. It tempts Emma to remain a spinster at her girlhood home of Hartfield, particularly when she has grown up to her father's preaching that "matrimony, as the origin of change, was always disagreeable" (p. 7). Although her reservations about marrying are less fixed than her father's, as when she defends the Weston marriage against his selfish attack in the opening chapter, she tells Harriet,

> "I have none of the usual inducements of women to marry.... And, without love, I am sure I should be a fool to change such a situation as mine. Fortune I do not want; employment I do not want; consequence I do not want: I believe few married women are half as much mistress of their husband's house, as I am of Hartfield; and never, never could I expect to be so truly beloved and important; so always first and always right in any man's eyes as I am in my father's." (p. 84)

Emma already enjoys "employment" and "consequence" beyond the dreams of Fanny Price and most young women of the time. Naturally she is inclined to preserve her life of trifling ease rather than risk a challenging and male-

dominated alternative. Naturally she is a snob, for a snob is a spokesperson for the status quo who would keep all people, including the most able, fixed in the social niches in which they were born. When she wants the Coles "to be taught" a "lesson" against social climbing, when she has Harriet snub the Martins as unfit friends for the friend of Emma Woodhouse, she is practising the philosophy of her times (p. 207). Were she to continue as she is, she would satisfy society at large. She has no need of a marriage of convenience, and, as Nicholas Hans observes, her society has no use for able women.[1] To become a heroine she must throw off her father's doctrine and the social status quo. She must accept change as a principle and work to make it positive.

Highbury society may seem stable, but it is changing inexorably despite the Woodhouses' wishes. Through marriage Anne Weston gains unexpected prestige in the first volume of the novel, Mrs. Elton enters town as the new leading lady in the second, and Jane Fairfax leaves permanently as Mrs. Frank Churchill in the third. At the close the birth of the Weston daughter ushers in a future generation. Even from the nunnery of Hartfield, Isabella has fled into a fruitful marriage with John Knightley. Neither the social position of important families nor Highbury itself is standing still. The Coles and the Coxes are rising, the Bates are sinking, and the town itself is declining. When Emma and Mrs. Weston walk Frank Churchill by the Crown Inn,

> they gave the history of the large room visibly added; it had been built many years ago for a ball-room, and while the neighbourhood had been in a particularly populous, dancing state, had been occasionally used as such;--but such brilliant days had long passed away, and now the highest purpose for which it was ever wanted was to accommodate a whist club established among the gentlemen and half-gentlemen of the place. (p. 197)

The little used ball-room at the Crown symbolizes hard times and decay, a change for the worse in Highbury. It also suggests the lack of an active and benevolent social leader in town, perhaps since the deaths of Mrs. Woodhouse and the mother of the Knightleys. Hartfield or Donwell Abbey or both need an able and understanding mistress to reactivate their prestige as the potential force for good in the community. None of Jane Austen's preceding novels creates such a sense of a whole society. Highbury is a community on the decline unless the heroine can revive it.

The newly independent Emma of the first chapter, who has just lost her governess to Mr. Weston, has in fact become the leading lady in Highbury. With only bachelors or widowers occupying both of the nearby stately homes and the vicarage, there is a void at the top of the social scale which the lady of Hartfield must fill. Emma is a power in Highbury whether she likes it or not. Of course she likes it very much, to be sought in counsel, to share everyone's intimate thoughts, to guide her subjects into the marriages she chooses for them. When events like the Weston match go according to her guesses, she fancies that she has promoted, caused and sanctioned them for the public good. Overestimating her ability while underestimating her influence, she initiates the program of matchmaking which constitutes the novel. Her goal may be inadequate, her method the gross interference of a busybody, but Highbury must have a social leader. The early Emma makes a poor one as a matter of course. She has no precepts or models for developing worthy ambitions, no sound methods or goals for guiding the people who look up to her. She can give them no adequate direction because she lacks a serious social outlook. The England of her time is more to blame than she is, for it failed to prepare women of talent and drive for public life. Emma is on her own. She must work out her own principles of leadership and learn to practice them wisely.

(ii)

To become a significant social leader Emma needs a worthwhile ideal, but she cannot find one in a society contemptuous of women. As an alternative she picks one up from fiction. She treats her active entry into Highbury society as a romance of her own writing, in which she arranges the lives of friends and neighbours as if they were heroes and heroines of her own creation. In doing so she substitutes outward show for true worth when assessing others, as when she "was pleased to see" Knightley coming in his carriage to the Coles' party (p. 213). As a storymaker she delights to recall that occasion because of "her condescension in going to the Coles" and, in the language of romance, leaving "a name behind her that would not soon die away" (p. 231). The bald truth is different. Emma may dream of herself as the heroine of the party, but Jane Austen exposes her as in fact a snob who dreads "all the horror of ... falling in with the second and third rate of Highbury" (p. 155). Applying the simple, absolute contrasts of second-rate fiction, Emma classifies all social climbers as despicable for brashly upsetting the existing order. She justly looks down on the "impertinently curious"

Coxes, but she fails to distinguish between them and the "'worthy'" Coles (pp. 232, 210). She wishes the Coles "to be taught that it was not for them to arrange the terms on which the superior families would visit them" (p. 207). Similarly when she attempts to refashion the lives of her neighbours according to romance, she fails to realize that in everyday terms she is wasting her talents on matchmaking. It is a frivolous mission for a woman with her ability and power, but at first it satisfies her urge to treat her acquaintances as characters under her control.

Although Emma grows into an admirable as well as a credible heroine by changing her attitude to new friends like Harriet Smith and Frank Churchill and old neighbours like Miss Bates and Jane Fairfax, her first assessments of them are not promising. A social leader needs to discern and encourage the real talents of those who look up to her, but Emma prefers to fasten on mysteries, hoping that they hide traits of more romantic promise. With disconcertingly little effort she has soon so "improved" the everyday Harriet as to win Knightley's praise: "'You have cured her of her school-girl's giggle; she really does you credit'" (p. 58). Her urge to do her disciple a greater good by marrying her off handsomely fails because she tries to construct a Romance of Harriet Smith. Tempted by the mystery of Harriet's birth, she fancies her to be an orphaned and not really illegitimate heroine. Like a Charlotte Smith, Emma hopes to reveal that Harriet has the noble ancestry of an Emmeline and arrange a glamorous marriage for her. Emma's "first attempts at usefulness were in an endeavour to find out who were the parents; but Harriet could not tell....Emma was obliged to fancy what she liked"; and fancy she does, with the feminine convention as her guide (p. 27). She refuses to see that in the ordinary world Harriet is only a second-rate Miss Bates who runs through several wild guesses in a breath while playing charades.

Emma has to learn that her power can issue in evil as well as good. She must come to understand that her bookish plot of switching Harriet's love from Robert Martin to the Reverend Mr. Elton is damaging to all three of them. At her nadir in the drama of Chapter Seven, Emma the would-be author of romance behaves in fact like an insidious hypocrite as she manipulates Harriet's reaction to Martin's letter of proposal. She sneers, with a then radical confidence in women's education, that its "strong and unaffected" language must be his sister's rather than his own (p. 51). She alternates aloof refusal to give advice with dogmatic generalizations. She

brandishes her cruel weapon of social ostracism at a girl who would marry a farmer instead of a fancied hero like Mr. Elton. Ironically she overlooks Harriet's essential worth, which Knightley later praises. She sees her first example of public self-restraint in Harriet's humility when Mr. Elton scorns her love. Like Catherine Morland, Marianne Dashwood, and the amateur actresses at Mansfield Park, Emma has to learn Jane Austen's repeated lesson that fictional life is a dangerous model for ordinary people unless they use it judiciously.

Emma has found that her bookish plotting can injure her disciple's future, but she still applies it to mysteries from the unknown world beyond Highbury. Unlike Harriet, Jane Fairfax provides her with a serious rival in accomplishments who could, as Knightley urges, stimulate her growth in sympathy and respect for intellectual equals. Recalling Camilla's Edgar, Knightley wants Emma to make a friend of this woman of his choice. Instead, on contemplating "Jane's decided superiority both in beauty and acquirements"(to Miss Campbell), Emma fancies a conventional intrigue to suit "the fair heroine's countenance" (pp. 165, 220). Delighted to have another mystery to stimulate her, she imagines an adulterous urge reminiscent of a Geraldine Verney of Charlotte Smith's *Desmond* to explain Jane's unexpected refusal to join the Campbells on a visit to their new son-in-law Dixon. The genuine puzzles of Jane's new piano and secretive walks to the post office seem to Emma to be proofs of her wild guesses. She has yet to develop the habit of looking for the most natural reason for odd conduct. The conventional explanation occurs to her before the mundane one of an engagement kept secret for the mercenary reason that it would offend the young man's wealthy aunt. As a result Emma fails to realize that the "reserve" and "odious" "composure" which Knightley condemns in Jane are masks for an abnormal anxiety which she could help alleviate as a friend and disinterested social leader (pp. 203, 263). Emma neglects the easiest way to learn her public responsibilities by not making a companion of the highly intelligent but hard-pressed young woman. Had she done so, she would have avoided the series of blunders caused by knowing Harriet too well and Jane too little.[2] Jane suffers too, for the odious Mrs. Elton can patronize her because Emma has not increased her social prestige by making a friend of her.

Frank Churchill the anti-hero increases Emma's obsession, but ultimately he helps cure it. As community leader she ought to be

demonstrating the dignity of Highbury life in opposition to his secret scorn of it. Instead she imagines that he must be a "hero" who is "very much in love" with her (pp. 256, 265). Clever and idle like Emma, he also enjoys making a fiction of life, but with him the deception is deliberate. Glad to start a false flirtation to keep his engagement secret, he strides into Highbury sneering at Jane Fairfax's pale face and reserve, and encouraging Emma's gossip about Jane and Dixon. Eager to match wits with Emma, he encourages her most destructive romanticizing. Sensing her urge to manipulate the ball as if it were an incident in a novel, he flatters this vanity: "'Oh! Miss Woodhouse, why are you always so right?'" (p. 259). At Box Hill he tempts her storymaking urge to manipulate lovers, which she has been struggling to overcome since the Harriet-Elton fiasco. Encouraging her most vulnerable weakness, he begs her to make a match for him. In apparent verification, the most bookish incident in the novel, his rescue of Harriet from the gypsies, seems to justify her false image of him as a romantic hero. Yet although he deceives her about others, she is perceptive enough to realize that he is flirting with her. She may fail to recognize the deceit behind his trip to London for a haircut (to buy Jane a piano), but she sees that he thinks so little of his reputation in Highbury as to let himself be branded a fop there. The news that he has subjected Jane to the misery of a secret engagement to preserve his inheritance sinks him in her opinion, but it also confirms her estimate of his character. By defining his moral weakness along with her own error, Emma deepens her social experience while strengthening her insight and integrity. Her stamina and resilience--the fortitude of conventional heroines--emerge as new facets of her heroism when she is undergoing her rounds of self-criticism, confession and reform in response to her errors.

Along with these misreadings of newcomers, the reverse mistake with Miss Bates completes Emma's course of practical education as a social leader. For most of the novel Emma is so blinded by her romantic fantasies that she overlooks the dull, day-to-day side of heroism. In view of Jane Austen's stress on outgoing happiness as the end of life, Miss Bates qualifies as an exceptionally admirable woman in ordinary society. "'She is a standing lesson of how to be happy'", as Mr. Weston, who is another, puts it; but more than that she is an apostle of happiness:

> She was a happy woman, and a woman whom no one named without good-will. It was her own universal good-will and contented temper which worked such wonders. She loved every

body, was interested in every body's happiness, quick-sighted to every body's merits. (pp. 255, 21)

In a novel which extends the ideal of happiness to a whole community, it is fitting that Emma's final error should teach her a lesson through Miss Bates. Emma's romantic fancies about Harriet and Jane as heroines and Frank as a hero mainly waste her own talents. In contrast, her "'insolent ... wit'" to Miss Bates on Box Hill weakens what in lieu of an established social leader has been the one positive feminine force in Highbury society (p. 374). As Knightley points out, Emma has lowered Miss Bates's reputation "'before others, many of whom (certainly *some*,) would be entirely guided by *your* treatment of her'" (p. 375). In her worst lapse in applying her initial standards for judging, Emma has suspended her criterion of sense for the undeserving Frank Churchill rather than the worthy Miss Bates: "'I do not know whether it ought to be so, but certainly silly things do cease to be silly if they are done by sensible people in an impudent way'" (p. 212). Yet in the end even this lapse may be constructive. It breaks down the rigidity of Emma's harsh opinion of folly and prepares her for a shift in standards as well as a revised estimate of this agent of active good will.

(iii)

To show Emma's maturing from an idle matchmaker into the social heroine of Highbury, Jane Austen once again employed "fact and fiction ... to complement one another", as Henrietta Ten Harmsel explains.[3] Here, though, she combined them by means of a more flexible artistic framework. As usual, details from the feminine convention form the essence of the heroine's character, but they are no longer fixed characteristics. They become fluid traits which dramatize the potential for either good or evil in a capable young woman with too little to do. For the early Emma, Jane Austen modified the static strengths of beauty and sense by defining them closely and limiting their scope. To friends like Mrs. Weston and Knightley she is "loveliness itself" with her "true hazel eye" (p. 39). They also applaud her lack of the most common vanities. Emma is modest about her looks and knows that Jane Fairfax has surpassed her in music, no matter what flatterers like Harriet Smith may say. Then, having established Emma's basic image out of the convention, Jane Austen shows how her capability at home has led to a more subtle vanity which disturbs Knightley. She supposes that she can manage the town as simply as she has managed Mr. Woodhouse at home.

Superior as usual to a less intelligent father, the heroine has developed her first hankering after power by running his house ably and generously, but too easily. She provides him with all the private and public comforts that an indolent gentleman of the time could desire. And she does more. Although "he could not meet her in conversation, rational or playful", she gently teaches him to accept a right view of conduct which irks him (p.7). It is an early example of her deliberate or chosen heroism, as opposed to what Juliet McMaster describes as chance heroism.[4] She persuades him to think of the crotchety John Knightley as the good son-in-law that he is, she provides meat and cake for his guests when he would feed them gruel, she sees all his weaknesses but refuses to curtail his prestige. Living with Mr. Woodhouse is no easy task for an ambitious young woman, but she has proved herself a good companion and well deserves his frequent lavish praise. In spite of his example she has learned to fulfill the duties of lady of the house with a disinterest and energy which Fanny Price still has to learn as *Mansfield Park* ends. Yet her will has been so rarely thwarted, her power has come so easily, that she enters Highbury society with the assumption that it is as malleable as her father. Through her errors with Harriet, Jane Fairfax, and Frank Churchill she must learn to develop her good sense on a community scale and avoid "'a subjection of the fancy to the understanding'" (p. 37). The conventional superiority of a young woman to her parents or guardian proves to have its dangers as well as its artistic advantages.

Although Emma always has good sense and good will, however much she abuses them, she only gradually acquires the temper and openness of heroines of fiction. Building on the "happy disposition" of the opening sentence, Jane Austen constructed a rare drama out of the heroine's growth in the sweet temper of the convention. As a child Emma has had her "saucy looks" for Knightley and lapses in amiability with Anne Taylor (p. 462). They sour the sweetness of the early Emma, but not permanently. Her first signs of shame appear in fits of discontent, which shortly lead to self-criticism and repentance. She may not apologize for her "pet" at Isabella's objections to her drawing of John (p. 45), but she becomes disgruntled at having had Harriet snub the Martins and cross at having made fun of Miss Bates on Box Hill. Soon she is crying about Miss Bates and initiating one of her redemptive sessions of self-criticism and reform. Likewise her fondness for puzzles like the charades tempts her to be secretive rather than open about her matchmaking schemes, though she is never actively deceptive like Jane

Fairfax and Frank Churchill. She only likes to keep Knightley guessing, until she comes to accept his criticism of Frank: "'Mystery; Finesse--how they pervert the understanding!'" (p. 446). Then she can rejoice in the news of Harriet's engagement to Robert Martin because "the disguise, equivocation, mystery, so hateful to her to practise, might soon be over" (p. 475). Her lapses from conventional sweetness and openness suggest a spoilt girl of the world, but as she matures she acquires both traits. Her disposition seems perfect to Knightley when she accepts his proposal, and no more is necessary for any plausible heroine.

In *Emma* Jane Austen gave dramatic force to these conventional strengths of heroines through her brilliant and original inner effects.[5] Together they create the scenes of tension leading to growth through which Emma ceases to judge others by purely bookish expectations. Honest self-criticism is her most exceptional asset, and it too grows in scope and intensity. From the moment when Mr. Elton proposes to her instead of Harriet, no one is harsher in condemning her romantic matchmaking than Emma herself. As she brushes aside her humiliated vanity, the satire gives way to a sympathetic probing of a complex mind trying to define and correct its mistakes. Her remorse becomes dramatic as self-pity vanishes in an outgoing concern for her disciple. This shift initiates the slow process of making the early snob likable to readers, a creeping magic which is all Jane Austen's own and magnifies the sense of the heroine's growth:

> The first error and the worst lay at her door. It was foolish, it was wrong, to take so active a part in bringing any two people together. It was adventuring too far, assuming too much, making light of what ought to be serious, a trick of what ought to be simple. (pp. 136-137)

Here the self-doubts of a Cecilia or Camilla grow into a heroic third dimension.

Ironically, the more Emma tries to avoid such errors the more subtle they become, as she widens the range of her influence, or interference, to include Jane Fairfax and Frank Churchill. Those strangers from the supposedly glamorous world at large make a fool of the lady of Highbury, but they do teach her that she has abused her good sense with her romantic gossip about Dixon. Their inner life if explored would be a mere hypocrisy, but they help Emma's to deepen. With Frank she commits one last error of fancy, and it causes her the most violent of her inner agonies. Although she

has long sworn off active matchmaking, she has allowed herself to discuss her disciple's new idol without naming him. She is confident that her dream heroine Harriet must love her dream hero, Frank Churchill, whose rescue of Harriet from the gypsies seems pure romance. She comes to understand her error when she finds out that others have romantic daydreams as well, including Harriet. She learns that she has created an incipient tragedy as she comes to realize that she loves Knightley when Harriet talks of loving him too.

With Emma consciously in love with Knightley and jealous of Harriet's apparently reciprocated love, her inner tension reaches a new magnitude and needs a new form of expression. To achieve it Jane Austen modified conventional practices for Emma as a heroine of "true sensibility" (p. 478). Although beginning with some stilted conventional language, she went on to express Emma's sorrow and joy by means of a harmony between nature and feelings which had partly eluded her in her mocking of Fanny Price.[6] With Knightley away in London, a traditional love melancholy sets in, for Emma dreads his returning as Harriet's avowed suitor. Her first feelings lie dormant in her conventional "great terror" (p. 405). The excessive language of "the spontaneous burst of Emma's feelings" on Harriet's disclosure--"'Oh God! that I had never seen her!'"--also jars against the typically unadorned style (p. 411). Then, in the dreary scene of Emma's "very long, and melancholy" evening alone with her father, Jane Austen communicates her heroine's agony directly through an empathy with nature rather than by a mental drama like Elizabeth Bennet's:

> The weather added what it could of gloom. A cold stormy rain set in, and nothing of July appeared but in the trees and shrubs, which the wind was despoiling, and the length of the day, which only made such cruel sights the longer visible. (p. 421)

This mood exposes the emotional poverty of Emma's seeming contentment as mistress of Hartfield by echoing the loneliness of the opening chapter at the climax. It also prepares a medium for communicating her quick change from despair to happiness.

The next afternoon, the sudden return of summer weather readies Emma's emotions for Knightley and the happiness of his avowed love:

> Never had the exquisite sight, smell, sensation of nature, tranquil, warm, and brilliant after a storm, been more attractive

to her. She longed for the serenity they might gradually
introduce. (p. 424)

These parallels between Emma's mood and the outdoor scene show that Jane Austen had come to accept another conventional equation of her predecessors, especially Charlotte Smith and Ann Radcliffe. As a result when Knightley suddenly walks in, Emma's positive emotions give the proposal scene an intensity new for Jane Austen. The first words, "ready to sink", sound like a cliché for a bookish heroine, but an upsurge of joyous language catches her ecstasy:

Emma was almost ready to sink under the agitation of the
moment. The dread of being awakened from the happiest
dream, was perhaps the most prominent feeling. (p. 430)

By admiring emotions which are plausible while laughing more gently at conventional excesses, Jane Austen resolved her own ambivalence towards sensibility as well as nature. The beauty of this mood continues to the end of the novel, buoyed up by the now genial humour.

Jane Austen also reworked the larger effects of the convention as a framework for Emma's public and social as well as personal reformation. She played with its clichés for the would-be matchmaker but searched out its hidden truths to trace Emma's growth as a serious social leader. Once again the love triangle provides the conflicts, but she molded it so that it too is fluid rather than fixed.[7] The conventional triangle involving Jane Fairfax and the married Dixon exists only in Emma's bookish imagination. So does another, involving Harriet, Robert Martin, and whatever man seems most heroic to Emma's fancy at a given moment. When Emma suddenly has to play the leading lady, or victim, in Mr. Elton's half drunken proposal scene, she finds to her chagrin that she has staged a dramatic crisis for herself instead of Harriet. Then in the last two of the original three volumes Emma the Cupid for others unwittingly sets up an apparent triangle for herself. It is one based on an appearance of choice between her dream hero Frank Churchill and her old friend Knightley, between her fancy of a better life elsewhere and the opportunity to improve the one she knows in Highbury. Ironically it is a delusion of the reader more than Emma, for though long oblivious to Knightley's affection for her she knows that Frank is not seriously courting her. In effect Jane Austen exploited the conventional plot as both a hobby for a matchmaking Emma and a principle of unity for her growth in maturity. It is a sophisticated reuse of the combination of bookish daydreaming and

practical courtship through which she had unified Catherine Morland's love life in *Northanger Abbey*.

With Emma's public role dependent on marriage, the hero is particularly crucial to her success. Again Jane Austen looked to the convention for the type of man who would respect the heroine as a woman but not overshadow her. She kept the traditional image so evident in Knightley that he lacks Emma's full life. "His tall, firm, upright figure" gives him the stature of a Grandison, but his manliness is so latent and unexercised that in action he looks closer to Lord Orville (p. 326). The heroine's vital sessions of self-criticism would be incomplete without confession to Knightley, but Emma listens actively to his lecturing, not passively, as Catherine Morland does to Henry Tilney. She has her advantages over him too, for she is the more open-minded and so has the greater potential for growth in heroism:

> She did not always feel so absolutely satisfied with herself, so entirely convinced that her opinions were right and her adversary's wrong, as Mr. Knightley. He walked off in more complete self-approbation than he left for her. (p. 67)

Emma also has the more active mind and enjoys arguing a position not her own. There is an honest give and take between the two which promises a healthy balance in their marital conversation.

Emma has sized up the worth of her man, understands it well, and is willing to fight for him. In doing so she serves the community as well as herself. She knows that she is right to discourage him from marrying a simple-minded girl like Harriet who could not provide the inspiration that he and the town need. Knightley's busy career as magistrate and active landowner make him especially suitable as husband for a social leader, but he cannot carry out some of his responsibilities without a public-spirited wife. He needs a competent hostess at home and a feminine friend for the poorer women of Highbury. As Mary Evans remarks, "Property, therefore, is given a meaning through the appropriation by men of the energies of women".[8] When Emma rebounds from his criticism of her idle wit at Miss Bates on Box Hill to make friends with the good spinster and Jane Fairfax, she proves that she is best qualified to marry him and become the permanent lady of Highbury. Once Emma has learned to restrain her fictional fantasies, the feminine convention provides the model for her success.

(iv)

Emma must work out her own program to be an effective social leader, for she can find none for a woman in either the England of her times or conventional romance. A principle first emerges in her heroic efforts as hostess at home. Although she can keep house well for her father alone, she cannot maintain harmony in the larger family group without George Knightley's assistance. At the Christmas reunion in Chapter Twelve she creates harmony by first placating a cross Knightley and then joining with him to extend peace to the whole group. She decides that Knightley and she must "appear to forget that they had ever quarrelled" over her having persuaded Harriet Smith to reject Robert Martin's proposal (p. 98). When he arrives, she is careful to be found dandling their new niece in her arms, "it did assist", and in a moment there is "perfect amity" between them (p. 98).

Then as the scene widens to include her father, John Knightley and Isabella, Emma struggles heroically to maintain harmony between her brother-in-law's bristling self-reliance on good health and her father's chatter to Isabella about medical remedies:

> the little party made two natural divisions; on the one side he and his daughter; on the other the two Mr. Knightleys; their subjects totally distinct, or very rarely mixing--and Emma only occasionally joining in one or the other. (p. 100)

When Mr. Woodhouse advises Isabella against a seaside holiday as unhealthy for her family, Emma, "feeling this to be an unsafe subject", feigns envy and turns the conversation to local news (p. 101). When John turns from discussing the Donwell estate with George to resent his wife's and father-in-law's concern over his pale looks, Emma hastily takes an interest in the "bailiff from Scotland" (p. 104). With her skill, topic after topic "passed away with similar harmony", but peace suddenly disappears in a brief quarrel between John and Mr. Woodhouse over rival seaside resorts (p. 104). Then Emma can restore harmony only with George Knightley's help. This drama in depth absorbs the conventional image of a vaguely superior heroine and her hero in a more practical creation. It establishes Emma as skilled at maintaining social harmony, sacrificing her own concerns with disinterest and some humility. It also prefigures her need of the timely support of a perceptive partner like her future husband.

If Emma can extend this harmony to the community at large, she can change Highbury for the better. If not, it will change for the worse under

Mrs. Elton and wholly reflect the society of her times, including its degradation of women. A late newcomer to town like Mrs. Elton, who makes no appeal to Emma's romantic fancy, sets off her advantages by contrast. Mrs. Elton demonstrates by reverse example how the good hostess of the John Knightleys' Christmas visit qualifies to be the leading lady of Highbury. As Emma calls on the bride and then receives her at Hartfield, the courtesy visits become a dramatic contrast of good and bad social leadership. Emma starts with a wisely cautious antipathy to Mrs. Elton's lack of "elegance" (p. 270). Then she draws out the woman's tiresome self-interest while with a busy mind she analyzes her manner as "self-important, presuming, familiar, ignorant, and ill-bred" (p. 281). As she listens to a monologue on the private topic of Maple Grove, she notes that Mrs. Elton "only wanted to be talking herself" (pp. 272-273). Mrs. Elton, who has no shreds of the convention about her, is in fact congratulating herself on having achieved the objectives of marriage in the patriarchy--security and prestige, and perhaps the chance to humiliate poor women. In retrospect Emma's patient and considerate hospitality to Miss Bates looks generous when opposed to Mrs. Elton's condescension about Anne Weston and Harriet Smith.

Later scenes confirm Emma's superiority to this would-be lady of Highbury. Mrs. Elton not only divides Emma's welcoming dinner for her into factions. She turns a private jealousy into a public rebuke by having her husband snub Harriet at the ball at the Crown. She also tries to take charge of Knightley's strawberry party at Donwell Abbey. Instead it proves that Emma alone is qualified to be the hostess of Donwell Abbey. While Mrs. Elton complains about the heat, Emma combines a heartfelt concern for the guests with an outgoing good cheer to console a succession of self-centred grumblers, including her querelous father, the sulky Jane Fairfax and the ill-tempered Frank Churchill. With the satire now directed at these lesser people, her self-sacrifice contrasts favourably with Mrs. Elton's voluble discontent. It verifies Emma's worth as Knightley's future hostess at the top of the social world in Highbury, "a Mrs. Knightley for them all to give way to" (p.228).

Emma rejects both the shrewd marriage of convenience that satisfies the Eltons and the "heroism of sentiment which might have prompted her to entreat him [Knightley] to transfer his affection from herself to Harriet" (p. 431). Instead she finds a plausible ideal in a marriage which perpetuates the essence but not the extravagance of the feminine convention. In the late

chapters, and particularly in the proposal scene, Jane Austen increasingly exploited several of its attitudes which she had once satirized. She not only relied on a harmony with nature to reinforce Emma's change from melancholy to joy. In a striking shift in standards late in the novel she now judged behaviour by *feelings* as well as *sincerity*, placing emotion before the *sense* though not the *merit* of *Pride and Prejudice*. The new pair of standards is instead reminiscent of the otherwise different world of Fanny Price and *Mansfield Park*:

> Seldom, very seldom, does complete truth belong to any human disclosure; seldom can it happen that something is not a little disguised, or a little mistaken; but where, as in this case, though the conduct is mistaken, the feelings are not, it may not be very material. (p. 431)

Here Jane Austen fully assimilated the spirit of the convention of the 1790's. By equating feelings and truth she accepted the Romantic principle which she had attacked three novels earlier in Marianne Dashwood. This new trust in emotions allows for a more thorough expression of reciprocated love, which Jane Austen achieves when Emma comes into the house after accepting Knightley's proposal:

> They sat down to tea--the same party round the same table--how often it had been collected!--and how often had her eyes fallen on the same shrubs in the lawn, and observed the same beautiful effect of the western sun!--But never in such a state of spirits, never in anything like it; and it was with difficulty that she could summon enough of her usual self to be the attentive lady of the house, or even the attentive daughter. (p. 434)

Like her predecessors Jane Austen now conveyed joy in love through images of nature.

Once again Jane Austen modified the happy ending of the convention to suggest a sound alternative to marriages of convenience for her society. For Emma and Knightley, domestic well-being is the basis of public as well as private harmony. When Emma accepts Knightley, she already has an example of a positive marriage before her to replace her romantic fantasies. By marrying "a well-judging and truly amiable woman" like Anne Taylor as the novel opens, the good-natured Mr. Weston was "beginning a new period of existence with every probability of greater happiness than in any yet passed through" (p. 17). Certainly Emma has spent some of her happiest moments

with the contented Mrs. Weston when they enjoyed "half an hour's uninterrupted communication of all those little matters on which the daily happiness of private life depends" (p. 117). Yet with her natural and acquired wisdom Emma achieves a domestic joy with Knightley that is more nearly ideal. It is "something so like perfect happiness, that it could bear no other name" (p.432). To Emma the woman bored at home, marriage will overcome her "great danger of suffering from intellectual solitude" in her unstimulating life with her father (p. 7). In marriage she will help to create the vital evenings which Knightley, like Darcy, admires as the epitome of civilized living, "sometimes with music and sometimes with conversation" (p. 170). To Emma the social heroine now capable of exercising her wider influence wisely, marriage will bring increased opportunities. It is in the public sphere that *Emma* takes the theme of domestic comfort beyond the example of Charlotte Smith and Maria Edgeworth.

For Emma, *entering the world* means something new in the convention. It means staying at home in Highbury and learning how to guide the familiar society in which she has grown up as a girl. The unusually long aftermath of six chapters following the climactic proposal is necessary to demonstrate the public good feeling that Emma's marriage creates. Emma must convey to her fellow citizens a harmony found in the convention but not in their patriarchal society. She rejoices at her public impact when she and Knightley pass that harmony on to others. She revels in the news of Harriet Smith's engagement to Robert Martin, which eradicates the evil of her most deplorable error: "She was in dancing, singing, exclaiming spirits; and till she had moved about, and talked to herself, and laughed and reflected, she could be fit for nothing rational" (p.475). For Harriet this marriage means not only the "security" provided women by marriages of convenience but also the "stability, and improvement" and "steady and persevering ... affection" which is the essence of marriage in the courtship convention (p. 482). With the well-earned authority of a Mrs. George Knightley, Emma can also befriend Jane Fairfax while condemning her secret engagement to Frank:

> "What has it been but a system of hypocrisy and deceit,--
> espionage, and treachery?--To come among us with professions
> of openness and sincerity; and such a league in secret to judge
> us all!" (p. 399)

She can share Jane's confidence while looking down with dignity on Mrs. Elton officiously guarding Jane's no longer secret engagement. On a more

prophetic level, the birth of Anna Weston symbolizes the spirit of renewal which has come upon the women of the community.

The fictional convention which caused Emma so much grief leads to her final triumph. The girl who fancied herself a heroic matchmaker grows into a true heroine by modifying the stereotype to suit the familiar world around her. Through self-criticism she learns how the heroine as social leader can renew the solid worth of her community. In *Emma* a limited optimism in the old establishment of the landed gentry replaces the pessimistic retreat of Fanny Price from the greed, envy, and even lust of society at large. Emma learns to live with and for her friends as well as her family, instead of escaping into a private world like Mansfield Park, or Pemberley. Her new happy stance reinforces and augments the optimism of Miss Bates, who has brought out the good will of her neighbours and given Highbury its distinctive tone of good cheer. When Emma comes to realize that Miss Bates is more admirable than the newcomers whom she has fancied as heroes and heroines of romance, she learns the value of becoming the best possible social leader. Through her marriage with Knightley she demonstrates Jane Austen's theme that an everyday woman of ability can become heroic by exerting her influence wisely as a wife, a hostess, and an active friend of repressed women. In this way Jane Austen developed the courtship convention into a guide for exploring not just the various states of love and marriage but also the best practical state of human society. When mercenary hypocrites like Frank Churchill play with the convention, they seize on its extravagances and "'pervert the understanding'" (p.446). When public spirited citizens like the reformed Emma develop its essence, they create a positive life for the whole community. For Jane Austen the convention at its best offered a true picture of English life as it could and should be lived but seldom was.

CHAPTER IX

ANNE ELLIOT: THE PASSIVE HEROINE AS SOCIAL CRITIC

In 1816 in *Persuasion*[1] Jane Austen characterized the passive heroine of the convention as alone able to pass on the virtues of the established social order in changing times. Like Fanny Price, Anne Elliot is the insignificant female dependent in her family. Yet like a conventional heroine she is also its superior in "elegance of mind and sweetness of character" (*Persuasion* p. 5). Sir Walter Elliot and his other two daughters, Elizabeth and Mary, flaunt a sterile, selfish pride in their rank and wealth which they would perpetuate in marriages of convenience. Because of their inferiority to Anne in sense and merit Sir Walter and Elizabeth must retrench by letting their ancestral estate of Kellynch-hall and making a transient home in an apartment in Bath. As they leave, only Anne and perhaps her godmother Lady Russell recognize their obligations as landed gentry and understand the true dignity of their position. Yet although Lady Russell appreciates Anne, she prizes marriages of convenience above feelings and so has persuaded Anne to reject a romance reminiscent of the feminine convention. As a result she has subjected Anne to eight years of family tyranny by having her deny her love for Frederick Wentworth, one of the socially rising naval officers of the war years. When the chance comes again, Anne is determined to marry for love, though to do so she has to abandon her ancestral class. Unlike Fanny Price and Emma Woodhouse she refuses to consider retreating into the enclave of the family estate and trying to revitalize social life on it by marrying the heir. In *Persuasion* the convention and its passive heroine become a principle of criticism for a patriarchal society which the heroine and perhaps Jane Austen no longer found worth renewing.

(i)

As an unwanted younger daughter Anne has endured her petty father and sisters patiently while necessary but implicitly exposed them as shallow, irresponsible, selfish, and so immoral. Her father slights her because he can envision no entry for her in his favourite book, the *Baronetage*. Elizabeth ignores her advice when "laying down the domestic law at home" with a tyranny which makes even the early Emma look considerate (pp. 6-7). She

scorns Anne's warning about her father and the devious Mrs. Clay, to whom she callously says of Anne, "'She is nothing to me, compared with you'" (p. 145). Inevitably the despised young woman must feel anything but heroic as like Sarah Burney's Clarentine she shrinks from such scorn: "Anne's object was, not to be in the way of any body" (p. 84). Yet to Lady Russell, the figure of wise authority in the opening chapters, only Anne regrets leaving the ancestral home for Bath, and only she is not superfluous to the tenants. It is Anne who must call on them to bid them each farewell. The responsibilities of rank mean so little to the rest of the family that Elizabeth can coldly tell their youngest sister, Mary Musgrove of Uppercross Cottage, "'I am sure Anne had better stay [with you], for nobody will want her in Bath'" (p. 33). That was the frustrating position of poor female dependents of the landed gentry in early nineteenth-century England, depicted with all its anguish for the victim as Anne goes to Uppercross instead of Bath. By despising Anne, the Elliots have revealed their own materialism, superficial standards, and lack of feelings. They and their class look deficient, not Anne. In a decaying social order in which Kellynch-hall is passing out of the hands of a baronet with no male issue, only Anne has the resilience to adapt to change and win a place of respect among their responsible successors.

As social critic Anne brings the perspective of the feminine convention to bear on the social order, starting with Sir Walter. Like the dead fathers of Cecilia and Emmeline, like Henry Dashwood and Mr. Bennet, he impoverishes his unmarried daughters through his indifference, indolence and vanity. He has already lost them their home because he and Elizabeth have insisted on living up to their public image of themselves. Without the help of a sensible woman like his deceased wife, they can think of only two savings --the yearly "present" for Anne and "some unnecessary charities", in those days most likely at the expense of poor women (pp. 10, 9). Sir Walter prides himself on the double "blessing" of his "baronetcy" and his "beauty", but he knows nothing of the real worth of either rank or good health, caring only for the deference that they bring him: "Vanity was the beginning and the end of Sir Walter Elliot's character; vanity of person and of situation" (p. 4). As Jane Austen quips, he shares this sort of pride with "the valet of any new made lord". Even more than Henry Crawford he is oblivious to his responsibility as a landowner for fostering the welfare of his tenants. If anything more blind than Mr. Woodhouse to social or personal change, he may at best "be deemed only half a fool" for considering "Anne haggard, Mary

coarse", while "thinking himself and Elizabeth as blooming as ever" (p. 6). To him, leaving Kellynch for Bath is no great decline, for society at the spa is willing to pay passing deference to his title and his appearance. That a poor, fading daughter like Anne may regret the loss never enters his mind. Elizabeth worries only that Mrs. Clay may not join them in Bath because Anne is to be occupying a room in their flat there. Neither Sir Walter nor Elizabeth really wants Anne in Bath because she will add nothing to their prestige there. They still measure their position by rank and wealth, though they have had to abandon their estate to preserve any show of it.

As a father Sir Walter is indifferent rather than oppressive to worthy women like his second daughter. It is his heir, William Walter Elliot, who is the deliberate tyrant of the patriarchal society. Despite his hypocrisy Anne soon assesses him for what he is. Like General Tilney he can look and behave as if he owned all the graces of a gentleman, but as exposed by Mrs. Smith he is "'a designing, wary, cold-blooded being ... who, for his own interest or ease, would be guilty of any cruelty, or any treachery'", especially to women (p. 199). He married his deceased wife only for her money, and he leaves Mrs. Smith nearly destitute by refusing to act as executor of her husband's will. His elopement with Mrs. Clay shows a ruthless determination to keep Sir Walter from a possibly fruitful second marriage that might frustrate his inheriting Kellynch-hall, at whatever disgrace to the woman concerned. In him Jane Austen gave male tyranny the single face she had left unidentified in recent novels. Like General Tilney he is a Montoni of the every day world who may well make Kellynch-hall his Udolpho when abusing women.

The most tolerable representatives of the old order, Lady Russell and the Musgroves, are less self-centred than the Elliots, but neither forward-looking nor concerned about women as individuals.[2] Lady Russell sounds perceptive in praising Anne, but by persuading her to reject Frederick's first proposal she has imposed her long humiliation as an unwanted daughter on her. Later she looks increasingly rigid in changing times as she resents seeing the responsible and kind-hearted Crofts take over Kellynch-hall but delights in the noise of Bath and its decadent gentry. The elder Musgroves love and respect their daughters Henrietta and Louisa and develop a "real affection" for Anne as a peacemaker in their family, though they show "a total indifference" to her exceptional talents (pp. 220, 47). To Anne's relief and the distress of Mary as an Elliot, they are "'totally free from all those ambitious feelings'" which would bring marriages of convenience on their

daughters (p. 218). Unfortunately, their wholesome values will pass away with them. Mary, who is married to Charles the heir, resents Henrietta's unambitious match to a Charles Hayter and will without doubt insist on more socially advantageous marriages in the next generation at Uppercross. Yet the idle Charles and bickering Mary, who "might pass for a happy couple", represent the best marriage which the landed gentry can offer young people in this novel (p. 43). Anne could have married Charles, for she was his first choice, but she would never have approved of the way he "trifled away" his time while Frederick was rising energetically in the navy (p. 43). She knows that she can find effective use for her domestic diplomacy and warm affection only outside the society into which she was born. Having endured her ignominy with the fortitude of a heroine, she must adopt the perspective of the convention to find a husband with outgoing values to match her own.

The move to Bath finally divides Anne from the Elliots as a family who crave social prestige rather than "'the company of clever, well-informed people'" (p. 150). As she sees her father and Elizabeth toady to "'our cousins Lady Dalrymple and Miss Carteret'", she can only "form a wish which she had never foreseen--a wish that they had more pride" (p. 148). Even the sensible Lady Russell and William Walter Elliot separate themselves from Anne and join the Elliot procession to call on these ladies of "no superiority of manner, accomplishment, or understanding" (p. 150). Anne gains in independence as a woman when she dissociates herself from this homage so that she can visit her poor, invalid friend Mrs. Smith, to the disdain of her father. Increasingly she goes her own way, spending as much time as she can with friends who value her conversation and affection--Admiral Croft, Frederick, the Harvilles, and the Musgroves when they visit Bath. This self-assertion rounds out Anne's implicit criticism of these decadent remnants of the landed family. During her years of humiliation and melancholy love she has gained an insight into its pettiness and the resilience to start a new life in a new society.

(ii)

To create a figure of independence out of this social victim, Jane Austen again looked to the feminine convention for a model. With more artistic flexibility than ever, she characterized the passive heroine of her predecessors with memorable beauty and intelligence. Anne's superior beauty stands out for the reader because of the tension between Sir Walter's contempt for her "haggard" looks and the attraction of "her delicate features and mild dark eyes" which are "so totally different ... from his own" (p. 6). At

once the surface trait ceases to be stylized, as in a few sharp phrases Jane Austen creates an awareness of beauty achieved only by her. Once away from home with the affectionate Musgroves, Anne recovers enough "animation of eye" to catch the attention of her cousin William Walter at Lyme, and in Bath the passing crowd praise her "delicate" beauty (pp. 104, 178).

The conventional "elegance of mind and sweetness of character" also look vital when Anne first speaks in the novel, to give her considered opinion of the navy (pp. 5, 19). She shows her knowledge of current affairs by instantly summing up Admiral Croft's career. As for the more formal learning of heroines, she may feel herself "'a very poor Italian scholar'" but William Walter praises her for translating from an opera on sight (p. 186). In health she suffers from the physical weakness of Fanny Price and earlier passive heroines. At Uppercross Mary's younger boy Walter can hold her down on the floor until she is rescued, and on the walk from Uppercross to Winthrop she becomes so "really tired" as to need a drive home (p. 87). A weakness like that and her very sweet temper may have made her less congenial than Elizabeth Bennet and Emma Woodhouse to Jane Austen the rambler, who declared, "she is almost too good for me" (*Letters*, p. 487). Yet Jane Austen refrained from mocking her like Marianne Dashwood and sometimes Fanny Price, perhaps because Anne laughs at herself. As a result the passive heroine of novelists like the later Charlotte Smith and Ann Radcliffe becomes a vivid portrait of the poor young lady of the period.

Along with external tension Jane Austen created a new inner depth for this heroine of "sensibility" (p. 245). Perhaps she had to probe emotions because Anne is too mature and too responsible for the mental drama of doubt and self-criticism which give depth to Elizabeth Bennet and Emma Woodhouse. Beginning with the early misery of the despised daughter, Jane Austen echoed the appeal of the women novelists for sympathy for passive heroines. Anne's long, silent love for Frederick disproves Marianne Dashwood's juvenile assertion that "'a woman of seven and twenty ... can never hope to feel or inspire affection again'".[3] The aching melancholy of silent love becomes vital when Anne sees Frederick again at Uppercross: "Alas! with all her reasonings, she found, that to retentive feelings eight years may be little more than nothing" (p. 60). An inner trembling produces a lyrical depth beyond all the overdone swoons of a generation of heroines when she hears of Frederick's close escape in a storm at sea: "Anne's shudderings were to herself, alone: but the Miss Musgroves could be as open

as they were sincere, in their exclamations of pity and horror" (p. 66). Her sad love surges through her whole being when Frederick rescues her from the naughty Walter on her back. The cold formality by which
> he meant to avoid hearing her thanks, and rather sought to testify that her conversation was the last of his wants, produced such a confusion of varying, but very painful agitation, as she could not recover from, till ... [she could] leave the room. She could not stay. (p. 80)

In contrast to Fanny Price, Anne exudes inner strength, not timidity, in her desperate need to be alone. She suffers still more, and demands more sympathy, when, like Grandison, Frederick comes to feel bound to another woman by honour but against his wishes. Continually increasing the anguish of these encounters in Richardson's manner, Jane Austen added an emotional dimension to the inner characterization of her heroine.

Although Anne looks mature in sense and feelings from the first, she grows in independence. Jane Austen's predecessors anticipated the course Anne's development took, her stamina in adversity. Even at home, unlike the self-effacing Fanny Price, she has forced herself to advise the sneering Elizabeth about Mrs. Clay and their father: "She had little hope of success; but Elizabeth ... should never, she thought, have reason to reproach her for giving no warning" (p. 34). At Uppercross, where the Musgroves love and respect her in their simplistic way, she becomes the community confidante. She patiently consoles the ever complaining Mary while discreetly sympathizing with everyone else's criticisms of that indolent, selfish whiner. Through their reliance on her "perseverance in patience, and forced cheerfulness" Jane Austen suggests the energy which the passive heroine has to exert to maintain domestic harmony (p. 39). Anne can see the necessary solutions but lacks the authority to do anything but listen interminably, soothe tempers, and so restore peace. She must help repeatedly to promote domestic comfort, though her talents are half wasted because they are undervalued and so underused. Anne's difficulty recurs "continually". The dialogue is presented as typical of "Charles's language", "Mary's declaration" and the corresponding argument "on Mrs. Musgrove's side" (pp. 44-46). Here the fortitude of the conventional heroine creates a hard-won harmony beyond the ability or understanding of the socially oriented Charles and Mary.

Anne's fortitude becomes most heroic in times of crisis, though more plausibly so than Evelina's in seizing a suicide's pistol. As sudden disasters

freeze her influential companions into inaction, Anne shows her stamina and resilience. When Mary's elder son Charles dislocates his collarbone, she proves the steadiest personality in the two Musgrove households:

> Anne had every thing to do at once--the apothecary to send for --the father to have pursued and informed--the mother to support and keep from hysterics--the servants to control--the youngest child to banish, and the poor suffering one to attend and soothe. (p. 53)

In such a situation an insignificant woman of the times could even feel "happy". She experienced "as many sensations of comfort, as were, perhaps, ever likely to be hers" in becoming indispensable for a change: "She knew herself to be of the first utility to the child" (p. 58).

Louisa Musgrove's fall on the Cobb at Lyme again allows Anne the opportunity to exert the fortitude of a passive heroine in an emergency. The sudden disaster immobilizes her more socially prominent companions, but not Anne. As the men and other women reel back with conventional gestures noted in the clichés of romance, Anne gives conviction to the presence of mind long attributed to passive heroines. With Louisa unconscious, Henrietta fainting, Mary screaming, and Frederick "staggering against the wall for his support", Anne has to direct every move for help while doing her best to restore reason to those around her. She calls for "'A surgeon!'" while the seaman Frederick merely apostrophizes like a sentimental hero, "'Oh God! her father and mother!'" When Frederick starts "darting away" for the surgeon, she points out that Captain Benwick as a resident of Lyme is the logical person to go. As Jane Austen is careful to stress, Anne must force herself to act despite her equally strong sympathy for Louisa:

> As to the wretched party left behind, it could scarcely be said which of the three, who were completely rational, was suffering most, Captain Wentworth, Anne, or Charles. (p. 110)

Anne guides the men as well as the women, for Charles and Frederick "both seemed to look to her for directions" (p. 111). As the need for strong physical exertion arises, they become the more active again, but they have acknowledged Anne's dominance in an emergency. In the incident on the Cobb, Jane Austen dramatized "the presence of mind" of the passive heroine (p. 182). It was a heroic potential which society was neglecting in the slighted young women of the times.

Although Anne has proved her heroism to Frederick, like her conventional prototypes she now must suffer an even more intense melancholy. She has to endure the public assumption that Frederick is courting Louisa. Forced back to Uppercross by the selfish Mary, who insists on staying in Lyme to console, or worry, Louisa, Anne is left all alone with "a saddened heart":

> she was the very last, the only remaining one of all that had filled and animated both houses, of all that had given Uppercross its cheerful character. (p. 123)

As Anne hears news of Louisa, Captain Benwick and Frederick from a distance, and later watches the Christmas festivities at Uppercross, she can foresee no joy for herself. She can only wait for the dread news that Frederick and Louisa are engaged. When staying at Lady Russell's lodge before going on to Bath, she seems the epitome of credible sensibility. Her great wish is to avoid meeting an estranged Frederick in the rooms at Kellynch-hall in which he first courted her. More than ever Anne regrets Lady Russell's advice, which persuaded her to sacrifice love for the hope of convenience:

> She felt that were any young person, in similar circumstance, to apply to her for counsel, they would never receive any of such certain immediate wretchedness, such uncertain future good. (p. 29)

By making love the determining reason for marrying, Jane Austen at last accepted the sensibility of fictional heroines without ambivalence. Out of the passive heroine of the convention she created a character who epitomizes the miseries as well as the neglected strengths of scorned young ladies.

(iii)

The solitary Anne who needs something to occupy her time and mind turns like a conventional heroine to books. Poetry increases her delight in the countryside but also fosters an independence which later flourishes through it. Like Fanny Price she has to imagine an inner world to offset her lonely life at home. Still isolated when walking in a group of six to Winthrop, she responds to the scene through verse:

> Her *pleasure* in the walk must arise from the exercise and the day, from the view of the last smiles of the year upon the tawny leaves and withered hedges, and from repeating to herself some few of the thousand poetical descriptions extant of autumn, that

season of peculiar and inexhaustible influence on the mind of taste and tenderness, that season which has drawn from every poet, worthy of being read, some attempt at description, or some lines of feeling. She occupied her mind as much as possible in such like musings and quotations. (p. 84)

The Anne of this mood is developing an alternative outlook to the snobbery of the patriarchal society. She is enjoying poetry as opposed to gossip with a Romantic enthusiasm surprising for the Jane Austen of *Sense and Sensibility*. When estimating the worth of poets by their treatment of autumn, Anne sounds like a sonnet-writing Celestina or an unrepentant Marianne Dashwood. She also sounds like a woman with a mature mind, not a social outcast but a constructive observer and critic. For her Jane Austen approves the reading of poetry as a measured response to a restrictive life.

Anne's love of nature also enlarges the scope of her inner life and independent perspective. In *Persuasion* Jane Austen treats nature with a new acceptance reminiscent of her most advanced predecessors, on the walk to Winthrop and in the description of Lyme. She never mocks Anne for being enraptured by it, but instead joins her in admiring the "green chasms between romantic rocks" above Lyme as worthy of "unwearied contemplation" (p. 95). Emily St. Aubert's approach to Udolpho is more detailed but scarcely more Romantic. If a humour reminiscent of the mocking of Marianne and Fanny occurs, it is a friendly and strengthening banter. As Anne nears Winthrop through the fields, external activity breaks in on her poetic reveries about nature, to her own amusement, when "the ploughs at work, and the fresh-made path spoke the farmer, counteracting the sweets of poetic despondence, and meaning to have spring again" (p. 85). Here the humour no longer belittles the heroine's enthusiasm, for she includes herself among those briefly tempted to live by bookish delusions. As Robert K. Wallace sees it, the outdoors is not "a refuge" but "a shaping influence on the heroine's emotions".[4] Through it the despised woman enjoys a richer life than the society which humiliates her. By reacting to poetry and nature with the wisdom of experience along with the joy of conventional heroines, Anne has opened a vista on a larger and freer life.

Yet Jane Austen retains her long-standing suspicion that books, and especially poetry, can falsify emotional responses to life. In *Persuasion* it is Captain Benwick who fancies himself lovelorn through poetry. He revels in Romantic writers who are more recent than Charlotte Smith and Ann

Radcliffe, but to Anne his enthusiasm seems a pose like that Jane Austen suspected in some earlier heroines. Anne shares his appreciation of the "tenderest songs" of Scott and "all the impassioned descriptions of hopeless agony" of Byron, but she sees that they have exaggerated and falsified his feelings (p. 100). Like Anne a forlorn lover, of the dead Fanny Harville,

> he repeated, with such tremulous feeling, the various lines which imaged a broken heart, or a mind destroyed by wretchedness, ... that she ventured ... to say, that she thought it was the misfortune of poetry, to be seldom safely enjoyed by those who enjoyed it completely. (pp. 100-101)

Here Anne sounds like a reformed Marianne Dashwood or adult Fanny Price. She is aware of the brevity of bookish poses and quite prepared for Captain Benwick to love any Louisa Musgrove who will listen to his woes. This time, though, it is a man who puts his individuality in jeopardy to books, not the heroine.

In contrast to Captain Benwick as well as Marianne Dashwood and Emma Woodhouse, Anne fully understands the temptations and dangers of trying to order her own life by books. Fond though she is of reading in her long, empty hours, she never tries to envision a heroic role for herself to fit the courtship convention. With her sense of humour she can estimate her own behaviour in terms of books but keep the comparison valid. When she moves her seat at the opera to be more accessible to Frederick, she smiles at herself as a Miss Larolles. This analogy to a minor character in *Cecilia* depends on Jane Austen's still inspiring memory of Fanny Burney and the feminine convention, derived from a complete assimilation of it.[5] Because books enlarge rather than pervert Anne's inner life, their lure ceases to be a theme for her self-education. As a result Jane Austen left behind her double use of the convention, as a serious artistic model but also a false guide for heroines who would live by it. By rejecting the undue influence of books, Anne unlike her predecessors has begun to take command of her own life.

When Anne comes to Bath, the independent life created through books and nature finds new sources and outlets. Her self-reliance in choosing friends adds dramatically to her stature as a heroine. Although her father and Elizabeth both snub her in favour of Mrs. Clay, they look spiritually wizened beside her. Lady Dalrymple humiliates them but not Anne when they accept an invitation given "to make use of the relationship which had been so pressed on her" (p. 157). Instead Anne looks heroic when separating

herself from their clique and renewing her friendship with Mrs. Smith, "a poor, infirm, helpless widow, receiving the visit of her former protegée as a favour" (p. 153). Her father may scold her for her choice, but she looks the more forceful in silence: "She made no reply" because "her sense of personal respect to her father prevented her" (p. 158). When the Crofts arrive in Bath, she exerts the same independence of judgement and conduct. Although the Elliots scorn what they presume to be social climbing, the Crofts "considered their intercourse with the Elliots as a mere matter of form" (p. 168). Anne knows that the worthwhile privilege is to be their friend. She admires their married happiness and appreciates the Admiral's heartfelt welcome when she greets him by a printshop window.

Strong in her new independence when Frederick comes to Bath, Anne speaks to him despite her family's disdain, which of course vanishes when Lady Dalrymple praises his appearance. The heroine also looks mature beside the hero in emotional insight, for she shows the greater self-possession during their first meeting in town and in the wise assessment of their love. At the opera as she chats with him but sits by William Walter, she can analyze his abrupt departure as "jealousy of Mr. Elliot" but refuse to worry unduly: "'Surely, if there be constant attachment on each side, our hearts must understand each other ere long'" (pp. 190, 221). Anne has gained the initiative of a heroine and is ready to foster Frederick's love at the climax.

Anne can dominate the proposal scene because her vital feelings reinforce her new freedom of action in Bath. She has welcomed the news of Frederick's release from Louisa and the assurance of his renewed love for her. Now her long-lived melancholy gives way to joy, which Jane Austen fully reproduces. Anne brings on Frederick's proposal, and then accepts it, with a vibrancy beyond any expressed by her predecessors. When discussing the durability of women's feelings in hopeless circumstances with Captain Harville, she convinces both him and Frederick that she has endured a distinctly feminine emotional experience:

> "I believe you [men] capable of every thing great and good in your married lives.... All the privilege I claim for my own sex (it is not a very enviable one, you need not covet it) is that of loving longest, when existence or when hope is gone." (p. 235).

This speech wins the argument, for Captain Harville respects Anne as a woman. Frederick responds by scribbling his letter of proposal. Through the device of this letter Jane Austen kept Anne in control of the climax as central

heroine. When she reads Frederick's letter, her emotion overwhelms her physical calm but not her presence of mind, as she struggles to gain a little time alone or with Frederick. As she accepts him while they wander up Union-street oblivious of the crowd, her joy brings the courtship plot to a fully emotional climax. This intense characterization also does unique justice to the slighted women of a generation.

These scenes at the climax provide the one opportunity to observe Jane Austen reworking her art, to strengthen Anne's independence. When rewriting the Cancelled Chapter as Chapters Twenty-Two and Twenty-Three, she directed her energies first of all to that end.[6] In the original version Anne looks negatively passive as she is forced by Admiral Croft to enter his lodgings against her immediate wishes. She is indecisive, she appears subservient, and when the servant momentarily denies her admittance to the house she again looks a humiliated woman. Once indoors she is forced to do the Admiral's arbitrary bidding, waiting alone in a room while half hearing what the Admiral and Frederick are whispering about her. She then accepts Frederick's proposal in awed silence (pp. 255-258). In contrast the new chapters complete her growth in independence. She looks more than ever in command of her life when she virtually transfers herself from her father's apartment to the Musgrove's hotel suite on their arrival in town. She expands in her intimacy with these warm friends. She acts authoritatively with them in her quiet, courteous way, to decide on changing their night for the theatre. In her conversation with Captain Harville the next day she proves that like Harriet Byron she is a woman who can discuss a precise idea succinctly and convincingly. When she reads Frederick's letter of proposal, she makes certain that he learns of her response as soon as possible. Her "overpowering happiness" provides a fitting culmination of her inner intensity and anticipates "all the immortality which the happiest recollections of their own future lives could bestow" (pp. 238, 240). For once the passive heroine has control of her own destiny. As a result she can carve out a position of respect for herself among her new naval friends in their different and less patriarchal society.

(iv)

Although Anne has loved Frederick for years, she chooses him for social as well as emotional reasons. Her marriage has a wider significance than Fanny Price's or even Emma Woodhouse's. Jane Austen manipulates the courtship plot to suggest that Anne is making a conscious choice of suitors. Although the usual love triangle is peripheral to the plot, it is crucial

to the theme. William Walter Elliot offers Anne the chance to gain a place of prominence in the old social order. He charms her with the vision of "becoming what her mother had been; of having the precious name of 'Lady Elliot' first revived in herself" (p. 160). He half proposes to her at the opera, absconding with Mrs. Clay only to thwart that schemer's ambition of marrying Sir Walter, as Mrs. Smith notes. Unfortunately the full social impact of William Walter's involvement with Anne is obscured by the bookish mystery surrounding Mrs. Smith, who makes him sound like a conventional villain: "'Oh! he is black at heart, hollow and black!'" (p. 199). Such a melodramatic diatribe could well have vanished with further rewriting,[7] but it shows how strongly the conventions of fiction shaped Jane Austen's conception of her most mature novel. In choosing Frederick Anne is rejecting a male tyrant of both the patriarchy and the convention.

Anne's choice gains more significance from the theme of social change inherent in the plot. As a novel of manners *Persuasion* stresses fundamental social movement rather than the "buzz of persons" in Bath, which is reduced through Mrs. Smith to an invalid's indoor gossip (p. 183). In a society in flux the passive heroine gains stature as the one member of the old order who is capable of appreciating and embracing the new. *Persuasion* pictures a society in transition in contrast to the essentially stable system which pervades all the earlier novels. In them Jane Austen had satirized the discrepancy between social ideals and social conduct, but she had presented the existing hierarchy as constant. The later novels show an increasing uneasiness at its materialism and disregard for women as individuals, but until *Persuasion* they imply that England must abide with it. The Bertrams withdraw into Mansfield Park so that they can live by its best principles. Emma as social leader seems destined to inspire a period of renewed harmony for a town on the decline. In *Persuasion* in contrast the opening satire of Sir Walter reading the *Baronetage* suggests a permanent decline. With his one son stillborn, living beyond his means, and forced to move off the family estate, he represents a society in decay. Feeling no responsibility to his tenants, and gratified by the elegant but ephemeral society in Bath, he lacks Anne's awareness that the world has pushed him aside.

No previous heroine has recognized the isolation of "every little social commonwealth", including her father's, and the falsity of its assumption that it constitutes the world (p. 43). Anne alone sees the larger significance of the Crofts' living in her family's old home:

> she could not but in conscience feel that they were gone who deserved not to stay, and that Kellynch-hall had passed into better hands than its owners'. (p. 125)

The Crofts, who have no hereditary obligations, will perform the neglected duties to the tenants, just as they appreciate the quiet heroine at her true worth. Admiral Croft's frank heartiness, and his contempt for the vanity reflected by Sir Walter's many mirrors, give body to the new standards of warmth and sincerity used to judge William Walter. Anne has adopted them from the beginning, being "on the side of honesty against importance" in urging the Elliots to retrench (p. 12). By marrying Frederick she turns her back on the old, sterile patriarchal society of her father. Instead she moves forward with the most progressive group in the novel, the frank naval officers. Their honest affection more than offsets any lingering roughness reminiscent of the Prices in Portsmouth. As the novel closes, Anne has committed herself to a more flexible way of life:

> She gloried in being a sailor's wife, ... belonging to that profession which is, if possible, more distinguished in its domestic virtues than in its national importance. (p. 252)

The novel which opens with an overspent baronet trying to preserve appearances in Bath ends with his one praiseworthy daughter forsaking the life of the landed gentry for good.

In a changing world the one constant ideal is the happy marriage of the convention, adapted to suit a heroine who is moving into a new social order. By prizing the "domestic virtues" of sailors above their "national importance", Jane Austen was able to stress the significance of women in a changing society. In *Persuasion* she followed the usual quest of her heroines for a civilized life through marriage, but with a difference. Here the domestic comfort which Anne's predecessors brought into stately homes or associated parsonages has passed into the new order of rising naval officers. A spinster steeped in the old values of family and wealth like Elizabeth Elliot could be "very, very happy" in her "selfish vanity" as she walks arm in arm with a Miss Carteret, but Jane Austen regards that happiness as sterile (p. 185). Because Anne shares with Mrs. Smith "the choicest gift of Heaven", "that power of turning readily from evil to good, and of finding employment which carried her out of herself", she can endure the Elliot's environment while she has to, but her real happiness exists only outside it (p. 154).

With Anne the intellectual aspirations of heroines in the convention also pass out of the patriarchy. In her active mind she appreciates the social happiness which she envisions with Frederick, the Harvilles, Captain Benwick and their friends. It is "a bewitching charm in a degree of hospitality so uncommon" in the life she has known as to look ideal (p. 98). At Bath she admires the Crofts as "a most attractive picture of happiness" (p.168). Like Elizabeth Bennet and Emma Woodhouse she places the highest value on the intellectual give and take "'of clever, well-informed people, who have a great deal of conversation'" (p. 150). William Walter agrees "'that is the best'" company, but he pursues place and wealth instead. In *Persuasion* the heroine can rarely converse intelligently except with her new naval friends. At her father's party in Bath she can stimulate her mind only by pitying those who are enjoying the occasion. In contrast, with Captain Harville she can discuss an abstract topic as an equal. Her argument with him that the woman is the preserver of lasting human affection suggests a unique value for the slighted young lady of the times.

Anne could become the next Lady Elliot, re-establish a responsible society at Kellynch-hall, and incidentally gain a more prominent entry in the *Baronetage*. She refuses to consider the option, for as a sensitive woman she has to escape the heartless, isolated life which marrying William Walter would perpetuate for her. By committing herself to the forward-looking society opening up in *Persuasion*, she moves into a future in which her new friends will love and respect her as a person and a woman. By leaving a family that has found no use for her talents, she has won through to a responsible happiness. She moves into a society which cares about her strengths as a woman rather than her birth or wealth. In her, Jane Austen has modified the happy marriage of the convention to suit a society in flux.

In Anne Jane Austen enlarged the heroine of the feminine convention into the heroine of her times. "She extricates her", as Bernard J. Paris puts it, "by recourse to the conventions not only of comedy, but also of romance".[8] As Barbara Hardy explains, "the romantic novel still saves Anne from the consequence of her choice" when she originally let the dictates of society decide against her marrying as she chose.[9] Yet Anne's vision of happiness as seen in the Harvilles and Crofts is more practical than romantic or golden. It is also more challenging. This marriage is not a fictional daydream of perpetual bliss. In contrast to Elizabeth Bennet and Emma Woodhouse, Anne will not experience a happiness that is fixed. While recalling the

feminine convention in her basic character and story, she faces an unusually disquieting prospect. Though "glowing and lovely in sensibility and happiness" like a traditional heroine as she accepts Frederick, she carries the happy ending of fiction into an unsettled future of shifting homes such as Mrs. Croft has experienced (p. 245). Nor will her unease be limited to that insecurity. Her emotions will suffer again and again as she pays "the tax of quick alarm" of the wife of a sea captain (p. 252). Then she will have continually to prove her worth as comforter of her new family and friends. Then her resilience under stress will have to provide the same centre of clear thinking and calm control that it did in the moments of crisis at Uppercross Cottage and Lyme. In shifting times, Jane Austen suggests, the fortitude and affection of conventional heroines are more fundamental to human welfare than adherence to the mores of her class. By characterizing the inner independence which makes Anne's move possible, Jane Austen transformed the slighted woman of the times into the heroine of an uncertain world. By dramatizing Anne's accommodation of social change, which places serious demands on overlooked women, she mastered the art of the passive heroine.

CHAPTER X

COMPROMISE WITH THE CONVENTION

Jane Austen created great heroines by applying the courtship convention of her feminine predecessors to a criticism of worldly marriages. In an age of patriarchal families she saw that representative women of the times could become heroic only by ennobling the meaning of marriage. She sought an ideal by defining the climax of the convention, the heroine's wedding, as the acme of civilized living. To do so she shaped the implausible maidens of earlier novelists into a succession of more representative but still independent young women. They stand apart from their repressive society, judge it as wanting in respect for them, and establish a better life for themselves and their families. As they enter the adult world, they are more than observers and victims, as the Evelinas, Ethelindes, and Emily St. Auberts of the preceding generation of novelists typically were. They are heroines who grow in wisdom and self-reliance as they surmount both the social tyranny of the patriarchy and the extravagant visions of fictional escape.

By establishing a middle position between the two routes to marriage, Jane Austen gave substance to a modified convention as a plausible alternative to both. She dramatized the difficulties of young women entering the social world in a series of homely crises which only they can overcome. When married to a considerate and intelligent gentleman, a witty Elizabeth Bennet will continue to generate the informed conversation necessary for intellectual equality. Through it she can turn the selfish trivia of a Netherfield ball or a Rosings dinner into the model civilization of a Pemberley. In *Persuasion* and the final, unfinished *Sanditon* the heroines' visits to temporary quarters in Bath and visibly changing seaside resorts fragment the formerly stable society into decadent and progressive groupings. Elizabeth Bennet and Emma each tour a stately home from which as wives they will centre a positive but conservative society. By contrast Anne Elliot as a sailor's wife must look forward to a series of rented lodgings like those of the Harvilles and Crofts. In her, Jane Austen adapted the convention to changing times, through a marriage which will carry the virtues of country women forward into a new society.

Through an increasingly broad perspective of the life of the times Jane Austen showed public as well as private well being revolving around the romantic courtship of her heroines. Although she was an acute satirist of all social poses, she increasingly restricted her heroine's standards for judging people to the principles of the courtship convention. Early and late, the coquetry of devious characters, including all deceit between couples, remains the central evil in the world of her novels, although greed and selfish ambition make it more deplorable than in most of her predecessors. The concept of what makes for good shifts more radically but is equally conventional. In a fixed society Jane Austen began by developing heroines like Elinor Dashwood as epitomes of the sense, merit and taste which had seemed crucial for an elevating marriage in Dr. Johnson's day. As her reliance on a fixed social world starts to waver in *Mansfield Park*, the old standards of an Elinor give way to Fanny Price's reliance on "true merit and true love". Even more so, Anne Elliot's trust in warmth and sincerity is reminiscent of heroines of sensibility like Marianne Dashwood. Then sensitivity to human relations, fortitude in crises, and retentive feelings characterize the enduring values which the heroic woman contributes to public as well as family life. Happiness, the great good in conventional novels, remains the constant goal in life and the essence of the climactic marriage, but it takes on an ever deeper meaning. It is muted in the aimless world of *Mansfield Park*, regenerative through the heroine's pervasive good will in *Emma*, and socially expansive in the vibrant world which Anne Elliot enhances at the end of *Persuasion*.

In the final, unfinished *Sanditon*[1] Jane Austen was still relying on the feminine convention to shape her criticism of contemporary life. Although this fragment of twelve unusually short chapters[2] is too brief to reveal the nature of the climactic compromise, it repeats her long-standing contrast between the extremes of worldy-wise and romantic marriages. As with Mrs. Ferrars in *Sense and Sensibility*, social tyranny is centred in a single woman who exercises power with a patriarchal callousness, especially against poor young women. The twice-widowed Lady Denham has realized her ruthless social ambitions of wealth and rank successively in two marriages of convenience. Like Fanny Price, the apparent anti-heroine Clara Brereton is an impoverished "young female relation", wholly dependent on this tyrant (*Minor Works*, p. 377). Clara looks the epitome of "whatever Heroine might be most beautiful & bewitching" in the novels of the times, but she acts as

practically as Charlotte Lucas (p. 391). Unlike Fanny Price and Anne Elliot she is not in subjection, for she is apparently manoeuvering the foolish Sir Edward Denham to her advantage. It is he, not Clara, who is deluded into living by books and "Sensibility" (p. 396). He revels in the most extravagant and evil coquetry in Jane Austen's novels. He aspires to be a Lovelace to Clara, recalling from Richardson the very fount of the novel tradition as it came to Jane Austen.

A more benign version of the delusion of living by books afflicts the seaside speculator, Thomas Parker, in the opening incident of the overturned carriage, which is reminiscent of the opening chapter of Charlotte Smith's last novel, *The Young Philosopher.* Recalling Jane Austen's satire in "Lesley Castle" and *Mansfield Park,* Mr. Heywood mocks Parker with an absurdly mundane medical gibe at his commercial use of verse. When Parker quotes Cowper to support his propaganda for a resort, Heywood exposes the misapplication: "'With all my Heart Sir--Apply any Verses you like to it--But I want to see something applied to your Leg'" (p. 370). With Parker's schemes of regeneration tied to an abuse of poetry, the fallacy of living too closely by books remains the deceptive alternative to the callous society of the times.

Artistically too, both "my Heroine" Charlotte Heywood and the antiheroine show that Jane Austen continued to adapt the conventional model rather than create a new one (p. 395). Charlotte thinks of Clara as a white figure of mystery in terms of the convention:

> she cd not separate the idea of a complete Heroine from Clara Brereton. Her situation with Lady Denham so very much in favour of it!--She seemed placed with her on purpose to be ill-used. Such Poverty & Dependance joined to such Beauty & Merit, seemed to leave no choice in the business. (p. 391)

Yet in contrast to Emma Woodhouse, Charlotte herself is not inclined to judge her new friends unduly by books. Jane Austen mentions the possibility only to deny it:

> These feelings were not the result of any spirit of Romance in Charlotte herself. No, she was a very sober-minded young Lady, sufficiently well-read in Novels to supply her Imagination with amusement, but not at all unreasonably influenced by them. (pp. 391-392)

Charlotte looks to Fanny Burney's *Camilla* for only a negative comparison to her own current interests.[3] She is, rather, a practical judge of character, like Elinor Dashwood and the mature Elizabeth Bennet. When she listens to Sir Edward quoting poets like Burns, Scott and Wordsworth as his authority on women, she sees him as a "downright silly" and "very sentimental" man (pp. 396-398). When she hears Lady Denham curtailing housemaid's wages and the fortunes of young heiresses, she realizes that she must rely on her own insight in judging strangers, not on Thomas Parker's eulogies: "His Judgement is evidently not to be trusted.--His own Goodnature misleads him" (p. 402).

Charlotte is equally perceptive about more basic social impacts. As she visits and observes the unsettled seaside community, she sees how a changing society influences human character, which she observes from the perspective of the convention. Parker's enthusiasm takes a commercial turn, his brother Arthur's masculine indolence leads on to a self-indulgent gluttony, their sister Diana's feminine interference mushrooms into "'Activity run mad!'" and Lady Denham's lust for power sinks into miserly greed (p. 410). These instances of Charlotte as judge of character show that Jane Austen at the end of her career was still enlivening her heroines by dramatizing the static assumptions of the courtship convention. The lack of a sense and taste that are generous and a sensibility that is quietly sincere reveal the Parker family for what it is to a wisely read Charlotte. She reacts to new acquaintances like a mature women because she retains an independent stance and informed intelligence rare for young women of her time.

As *Sanditon* reminds the reader, Jane Austen characterized her basic heroine by developing the traits found in the feminine convention, not by creating a new image. Her heroine, though not fully orphaned, gains the spiritual independence of Harriet Byron the prototype and Evelina the founding model by being shown as superior to her elders in wisdom and industry. She learns to act on her own as she enters the social world by giving dramatic force to the introductory static strengths of her literary forebears, especially in intelligence and true sensibility. The alleged wit with suitors becomes the vibrant wisdom of an Elizabeth Bennet in reassessing Darcy and Wickham as eligible bachelors. On moving into the courtship plot, heroines like Catherine Morland in Bath can vitalize these traits because they experience the conventional gap of living apart from parents and husbands. Then the familiar love triangle helps an Elinor Dashwood grow into a bride

who knows how to keep the mercenary patriarchs (male and female) at a distance. For Emma Woodhouse and Anne Elliot only the illusion of a triangle remains to frame their growth in self-reliance. The expected attention of multiple suitors becomes only a self-delusion for Emma flirting with Frank Churchill. For Anne Elliot a hint of it in William Walter's self-serving courtesy justifies the usually sentimental appeal for sympathy for passive young women like Ann Radcliffe's. Finally, these heroines share the third dimension created by Richardson but not exploited by his feminine followers in the varied inner life which gives their basic character its rare depth. In sum, they achieve greatness by vivifying the traits and roles that they inherit.

Jane Austen also developed the conventional courtship into a course in social education as well as artistic practice. It teaches young women to achieve a measure of personal freedom and then strive to retain it in marriage to a man who respects his bride's intelligence. Jane Austen saw that a study of the potential contribution of women to civilization was latent in the feminine novels and their heroines. As she deepened their vision of married happiness, she developed a social ideal out of her artistic model. Negatively, she showed the dangers of an undisciplined application of the conventional expectations to everyday life. They range from the Gothic fantasies of Catherine Morland to Sir Edward Denham's daydream of acting the Lovelace to Clara Brereton. Positively, she found the one hope for women to rise above the degradation of marriages of convenience in the liberating romance of her predecessors. Despite the parody and satire of bookish living in *Northanger Abbey* and *Sense and Sensibility*, the convention repeatedly provides the heroine at the climax with her escape from a milieu of avarice and contempt for women. In the calculating worlds of *Pride and Prejudice* and *Mansfield Park* Jane Austen drew on the convention to establish a median between the fantasies of superficial romanticists like the Bertrams and Crawfords and the commercial marriages arranged by the Collinses and Rushworths. By opposing both extremes on principle, Fanny Price secures domestic tranquillity for a family nearly destroyed by them. In *Emma* the heroine as social leader forms a centre of renewal for her whole community through marriage. In *Persuasion* the heroine as social survivor carries this high ideal forward into the society of the future which she joins. In these great heroines Jane Austen transformed the stereotype of fiction into

admirable women who earn a mature happiness. They justify the convention as they enlarge its climactic marriage into a vision of civilized living.

NOTES

NOTES TO CHAPTER I

[1] Harrison R. Steeves, *Before Jane Austen. The Shaping of the English Novel in the Eighteenth Century*, New York: Holt, Rinehart and Winston, 1965, p. 4.

[2] See p. 23-24 and ch. 2, note 23.

[3] Marriage would satisfy not only Lovelace as an atonement to Clarissa, but also the reformed Belford, Lady Betty Lawrence and other social spokesmen of Lovelace's family, her final avenger Colonel Morden, and such disinterested social observers as Miss Lloyd and Miss Bidulph.

[4] Cf. *Mansfield Park*, p. 468. All references to Jane Austen's novels are to the edition of R. W. Chapman, *The Novels (Works) of Jane Austen*, London: Oxford University Press, vols. I - V (*Sense and Sensibility*; *Pride and Prejudice*; *Mansfield Park*; *Emma*; *Northanger Abbey and Persuasion*), 3rd ed., 1933; VI (*Minor Works*), 1954.

[5] Cf. Alexander Pope, "Epistle II (To a Lady), Of the Characters of Women": Nothing so true as what you once let fall,
"Most Women have no Character at all".
Matter too soft a lasting mark to bear,
And best distinguish'd by black, brown, or fair. (11. 1-4),
which Charlotte Smith quotes in the 1790's. See pp. 28, 35, and ch. 2, notes 44 and 70.

[6] Cf. Lawrence Stone, *The Family, Sex and Marriage in England 1500-1800*, New York: Harper & Row, 1977, pp. 289-290 (Opinion in the late eighteenth century "was turning decisively against parental dictation of a marriage partner", p. 289).

[7] Horace Walpole, *The Castle of Otranto*, ed. W. S. Lewis, London: Oxford University Press, 1964, p. 88.

[8] Cf. Stone, pp. 667-668 ("With this reassertion of parental authority in the early nineteenth century, the status of women inevitably declined", p. 667).

[9] Henry James, "Preface", *The Portrait of a Lady*, New York: Charles Scribner's Sons, 1908, pp. xiii-xv. Reprinted in Richard P. Blackmur, ed., *The Art of the Novel*, New York: Charles Scribner's Sons, 1934, pp. 49-50.

[10] James, pp. xv - xvi. Blackmur, p. 51.

[11] *The Letters of Philip Dormer Stanhope, Fourth Earl of Chesterfield*, London, September 5 (O.S.), 1748.

[12] Samuel Richardson, *The History of Sir Charles Grandison*, Oxford: Shakespeare Head Press, 1931, vol. I, p. 10.

[13] *Grandison*, vol. I, p. 68.

[14] *Grandison*, vol. VI, p. 325 ("What, my dear grandmamma, is the boasted character of those who are called HEROES, to the un-ostentatious merit of a TRULY GOOD MAN?"

NOTES TO CHAPTER II

[1] Cf. Frank W. Bradbrook, *Jane Austen and Her Predecessors*, Cambridge University Press, 1966, pp. 90-119.

[2] Cf. William H. Magee, "The Happy Marriage: The Influence of Charlotte Smith on Jane Austen", *Studies in the Novel*, vol. VIII (Spring, 1975), pp. 120-132.

[3] Frances Burney, *Evelina, or the History of a Young Lady's Entrance into the World*, ed. Edward A. Bloom, London: Oxford University Press, 1970, pp. 7-8. (Type face standardized).

[4] *Evelina*, p. 238.

[5] Cf. Dr. John Gregory, *A Father's Legacy to His Daughters*, 1774 (Edinburgh: A. Strahan, and T. Cadell, 1788). "But if you happen to have any learning, keep it a profound secret, especially from the men, who generally look with a jealous and malignant eye on a woman of great parts, and a cultivated understanding" (p. 122).

[6] *Evelina*, pp. 257, 267.

[7] *Evelina*, p. 325.

[8] J. M. S. Tompkins, *The Popular Novel in England, 1770-1800*, London: Constable & Co., 1932, p. 21.

[9] *Northanger Abbey*, p. 38.

[10] Fanny Burney, *Cecilia: or, Memoirs of an Heiress*, Dublin, 1801, vol. I, p. 4.

[11] *Cecilia*, vol. II, p. 374.

[12] In 1814 in *The Wanderer*, her last novel, Fanny Burney is much more outspoken about women's rights, but by then Jane Austen was nearing the end of her career and would not likely have been influenced by other novelists in her essential views.

[13] Cf. *Minor Works*, p. 199.

[14] Cf. "Memoirs of Charlotte Smith", *The Miscellaneous Prose Works of Sir Walter Scott*, Edinburgh: Cadell and Co., 1826, vol. IV, p. 51.

[15] Cf. Magee, pp. 123-128.

[16] Ann Radcliffe, *A Sicilian Romance*, London: J. Limberd, 1830 [1790], p. 2.

[17] *Northanger Abbey*, p. 38.

[18] *Pride and Prejudice*, p. 369.

[19] Cf. Magee, pp. 120-132.

[20] Jane West, *A Gossip's Story*, 2nd. ed., London: T. N. Longman, 1797, vol. 2, p.221. See also note 46 below. For a discussion of Jane West as an anti-Jacobin novelist, see Marilyn Butler, *Jane Austen and the War of Ideas*, Oxford: The Clarendon Press, 1975, pp. 96 - 103.

[21] Cf. *Jane Austen's Letters to Her Sister Cassandra and Others*, ed. R. W. Chapman, Oxford University Press, 2nd ed., 1952, pp. 256, 259. All references to the letters are to this edition.

[22] Hannah More, *Coelebs in Search of a Wife*, London: T. Cadell and W. Davies, 1809, vol. I, p. 239.

[23] Joseph Bunn Heidler, *The History, from 1700 to 1800, of English Criticism of Prose Fiction*, The University of Illinois Press, 1928, p. 171.

[24] Margaret Kirkham, *Jane Austen, Feminism and Fiction*, Sussex: The Harvester Press, 1983, p. 4.

[25] See note 5 above.

[26] Susanna Minifie, *Barford Abbey*, London, 1768, vol. I, p. 50.

[27] Cf. Erasmus Darwin, *A Plan for the Conduct of Female Education in Boarding Schools*, Derby, 1797, pp. 11, 62, 63, etc. Along with more academic aims, Darwin advocated teaching girls "softness of manner, complacency of countenance, gentle unhurried motion, with a voice clear yet tender, the charms which enchant all hearts!" (p. 11)

[28] *Persuasion*, p. 186.

[29] *Coelebs in Search of a Wife*, p. 239.

[30] Cf. Elizabeth Inchbald, *A Simple Story*, ed. J. M. S. Tompkins, London: Oxford University Press, 1967, p. 14.

[31] Cf. *Coelebs in Search of a Wife*, p. 14.

[32] Stuart M. Tave, *Some Words of Jane Austen*, Chicago: The University of Chicago Press, 1973, pp.10 - 11.

[33] Tompkins, p. 129.

[34] Charlotte Smith, *Celestina*, London: T. Cadell, 1791, vol. I, p. 125.

[35] Charlotte Smith, *Ethelinde, or the Recluse of the Lake*, London: T. Cadell, 1790, vol. I, pp. 50 - 53.

[36] Charlotte Smith, *Marchmont: a Novel*, London: Sampson Low, 1796, vol. II, p. 174.

[37] *Marchmont*, vol. II, p. 239.

[38] *Celestina*, vol. I. pp. 101, 128.

[39] *Celestina*, vol. IV, p. 26.

[40] Charlotte Smith, *Montalbert. A Novel*, London: E. Booker, 1795, vol. I, p. 75.

[41] Edward A. Copeland, "Money in the Novels of Fanny Burney", *Studies in the Novel*, vol. VIII (Spring, 1976), pp. 24 - 37.

[42] Cf. *Ethelinde*, vol. II, p. 139 ("'I am unhappy.--I want a companion, a friend, a rational being--and I meet only a fine lady, who sacrifices to the opinion of the weak and vicious, her health, her time, her fortune, and the peace of her husband".).

[43] *Pride and Prejudice*, p. 93.

[44] *Marchmont*, vol. I, p. 178. See pp. 4 above, 35 below, and ch. I, note 5, ch. II, note 70.

[45] Cf. Hazel Mews, *Frail Vessels, Woman's Role in Women's Novels from Fanny Burney to George Eliot*, University of London: The Athlone Press, 1969, pp. 9-21.
[46] Cf. for example *Ethelinde*, vol. III, p. 20; *Marchmont*, vol. I, pp. 54, 174 (and the "Preface"). See also Jane West's introduction to *A Gossip's Story*.
[47] Cf. Butler, p. 136.
[48] Cf. Butler, p. 30.
[49] Ann Radcliffe, *The Mysteries of Udolpho*, ed. Bonamy Dobrée, London: Oxford University Press, 1966, p. 5.
[50] Charlotte Smith, *Emmeline, The Orphan of the Castle*, ed. Anne Henry Ehrenpreis, London: Oxford University Press, 1971, p. 227. Cf. Butler, p. 39, who points out that *sensibility* became "a pejorative term" late in the eighteenth century, an interpretation of the research of Erik Erämetsä.
[51] Clara Reeve, *The School for Widows*, London, 1791, vol. I, p. viii.
[52] For a discussion of that genre, see Gary Kelly, *The English Jacobin Novel 1780 - 1805*, Oxford, 1976; cf. Butler, pp. 88 - 123; Mary Evans, *Jane Austen and the State*, London and New York: Tavistock Publications, 1987, pp. 64-80.
[53] Cf. *Mansfield Park*, p. 468.
[54] Charlotte Smith, *Desmond*, London: G. G. J. and J. Robinson, 1792, vol. II, p. 197.
[55] *Ethelinde*, vol. IV, p. 79.
[56] *A Simple Story*, p. 13.
[57] *The Mysteries of Udolpho*, p. 5.
[58] *A Simple Story*, p. 14.
[59] Sarah Burney, *Clarentine*, London, 1796, vol. II, p. 136.
[60] *Emmeline*, p. 2.
[61] Florence Hilbish, *Charlotte Smith, Poet and Novelist* (1749-1806), Philadelphia, 1941, p. 362.
[62] Cf. Eliza Blower, *Maria*, London: T. Cadell, 1785, vol. II, p. 203.
[63] *Clarentine*, vol. II, p. 174.
[64] *Emma*, p. 446.
[65] *Emma*, pp. 220, 165.
[66] *Maria*, vol. II, p. 201.
[67] Cf. *Maria*, vol. I, pp. 94 - 95 (where kissing is described as "a sound very much resembling that occasioned by the lapping of two canine animals in a soup-pot").
[68] Cf. Robert Palfrey Utter and Gwendolyn Bridges Needham, *Pamela's Daughters*, London: Lovat Dickson Ltd., 1937, especially Chapters IV ("Liquid Sorrow") and V ("Cut My Lace, Charmian"). For Jane Austen's early parody of hysteria see pp. 44, 46 below.
[69] *The School for Widows*, vol. II, p. 249.
[70] *Ethelinde*, vol. I, p. 8. Cf. Maria Edgeworth, *Belinda*, London: J. M. Dent, 1893 [1801], vol. I, p. 2, where the heroine's "character was yet to be

developed by circumstances". Cf. pp. 4, 28 above, and ch. I, note 5, ch. II, note 44.
 [71] *Marchmont*, vol. I, pp. 177-179.
 [72] *Emmeline*, p. 279.
 [73] *Maria*, vol. II, p. 181.
 [74] See p. 22-23 above.
 [75] Cf. the references to Delamere in "The History of England", *Minor Works*, pp. 144, 147.
 [76] *Minor Works*, p. 346.
 [77] See p. 44 below.
 [78] Cf. *Pride and Prejudice*, pp. 140, 366. See Tave, pp. 116 ff. for a discussion of the use of "novelistic jargon" in *Pride and Prejudice*.
 [79] Cf. Norman Page, *The Language of Jane Austen*, Oxford: Basil Blackwell, 1972, p. 152.
 [80] Cf. *A Sicilian Romance*, p. 3; *Ethelinde*, vol. I, p. 19; *Maria*, vol. I, p. 147.
 [81] Anne Henry Ehrenpreis discusses the increase in the emotional use of scenery from Charlotte Smith to Ann Radcliffe in her "Introduction" to Jane Austen, *Northanger Abbey*, Harmondsworth, Middlesex: Penguin Books, 1972, pp. 11-12.
 [82] Cf. Margaret Anne Doody, "George Eliot and the Eighteenth-Century Novel", *Nineteenth-Century Fiction*, vol. 35 (1980), p. 278.
 [83] *Emmeline*, p. 229.

NOTES TO CHAPTER III

 [1] Usually "Catharine", but sometimes "Catherine" or "Kitty"; "Percival", but sometimes "Peterson".
 [2] *Minor Works*, facing p. 242.
 [3] Cf. B.C. Southam, *Jane Austen's Literary Manuscripts*, London: Oxford University Press, 1964, pp. 15 - 16, 45 ff.
 [4] Cf. Q. D. Leavis, "A Critical Theory of Jane Austen's Writings", especially "II,*Lady Susan* into *Mansfield Park*", *Scrutiny*, vol. X, pp. 114-142, 272-294 (October 1941, January 1942); cf. pp. 61 - 87 (June 1941).
 [5] Frank W. Bradbrook, *Jane Austen and Her Predecessors*, Cambridge University Press, 1966, pp. 90 - 119.
 [6] See p. 27 above.
 [7] Cf. *Mansfield Park*, pp. 85 - 86.
 [8] Cf. *Minor Works*, p. 165; *Pride and Prejudice*, p. 279.
 [9] Cf. *Pride and Prejudice*, p. 279.
 [10] *Minor Works*, p. 200; *Northanger Abbey*, p. 113; *Mansfield Park*, p. 415.

[11] Margaret Kirkham, *Jane Austen, Feminism and Fiction*, Sussex: The Harvester Press, 1983, p. 32.
[12] *Letters*, p. 154.
[13] *Mansfield Park*, pp. 434-435.
[14] *Emma*, p. 17. Jane Austen assumes a similar ideal in describing Knightley's reaction to Emma's acceptance of his proposal: "Within half an hour, he had passed from a thoroughly distressed state of mind, to something so like perfect happiness, that it could bear no other name"; and Emma's "change was equal" (p. 432). Likewise the Crofts, whose marriage is a pattern of the ideal in the later novels, strike Anne Elliot as "a most attractive picture of happiness" (*Persuasion*, p. 168).
[15] *Persuasion*, p. 43.
[16] *Pride and Prejudice*, p. 23.
[17] *Pride and Prejudice*, p. 42; *Sense and Sensibility*, p. 93.
[18] *Minor Works*, pp. 198-200; cf.; *Northanger Abbey*, p. 73.
[19] Leroy W. Smith, *Jane Austen and the Drama of Woman*, New York: St. Martin's Press, 1983, p. 56.
[20] *Emma*, p. 446.

NOTES TO CHAPTER IV

[1] According to Cassandra Austen's memorandum (*Minor Works*, facing p. 242), Jane Austen produced a first version in the late 1790's. In 1803 she must have considered the (probable) revision of it as her most mature work, for she chose it as her first submission to a publisher, though the novel (in perhaps another revision) is now the least sophisticated of her six novels.
[2] Cf. Julia Prewitt Brown, *Jane Austen's Novels. Social Change and Literary Form*, Cambridge, Mass.: Harvard University Press, 1979, p. 55.
[3] Cf. not only the famous defense of the novel on pp. 37 - 38, but also Henry Tilney's praise of *The Mysteries of Udolpho* on pp. 106 - 108.
[4] See *Northanger Abbey*, p. 49; cf. p. 38.
[5] *Northanger Abbey*, p. 29; cf. p. 27 above
[6] See *Northanger Abbey*, pp. 104-105: "Catherine ... felt greatly relieved by Mr. Allen's approbation of her own conduct, and truly rejoiced to be preserved by his advice from the danger of falling into such an error herself".
[7] Barbara Hardy, *A Reading of Jane Austen*, London: Peter Owen, 1975, p. 171, suggests that the ending of *Northanger Abbey* is designed to draw attention to "the novel's realism". Jane Austen was frequently pursuing thematic and artistic plans simultaneously.
[8] Warren Roberts, *Jane Austen and the French Revolution*, New York: St. Martin's Press, 1979, p. 204.

NOTES TO CHAPTER V

[1] Leroy W. Smith, *Jane Austen and the Drama of Woman*, New York: St. Martin's Press, 1983, p. 74.

[2] Cf., for example, Lady Castlenorth in *Celestina*, Madame Cheron in *The Mysteries of Udolpho*, and Jane Austen's Lady Greville in "A Collection of Letters".

[3] P. J. M. Scott, *Jane Austen: A Reassessment*, London: Vision Press and Totowa, N.J.: Barnes and Noble, 1982, p. 85.

[4] Cf. Clara Reeve, *The School for Widows*, London, 1791, p. viii. The passage is quoted on p. 31 above.

[5] P. 303. Cf. W. A. Craik, *Jane Austen: The Six Novels*, London: Methuen, 1965, p. 39. Craik quotes Marianne's confession, "Had I died,--it would have been self-destruction" (*Sense and Sensibility*, p. 345).

[6] See p. 35 above.

[7] Cf. p. 140, where Jane Austen writes of Edward and Lucy, "The youthful infatuation of nineteen would naturally blind him to every thing but her beauty and good nature; but the four succeeding years--years, which if rationally spent, give such improvement to the understanding, must have opened his eyes to her defects of education, while the same period of time, spent on her side in inferior society and more frivolous pursuits, had perhaps robbed her of that simplicity, which might once have given an interesting character to her beauty"; cf. also p. 36.

[8] Jane Nardin, *Those Elegant Decorums. The Concept of Propriety in Jane Austen's Novels*. Albany: State University of New York Press, 1973, pp. 15 ff.

[9] Raymond Williams, *The Country and the City*, London: Chatto & Windus, 1973, p. 116.

[10] See p. 82 above.

[11] John Odmark, *An Understanding of Jane Austen's Novels. Character, Value and Ironic Perspective*, Oxford: Basil Blackwell, 1981, p. 9.

[12] P. 51; cf. p. 215: "Every qualification is raised at times, by the circumstances of the moment, to more than its real value; and she was sometimes worried down by officious condolence to rate good-breeding as more indispensable than good-nature".

[13] Craik, p. 53.

[14] Edward Copeland remarks on the unreality of the ending, saying that "The heroines of *Sense and Sensibility* (c. 1797) are saved not by their wits nor by any routing of the new-style villains, but only by the grace of their author, who grants them a couple of kindly eccentrics, who, with old-style Grandisonian generosity of purse, bail them out of trouble--and London" ("The Burden of *Grandison*. Jane Austen and Her Contemporaries", *Women & Literature*, n.s. Vol. III, ed. Janet Todd, 1983, p. 103).

NOTES TO CHAPTER VI

[1] *Letters*, p. 298.
[2] A. Walton Litz, *Jane Austen. A Study of Her Artistic Development*, New York: Oxford University Press, 1965, p. 101.
[3] Cf. Norman Page, *The Language of Jane Austen*, Oxford: Basil Blackwell, 1972, p. 28: "For the heroine, speech is the chief means of self-assertion."
[4] Cf. *Pride and Prejudice*, p. 279.
[5] Robert K. Wallace, *Jane Austen and Mozart*, Athens: The University of Georgia Press, 1983, p. 25.
[6] Cf. Susan Peck MacDonald, "Passivity and the Female Role in *Pride and Prejudice*", *Women & Literature*, vol. 6, no. 2 (Fall 1978), pp. 35 - 46, who analyzes "three aspects of the suffering implicit in the heroine's role--her lack of power, her frequent inability to speak, and her suffering from the aggression of others" (p. 40).
[7] Without Jane Bingley's idyllic marriage, Elizabeth's would surely seem only what P. J. M. Scott calls it, "an almost shamelessly juvenile phantasy. It is surely the adolescent girl's daydream" (*Jane Austen: A Reassessment*, London: Vision Press; and Totowa, N.J.: Barnes & Noble, 1982, p. 54). By contrast the Bingley marriage makes Elizabeth's look feasible in everyday life.
[8] Cf. *Pride and Prejudice*, pp. 193, 276, and also the deliberate torture of Elizabeth's emotions when her father reads her Collins's letter about herself and Darcy as lovers, and has her join in his twitting of the letter (pp. 363 - 364).
[9] She still deplored the "incivility" of love as well as the pure chance of love at first sight (p. 141; cf. p. 279).

NOTES TO CHAPTER VII

[1] *Letters*, p. 299.
[2] Marilyn Butler, *Jane Austen and the War of Ideas*, Oxford: Clarendon Press, 1975, p. 123.
[3] R. W. Chapman, *Jane Austen, Facts and Problems*, Oxford University Press, 1948, p. 194.
[4] Andrew Wright, *Jane Austen's Novels, A Study in Structure*, London: Chatto & Windus, 1953, p. 22.
[5] Lionel Trilling, "Mansfield Park", *Partisan Review*, vol. XXI (Sept.-Oct. 1954), p. 495.
[6] Lord David Cecil, "Jane Austen", *Poets and Storytellers*, London: Constable, 1949 [1935], p. 120.

⁷ Marvin Mudrick, *Jane Austen: Irony as Defense and Discovery*, Princeton University Press, 1952, pp. 155ff.

⁸ Howard S. Babb, *Jane Austen's Novels, The Fabric of Dialogue*, Ohio State University Press, 1962, p. 147.

⁹ W. A. Craik, *Jane Austen. The Six Novels*, London: Methuen, 1965, p. 92; Avrom Fleishman, *A Reading of Mansfield Park*, University of Minnesota Press, 1967, pp. 35-40.

¹⁰ Julia Prewitt Brown, *Jane Austen's Novels. Social Change and Literary Form*, Cambridge, Mass.: Harvard University Press, 1979, p. 100; P. J. M. Scott, *Jane Austen: A Reassessment*, London: Vision Press; and Totowa, N.J.: Barnes & Noble, 1982, p. 157; Alistair M. Duckworth, *The Improvement of the Estate. A Study of Jane Austen's Novels*, Baltimore: The Johns Hopkins Press, 1971, p. 55.

¹¹ *Letters*, p. 298.

¹² Cf. Chapman, pp. 195 - 196; Wright, p. 130.

¹³ Cf. Cecil, p. 107; R. Brimley Johnson, *Jane Austen. Her Life, Her Works, Her Family, and Her Critics*, London: Dent, 1930, p. 150.

¹⁴ Cf. p. 231 and especially p. 467, where the wording is unequivocal.

¹⁵ Wright, pp. 123 - 124.

¹⁶ Craik, p. 97; Mudrick, p. 179; Duckworth, p. 41.

¹⁷ Cf. Cecil, p. 112; Norman Page, *The Language of Jane Austen*, Oxford: Basil Blackwell, 1972, p. 81; Margaret Kirkham, "Feminist Irony and the Priceless Heroine of *Mansfield Park*", *Women & Literature*, n.s. Vol. 3, ed. Janet Todd, 1983, pp. 231 - 247.

¹⁸ Scott, p. 156; William H. Magee, "Romanticism on Trial in *Mansfield Park*", *Bucknell Review*, vol. XIV, no. 1 (March 1966), pp. 44-59.

¹⁹ Cf. *Mansfield Park*, pp. 125-127. Edmund notes "'*general* ... objections'" (unnamed), "'want of feeling on my father's account'", "'imprudent'" conduct "'with regard to Maria'", "'decorum'" and "'expense'".

²⁰ *Mansfield Park*, p. 176; cf. also p. 182, "'It is time to think of our visitors,' said Maria, still feeling her hand pressed to Henry Crawford's heart, and caring little for any thing else"; and pp. 191-192, "Maria was in a good deal of agitation. It was of the utmost consequence to her that Crawford should now lose no time in declaring himself, and she was disturbed that even a day should be gone by without seeming to advance that point".

²¹ Tony Tanner, "Introduction", Jane Austen, *Mansfield Park*, Harmondsworth, Middlesex: Penguin Books, 1966, p. 27.

²² Cf. *Letters*, p. 404 (Wednesday, 28 September, 1814. *Mansfield Park* had appeared in May): "I do not like him, & do not mean to like Waverley if I can help it--but I fear I must".

²³ Cf. *Pride and Prejudice*, p. 279.

²⁴ Mary Evans, *Jane Austen and the State*, London and New York: Tavistock Publications, 1987, p. 30; cf. pp. 54 - 55 ("the character in Austen's fiction who takes on the patriarchy at its most seductive and powerful is

Fanny Price.... Fanny's refusal of Crawford brings down on her head the full wrath of patriarchal rationality and authority.... Nowhere perhaps in all of Austen's fiction is male power so nakedly and unashamedly expressed").

[25] See p. 35 above.

[26] Cf. A. C. Bradley, "Jane Austen", *Essays and Studies by Members of the English Association*, vol. II (1911), pp. 9, 14 - 17.

[27] Juliet McMaster, *Jane Austen on Love*, Victoria, B.C., University of Victoria Literary Studies, 1978, p. 71.

[28] Cf. *Sense and Sensibility*, p. 140. At eighteen Fanny is younger than Elinor Dashwood, Elizabeth Bennet, Emma Woodhouse, and Anne Elliot even at the time of her first love for Captain Wentworth.

[29] David Monaghan, *Jane Austen. Structure and Social Vision*, London & Basingstoke, Macmillan Press, 1980, pp. 93, 95.

[30] Barbara Hardy, *A Reading of Jane Austen*, London: Peter Owen, 1975, p. 154.

NOTES TO CHAPTER VIII

[1] Nicholas Hans, *New Trends in Education in the Eighteenth Century*, London: Routledge & Kegan Paul, 1951, p. 208 ("The general impression which we get from the study of women's intellectual élite in the eighteenth century is that this élite was neither particularly wanted by society nor specially trained. These outstanding women were the results of individual accidental circumstances or in exceptional cases of specific abilities....").

[2] Cf. *Emma*, p. 421: "Had she followed Mr. Knightley's known wishes, in paying that attention to Miss Fairfax, which was every way her due; had she tried to know her better; had she done her part towards intimacy; had she endeavoured to find a friend there instead of in Harriet Smith; she must, in all probability, have been spared from every pain which pressed on her now."

[3] Henrietta Ten Harmsel, *Jane Austen: A Study in Fictional Conventions*, The Hague: Mouton & Co., 1964, p. 163.

[4] Cf. Juliet McMaster, *Jane Austen on Love*, Victoria, B.C.: University of Victoria English Literary Studies, 1978, p. 74 ("there are two kinds of rescue, the genuine and the spurious, and only one is the kind that arouses and deserves love. The spurious ones are such as are the staple of the usual romance, and are matters merely of chance.... The *real* rescue, the one that deserves return of love, is a moral act, a matter of choice....:).

[5] Cf. R. W. Chapman, "Jane Austen's Methods", *Times Literary Supplement*, February 9, 1922, pp. 81, 82; Andrew Wright, "Narrative Management; Points of View," *Jane Austen's Novels. A Study in Structure*, London: Chatto & Windus, 1953, pp. 36 - 82; Wayne C. Booth, "Control of Distance in Jane Austen's 'Emma'", *The Rhetoric of Fiction*, Chicago: The University of Chicago Press, 1961, pp. 243-266; A. Walton Litz, *Jane Austen*.

A Study of Her Artistic Development, New York: Oxford University Press, 1965, pp. 146 ff.

[6] Earlier in the novel Jane Austen mocks Emma's sudden delight in nature. When Emma was fondly anticipating the advent of her visionary hero, Frank Churchill, in Highbury, "she saw something like a look of spring" in Harriet's face, and "thought the elder at least must soon be coming out" (p. 189).

[7] Cf. William H. Magee,"Instrument of Growth: The Courtship and Marriage Plot in Jane Austen's Novels", *The Journal of Narrative Technique*, vol. XVII, (1987), pp. 202-203.

[8] Mary Evans, *Jane Austen and the State*, London and New York: Tavistock Publications, 1987, p. 24.

NOTES TO CHAPTER IX

[1] Published 1818; written 1815 - 1816 (Cf. *Northanger Abbey and Persuasion*, p. xiii).

[2] A contrary view, that Anne too is not forward-looking, is argued by Daniel P. Gunn, "In the vicinity of Winthrop: Idealogical Rhetoric in *Persuasion*", *Nineteenth-Century Fiction*, vol. XLI (1987), pp. 403 - 418. He feels that Anne is found to "suppress any impulse toward personal fulfillment" (p. 413), and that Wentworth comes to accept her view of marriage.

[3] *Sense and Sensibility*, p.38.

[4] Robert K. Wallace, *Jane Austen and Mozart*, Athens: The University of Georgia Press, 1983, p. 43.

[5] Cf. *Persuasion*, p. 189; see also Chapman's note, p. 273.

[6] The Cancelled Chapter is reprinted by Chapman on pp. 253 - 263 from J. E. Austen Leigh's *A Memoir of Jane Austen*. Cf. B. C. Southam, *Jane Austen's Literary Manuscripts*, Oxford University Press, 1964, pp. 86 - 99 for a close analysis of the many improvements.

[7] Cf. *Letters*, p. 484, "I have a something ready for Publication, which may perhaps appear about a twelvemonth hence." *Emma* took eight to nine months to appear after Jane Austen had finished it. Allowing for the time of printing and publishing, Jane Austen would have been able to spend another three to four months revising *Persuasion*. By comparison, the revised chapters are over three times the length of the cancelled chapter which they replace.

[8] Bernard J. Paris, *Character and Conflict in Jane Austen's Novels. A Psychological Approach*, Detroit: Wayne State University Press, 1978, p. 141.

[9] Barbara Hardy, *A Reading of Jane Austen*, London: Peter Owen, 1975, p. 191. Kenneth L. Moler, *Jane Austen's Art of Allusion*, Lincoln: University of Nebraska Press, 1968, p. 184, remarks: "Jane Austen thus carries on a rather complex definition of reality in terms of the formula of romance".

NOTES TO CHAPTER X

[1] Written "between 27 January and 18 March of 1817", *Minor Works*, p. 363. All references to *Sanditon* are to Chapman's edition in the *Minor Works*, pp. 363 - 427.

[2] Eleven of the twelve chapters in the fragment are sketches of perhaps half the length of the finished chapters in *Emma* and *Persuasion*. Apparently Jane Austen left the detail of incident and dialogue which might have given "my heroine" Charlotte the prominence of an Elizabeth Bennet or an Emma Woodhouse to be developed in a later draft (p. 395).

[3] Cf. *Sanditon, Minor Works*, p. 390: "She took up a Book; it happened to be a vol: of *Camilla*. She had not *Camilla*'s Youth, & had no intention of having her Distress". Significantly, in view of the comments on extreme youth and growing up in *Sense and Sensibility* and *Mansfield Park*, Charlotte Heywood is twenty-two (p. 374).

FURTHER READING

I. *Editions of Novels.*

A few novels by Jane Austen's feminine predecessors became available in scholarly editions in the 1960's and 1970's in the Oxford English Novels:

Burney, Frances. *Camilla.* Edited by Edward A. Bloom and Lillian D. Bloom, 1972.
Burney, Frances. *Evelina, or the History of a Young Lady's Entrance into the World.* Edited by Edward A. Bloom, 1970.
Inchbald, Elizabeth. *A Simple Story.* Edited by J. M. S. Tompkins, 1967.
Lennox, Charlotte. *The Female Quixote.* Edited by Margaret Dalziel, 1970.
Radcliffe, Ann. *The Italian, or The Confessional of the Black Penitents.* Edited by Frederick Garber, 1968.
Radcliffe, Ann. *The Mysteries of Udolpho.* Edited by Bonamy Dobrée, 1966.
Smith, Charlotte. *Emmeline: The Orphan of the Castle.* Edited by Anne Henry Ehrenpreis, 1971.
Smith, Charlotte, *The Old Manor House.* Edited by Anne Henry Ehrenpreis, 1969.

A few other editions of relevant novels have also recently appeared:

Burney, Fanny. *Cecilia.* Introduction by Judy Simon. London: Virago Press, 1986.
Smith, Charlotte. *Emmeline.* Introduction by Zoë Fairbairns. Pandora, 1988.

II. *Studies Linking Jane Austen to Her Predecessors.*

Bradbrook, Frank W. *Jane Austen and Her Predecessors.* Cambridge University Press, 1966.
Brown, Julia Prewitt. *Jane Austen's Novels. Social Change and Literary Form.* Harvard University Press, 1979.
Butler, Marilyn. *Jane Austen and the War of Ideas.* Oxford: The Clarendon Press, 1975.
Fergus, Jan. *Jane Austen and the Didactic Novel.* London and Basingstoke: The Macmillan Press, 1983.

Foster, James R. *History of the Pre-Romantic Novel in England.* New York: The Modern Language Association of America, 1949.

Grey, J. David, ed. *Jane Austen's Beginnings. The Juvenilia and Lady Susan.* Ann Arbor/London: U.M.I. Research Press, 1989.

Harris, Jocelyn. *Jane Austen's Art of Memory.* Cambridge University Press, 1988.

Heidler, Joseph Bunn. *The History, from 1700 to 1800, of English Criticism of Prose Fiction.* The University of Illinois Press, 1928.

Johnson, Claudia L. *Jane Austen. Women, Politics and the Novel.* Chicago and London: The University of Chicago Press, 1988.

Kelly, Gary. *The English Jacobin Novel 1780 - 1805.* Oxford: The Clarendon Press, 1976.

Kirkham, Margaret. *Jane Austen. Feminism and Fiction.* Sussex: The Harvester Press, 1983.

Lascelles, Mary. *Jane Austen and Her Art.* Oxford: The Clarendon Press, 1939.

Mayo, Robert D. *The English Novel in the Magazines, 1740 - 1815.* London: Oxford University Press, 1962.

Mews, Hazel. *Frail Vessels. Woman's Role in Women's Novels from Fanny Burney to George Eliot.* University of London: The Athlone Press, 1969.

Moler, Kenneth L. *Jane Austen's Art of Illusion.* University of Nebraska Press, 1983.

Pinion, F. B. "The Influence of Certain Writers on Jane Austen". *A Jane Austen Companion.* London and Basingstoke: The Macmillan Press, 1973. Pp. 158 - 179.

Smith, Leroy W. *Jane Austen and the Drama of Woman.* New York: St. Martin's Press, 1983.

Southam, B. C. *Jane Austen's Literary Manuscripts.* London: Oxford University Press, 1964.

Steeves, Harrison R. *Before Jane Austen. The Shaping of the English Novel in the Eighteenth Century.* London: George Allen & Unwin Limited, 1966.

Ten Harmsel, Henrietta. *Jane Austen: A Study in Fictional Conventions.* The Hague: Mouton & Co., 1964.

Thompson, James. *Between Self and the World. The Novels of Jane Austen.* University Park and London: The Pennsylvania State University Press, 1988.

Tompkins, J. M. S. *The Popular Novel in England, 1770 - 1800.* London: Constable and Co., 1932.

Utter, Robert Palfrey and Gwendolyn Bridges Needham. *Pamela's Daughters.* London: Lovat Dickson, 1937.

INDEX

Austen, Cassandra 42.

Austen, Jane:
 General--and the convention 1, 11, 13, 32, 171; artistry 11, 17, 34, 35, 38, 159; bookish living: 39, 163; comparisons with her predecessors 22, 24, 26, 28, 37, 40, 57; the ideal marriage 22, 31, 171, 172; Romantic enthusiasms criticized 30, 184nt9.

 Emma (including Miss Bates; Frank Churchill; Jane Fairfax; George Knightley; Harriet Smith; Anne Taylor Weston; Emma and Mr. Woodhouse)-- **135-153--women in the patriarchal village 135-139, Emma's bookish perspective 139-143, Emma and the convention 143-148, Emma as social leader 149-153.**
 and the convention 140, 141, 143-148, 151, 153, 175; artistry 69, 72, 119, 120, 131, 145-148; bookish living criticized 139-143, 164, 173, 186nt2; comparisons with Jane Austen's predecessors 4, 26, 33, 34, 36, 141, 152; the ideal marriage (and society) 55, 148-153, 155, 166, 167, 169, 171, 172, 182nt14; the patriarchy and women 18, 19, 53, 54, 135-139; Romantic enthusiasms 147, 151, 187 viiint6; other references 159, 187 ixnt7, 188nt2.

 Juvenilia--**41-62--increasing commitment to the convention** 32, **41-46**, 80, 122; **from parody to satire of bookish living 46-51**, 65, 66; **the patriarchy and women 51-57; artistry and the convention 57-62**, 63.

 "Catharine, or The Bower" (including Catharine Percival and Camilla Stanley)--and the convention 42, 45, **48-50**, 58, 62; artistry 49-50, 59, 60, 61, 62, 90; bookish living 48-49, 50; comparisons with Jane Austen's predecessors 16, 19, 105, 120; the ideal marriage 55, 57; Romantic enthusiasms satirized 66, women and the patriarchy 56, 58.

 "A Collection of Letters"--and the convention 44, 48; bookish living 42; women and the patriarchy 43, 183nt2.

 "Evelyn"--and the convention 45.

 "The History of England"--and the convention 42, 181nt75.

 "Lady Susan"--and the convention 42, 48, 61, 62, 97; artistry 43, 59; sensibility satirized 47, 80; other references 50.

 "Lesley Castle"--and the convention 58, 60, 62; bookish living criticized 42, 173; sensibility satirized 45, 47, 48, 80, 123.

 "Love and Freindship"--and the convention 25, 41, 48, 56, 57, 62; artistry 61, 123; bookish living satirized 46; sensibility satirized 43, 44, 47, 77, 80; Romantic enthusiasms satirized 47; other references 48.

 "The Three Sisters"--and the convention 45; artistry 59; the ideal marriage 54, 58; women and the patriarchy 23, 42, 48, 54.

 Volume the First--the convention satirized in "Edgar and Emma" 44; in "Frederic and Elfrida" 44, 61; in "Jack and Alice" 44, 61 (see also "The Three Sisters").

 Letters--51, 52, 117, 126, 159, 185nt22, 187 ixnt7.

Mansfield Park (including Sir Thomas, Edmund and Maria Bertram; Henry Crawford; Fanny Price; James Rushworth)--**113-134--the patriarchal society stultifying 113-115, 117-119, themes and moods 115-118, Fanny as a passive heroine of the convention 119-124,** *Lovers' Vows* **and the dangers of bookish living 124-129, the convention and an alternative society 129-134.**

and the convention 26, 33, 34, 62, 113, 116, 119, 122, 129-134, 175; artistry 35, 37, 43, 48, 51, 59, 113, 116, 117, 119-120, 122-123, 134, 159, 160; bookish living criticized 118, 123-129, 141, 164, 173; comparisons with the convention 16, 20, 22, 29, 38, 56, 61, 114, 119; Fanny as passive heroine 20, 22, 37, 118-124, 129, 133, 135, 144, 155, 159, 160; the ideal marriage 133-134, 166, 175; the patriarchy and women 3, 4, 31, 38, 52, 54, 67, 113-115, 117-119, 131, 133, 136, 173, 185-186nt 24; Romantic enthusiasms 48, 50, 82, 124, 126-129, 132, 134, 146, 159, 162, 163, 172; sensibility 119, 120-122, 123, 134, 151; social criticism (other than the patriarchy) 113-115, 117, 118, 135, 153, 156, 167, 168, 172; youth and education 131, 188nt3.

Northanger Abbey (including Catherine Morland; General, Frederick and Henry Tilney; and Isabella and John Thorpe)--**63-75--the convention dominant 63, parody of the convention 64-66, criticism of the patriarchy 67-69, the heroine of the convention matures 69-73, double use of the convention (parody and artistic framework, 73-75.**

and the convention 26, 28, 33, 43, 55, 63-64, 69, 73, 77, 88, 93, 116, 174; artistry 15, 16, 34-35, 38, 51, 63, 65-66, 68, 73, 83, 89, 117, 119, 129, 148, 182nt6; bookish living criticized 21, 65, 72, 111, 126, 141, 148, 175; the convention satirized 63, 77, 88, 93, early version 21, 42, 55; the ideal marriage 74-75, 95, 148; the patriarchy and women 67-68, 78, 95, 113, 135, 136, 157; praise of predecessors 17, 21; Romantic enthusiasms satirized 21, 66, 80, 91, 175; sensibility satirized 35, 43, 47, 65, 80.

Persuasion (including Anne, Sir Walter, and William Walter Elliot; Charles and Louisa Musgrove; Mrs. Smith; Captain Frederick Wentworth)--**155-170--the unvalued younger daughter and the patriarchy 155-158, the passive heroine of the convention developed 158-162, Anne's Romanticism and increasing independence 162-166, the ideal marriage outside the landed gentry 166-170.**

and the convention 1, 24, 25, 29, 62, 155, 158, 160-61, 175; artistry 159-160, 165-166; bookish living satirized 163-164; comparisons to Jane Austen's predecessors 27, 29, 43, 55, 155, 161, 164, 171; the ideal marriage 55, 166-170, 171, 172, 182nt14; the passive heroine 20, 29, 43, 113, 134, 155, 159, 161, 164-165; the patriarchy and women 3, 4, 22, 23, 54, 67, 78, 113, 155-158, 173; Romantic enthusiasms accepted 38, 43, 50, 155, 159-160, 162-163; social criticism (other than the patriarchy) 55, 166-170, 175; other references 1, 186nt28, 187 ixnt7, 188nt2.

193

Pride and Prejudice (including Mr., Mrs., Elizabeth, Jane and Lydia Bennet; Charlotte Lucas and William Collins; Fitzwilliam and Georgiana Darcy; Lady Catherine De Bourgh; and George Wickham)--**95-111**--**women and the patriarchy 95-98, degrees of escape from the patriarchy via the convention 98-102, artistic advances in the convention 103-107, the ideal marriage as the convention modified 107-111.**
the active heroine 56, 57, 103-107, 118, 119, 131, 134; and the convention 3, 28, 34, 38, 61, 98-102; artistry 22, 25, 34, 36, 37, 55, 62, 72, 89, 103-107, 120, 131, 134, 146, 159, 184nts3,7,8, 188nt2; comparisons to Jane Austen's predecessors 18, 19, 22, 25, 27, 29-30, 32, 36, 42; early version 21, 42, 55, 56, 102; humour, its merits and dangers 33, 97, 103-105, 113, 120, 174; the ideal marriage 22, 79, 107-111, 152, 169, 171, 184nt7; the patriarchy and women 4, 23, 53, 55, 95-98, 113, 135, 156, 174, 175, 184nt6; Romantic enthusiasms 38, 48, 109, 129, 151.

Sanditon--**172-174**--**and the convention 1, 172-174, 188nt3; bookish living satirized 173, 175; social criticism 171.**

Sense and Sensibility (including Elinor, Henry, John, and Marianne Dashwood; Mrs. and Edward Ferrars; Lucy and Nancy Steele; and John Willoughby)--**77-94**--**women and the patriarchy 77-79, excess sensibility in the conventional Marianne 80-84, approved sensibility in the artistically original Elinor 84-87, artistry and Elinor 87-93, the ideal marriage 93-94.**
artistry 35, 50, 82-83, 85, 88-94, 104, 105, 106, 108, 116, 119, 120, 172, 175, 183nt14; bookish living satirized 81, 126, 141, 164, 175; comparisons to Jane Austen's predecessors 18-19, 21, 24, 26, 28, 30, 34, 37, 38, 55, 61, 100, 159; the ideal marriage 28, 86-87, 94, 95, 98; the patriarchy and women 23, 53, 54, 77-79, 95, 135, 137, 156, 172; Romantic enthusiasms satirized 47, 122, 151, 163; sensibility approved 31, 34, 84-86, 103; sensibility satirized, 22, 31, 47, 50, 80-81, 84, 99, 100, 109, 111, 119, 121, 159, 183nt5; youth and education 131, 183nt7, 188nt3; other references 13, 21, 42, 55, 78.

"The Watsons" (including Lord Osborne and Emma Watson)-- and the convention 45-46, 57, 58, 59-60, 62; artistry 59-60, 61, 62, 63; the ideal marriage 52, 55; sensibility 58, 62, 80; women and the patriarchy 37, 42, 52, 53-54.

Austen-Leigh, James Edward 187 ixnt6.
Babb, Howard S. 115.
Baronetage, The 155, 169.
Bookish living 39-40, 41, 42, 46, 47, 50, 65-66, 80, 113, 123-126, 133, 140, 162, 163-164, 173, 174.
Barrett, Eaton Stannard: *The Heroine* 23, 64.
Bennett, Agnes: *Anna* 38.
Blower, Eliza: *Maria*--artistry 38; manners 34; sensibility 33, 36, 180nt67.

Booth, Wayne C. 186nt5.
Bradbrook, Frank W. 13, 43.
Bradley, A. C. 130.
Brontë, Charlotte: *Villette* 33.
Brown, Julia Prewitt 115.
Burney, Fanny: **convention setting** 10, **13-19**, 25, 36, 37; comparisons with Jane Austen 60, 87, 91; women and the patriarchy 3, 30, 178nt12; other references 22, 31.
Camilla **18-19**: and the convention 26, 27, 33, 36; comparisons with Jane Austen 18, 19, 21, 28, 37, 39, 65, 68, 70, 97, 113, 141, 145, 174, 188nt3; women and the patriarchy 18-19, 30, 37.
Cecilia **17-18**: and the convention 17-18, 28, 32; comparisons with Jane Austen 17, 18, 21, 36, 53, 59, 96, 145, 164; women and the patriarchy 18, 20, 28, 37, 53, 96, 156.
Evelina **13-17**: (including Lord Orville)--comparisons with Jane Austen 15-16, 36, 43, 56, 59, 62, 68, 70, 74, 77, 100, 101, 119, 148, 160, 171; convention setting 14-17, 21, 25-26, 28, 29, 32, 33, 36, 37, 39, 43, 62, 74, 109, 116, 174; manners 16-17, 34, 38, 89; women and the patriarchy 13-15, 17, 25-26, 29, 60.
Burney, Sarah: *Clarentine*--and the convention 30, 33, 40; the passive heroine and the patriarchy 22, 30, 118, 156.
Burns, Robert 174.
Butler, Marilyn 29, 113, 178nt20, 180nt52.
Byron, George Gordon, Lord 164.
Cecil, Lord David 115, 116.
Chapman, R.W. 115, 116, 177nt14, 179nt21, 187 ixnt6.
Chawton 50, 119.
Chesterfield, Philip Dormer Stanhope, Earl of 7, 8.
Congreve, William 9.
Convention in Jane Austen's novels 41, 42-43, 63, 69-75, 80-84, 103-111, 113, 123, 130, 133-134, 139-143, 151-153, 158-162, 171-172, 174-176.
Conventions in the feminine novels 1, 3, 13, 24, 32, 41, 50; beauty 8, 14, 18, 32, 33, 45, 64, 74, 82, 87, 99, 103, 119, 141, 143, 158-159; education 24-25, 44, 50, 56, 58, 159, 175; evil 29, 42, 48, 50, 58, 61, 71, 91, 109, 118, 124, 132, 173; fainting, fits, weeping 34, 44, 46, 73, 83, 93, 109, 122-123, 146-147; fortitude 33, 39, 78, 84, 136, 160-161, 170; frankness 33, 69, 99, 101, 141, 145, 152; gap of independence 14, 16, 17, 26-27, 28, 36, 69-70, 88-89, 107, 174; intelligence 8, 33, 39, 49, 55, 64, 70, 74, 88, 100, 106, 143-144, 159, 174; love triangle 16, 19, 35, 36, 65, 74, 91, 109, 132, 147, 166, 175; orphan 8, 14, 18, 36, 42, 45, 62, 64, 77-78, 140, 174; suitors 8, 14, 64, 103, 118, 165, 175; temper (sweet) 32, 34, 44, 45, 64, 103, 105, 144, 159; virtue 8, 28, 33, 48, 61; wit 14, 22, 38, 44, 56, 97, 98, 100, 103-105, 109, 119-120, 142, 174. (see also Courtship and marriage plot, Ideal marriage, Heroes in the feminine convention, Judging character, Sensibility and sentiment).

Copeland, Edward W. 28, 183 nt14.
Courtship and marriage plot 10, 13-14, 16-17, 19-20, 32, 36, 57, 60, 73-74, 91-93, 103, 110, 111, 116-117, 125, 133, 140, 147, 150-51, 165-167, 174-175.
Cowper, William 126, 173.
Craik, W. A. 81, 92, 115, 116, 183nt5.
Darwin, Erasmus 24, 179nt27.
Defoe, Daniel: *Moll Flanders* 10, 11; *Roxana* 10.
Doody, Margaret Anne 39, 116.
Duckworth, Alistair 115.
Edgeworth, Maria: *Belinda*--and the convention 21-22, 26, 29, 39; artistry 36, 39, 180-181nt70; comparisons with Jane Austen 21-22, 34, 36, 39, 53, 55, 152; the ideal marriage 22, 26, 53, 55, 152; women and the patriarchy 1, 3, 29.
Ehrenpreis, Anne Henry 180nt50, 181nt81.
Eliot, George 5.
Elizabeth I, Queen 51, 58.
Erämetsä, Erik 180nt50.
Essex, Robert Devereux, 2nd Earl of 42.
Evans, Mary 129, 148, 180nt52, 185-186nt24.
Fielding, Henry 9, 10, 61; *Amelia* 5; *Tom Jones* 2, 7 (Sophia Western), 10.
Fleishman, Avrom 115.
Gordon Riots 51.
Gray, Thomas 65.
Gregory, Dr. John 178nt5.
Gunn, Daniel P. 187nt2.
Hans, Nicholas 138, 186nt1.
Hardy, Barbara 134, 169, 182nt7.
Hays, Mary 22.
Heidler, Joseph 23.
Heroes in the feminine convention 2, 8-9, 10, 37, 68-69, 78-79, 91, 100, 116, 117, 136, 147-148, 165-167.
Heroine, Art of the Central 5-7, 11, 36-37, 43, 69-73, 82-87, 90-94, 102-107, 119-123, 130, 134, 140-153, 158-166, 170, 173, 175.
Hilbish, Florence 33.
Ideal marriage 19, 22, 53-55, 58, 62, 86, 87, 94, 109-111, 132-133, 150-153, 168-170, 172.
Inchbald, Elizabeth: *A Simple Story* (including Miss Fenton, Miss Milner, and Miss Woodley)--and the convention 29, 32, 33, 34, 119; comparisons with Jane Austen 22, 25, 62, 99, 119; women and the patriarchy 3,4.
Lovers' Vows (including Amelia and Anhalt)--bookish living (to Jane Austen) 116, 117, 118, 124-125, 132, 133; comparison to Jane Austen 129; Fanny Price and the play 120, 124, 127, 128, 131.
Independence (as an urge for women) 18, 19, 24, 27, 39, 41, 60-61, 113, 130, 158, 160, 164-166.

Inner characterization 6-7, 35, 72-73, 75, 83, 85-86, 90, 106, 120, 125-129, 131, 145-146, 159-160, 162-163, 175.
James, Henry: "Preface" to *The Portrait of a Lady* 5-6, 57, 72.
Joan, St. 6.
Johnson, R. Brimley 116.
Johnson, Samuel, 9, 25, 37, 38, 126, 172.
Judging character 15-16, 26, 30, 52, 56-57, 58, 70-71, 89-90, 99, 105-106, 120, 139-141, 143, 172, 173-174.
Kelly, Gary 180nt52.
Kirkham, Margaret 24, 51, 116.
Leavis, Q. D. 43.
Lennox, Charlotte: *The Female Quiote* 23, 64, 71.
Litz, A. Walton 103.
MacDonald, Susan Peck 107, 184nt6.
Mackenzie, Henry: *The Man of Feeling* 34.
Magee, William H. 116, 178nt2, 187 viiint7.
Manners (and domestic manners) 9, 10, 38, 41, 61, 167.
Mary, Queen of Scots 42.
McMaster, Juliet 131, 144, 186nt4.
Mews, Hazel 180nt45.
Minifie, Susanna: *Barford Abbey* (Fanny Warley) 24, 35, 44, 55.
Moler, Kenneth L. 187nt9.
Monaghan, David 133-134.
More, Hannah: *Coelebs in Search of a Wife* 23, 24, 25.
Mudrick, Marvin 115, 116.
Nardin, Jane 85.
Needham, Gwendolyn Bridges 180nt68.
Odmark, John 88.
Page, Norman 37, 116, 184 vint3.
Paris, Bernard J. 169.
Parody 23, 32, 34, 41, 42, 43-45, 46-48, 49, 63-67, 72, 74, 80, 83.
Patriarchy and restrictions on women 2, 3, 4, 5, 15, 23, 42, 45, 51-53, 60, 67-68, 77-80, 95-98, 113, 136-137, 156-158, 168.
Places in Jane Austen's novels--fictional: Barton, 82, 83; Cleveland 83; Donwell Abbey 136, 138, 149, 150; Everingham 118, 131; Hartfield 137, 138, 139, 146, 149; Highbury 135-153, 187 viiint6; Hunsford 100, 101; Kellynch-hall 155, 156, 157, 162, 168, 169; Longbourn 95, 100, 108, 109; Mansfield Park 113-117, 120-122, 126, 127, 133, 134, 141, 153, 167; Maple Grove 150; Meryton 102, 106, 107; Netherfield 100, 105, 107, 171; Norland 82, 90; Northanger Abbey 63, 65, 67, 70, 72, 73; Pemberley 95, 100, 101, 106-111, 113, 133, 153, 171; Rosings 100, 171; Sotherton 118, 120, 126, 129, 134; Uppercross 156, 158, 159, 162, 170; Winthrop 159, 162, 163.

Places in novels-real: Antigua 114, 120, 121; Asia 52, Bath 63-66, 70-74, 85, 155-159, 162, 164-169, 171, 174; Bengal 52, Box Hill 142-144, 148; Brighton 95, 99; Cumberland 38, 128; Devonshire 82; England 26, 29; France 26; Italy 127, 128; Kent 106-108; London 8, 11, 14, 17, 21, 27, 28, 34, 46 (Newgate), 51, 81, 82, 83, 90, 114, 115, 125, 142, 146; Lyme 29, 161-163, 170; Melrose Abbey 48; Oxford 3, 10; Portsmouth 26, 52, 114, 120, 121, 126, 129, 168; Sussex 82; Switzerland 26; Tintern Abbey 127; Wales 26.

Pope, Alexander 4, 65, 177nt5.

Radcliffe, Ann **20-21**: and the convention 65, 70, 119; bookish living (to Jane Austen) 65; comparisons with Jane Austen 20-21, 24, 31, 38, 49, 69, 70, 80, 119, 147, 159; Romantic enthusiasms 66, 147, 163-164; sensibility 20-21, 25, 30, 49, 80, 175; women and the patriarchy 3, 31, 159.

The Italian (including Ellena Rosalba and Schedoni)--and the convention 24, 33, 34, 40, 78; women and the patriarchy 21, 27.

The Mysteries of Udolpho (including Emily St. Aubert and Montoni)--and the convention 4, 21, 24, 29, 34, 35, 62, 67, 78, 109, 157; bookish living (to Jane Austen) 66, 95, 126; comparisons with Jane Austen 21, 62, 64, 66, 67, 81, 96, 109, 171, 183nt3; Romantic enthusiasms 38, 66, 81, 127, 163; sensibility 25, 30, 32, 34, 64; women and the patriarchy 4, 21, 53.

The Romance of the Forest (including Adeline La Motte)--and the convention 28, 29, 62, 72, 129; bookish living (to Jane Austen) 95; comparisons with Jane Austen 62, 64, 72, 129; sensibility 21, 34, 64.

A Sicilian Romance: 20-21.

Reeve, Clara: *The School for Widows*--and the convention 34; comparisons with Jane Austen 22, 31, 80, 88; sensibility 22, 31, 49, 80; women and the patriarchy 3, 88.

Richardson, Samuel: and the convention 1, 3, 11, 13, 35, 121, 173; artistry 6, 7, 8, 15, 35, 61, 72, 128, 175; sentiment 121, 128, 160; women and the patriarchy 2, 11.

Clarissa (including Belford and Lovelace)--and the convention 9, 27, 173, 175; artistry 7, 8, 11, 33, 35, 106; sentiment 9, 34; women and the patriarchy 2, 4, 5, 7, 30.

Pamela--artistry 7,8; sentiment 34; women and the patriarchy 2, 5, 7.

Sir Charles Grandison (including Harriet Byron)--**and the convention 7-9**, 13, 14, 15, 20, 21, 32, 33, 35, 37, 65, 68, 91, 100, 101, 148, 160, 174, 177nt14; the passive heroine 20; sentiment 9; women and the patriarchy 3, 10, 70, 166.

Roberts, Warren 75.

Romantic enthusiasms and Jane Austen (emotions, nature, places, poetry love)38, 46-49, 50, 66, 73, 81-83, 92, 93, 103, 109, 121-123, 126-129, 132, 146-147, 151, 162-163 (see also Sensibility and sentiment).

Satire 32, 37, 41-42, 45, 46, 48, 66, 74, 77, 80-84, 92, 98, 104, 116, 121-123, 125-128, 139-141, 145, 156, 173.

Scott, P. J. M. 77, 115, 116, 184nt7.
Scott, Sir Walter 20, 65, 126, 164, 174; *The Heart of Midlothian* 11, 36, 111, 164; *The Lay of the Last Minstrel* 47-48, 119, 123, 126; *Waverley* 185nt22.
Sensibility and sentiment 9, 30, 33, 34, 41-42, 43, 44, 46-50, 58, 64, 65, 66, 73, 80-81, 84-86, 92, 93, 94, 100, 119, 121-123, 128-129, 132, 146-147, 159-160, 162, 165-166, 170, 173, 174.
Shakespeare, William 5, 65, 117.
Sheridan, Richard B.: 38; *The Rivals* 10.
Smith, Charlotte: and the convention 19,33; comparisons with Jane Austen 22, 25, 38, 49, 55, 80, 102, 119, 129-130, 152, 159, 163; the ideal marriage 31, 55, 152; the passive heroine 119, 159; Romantic enthusiasms 47, 66, 147, 163; sensibility 49, 80; social criticism 31; woman and the patriarchy 3, 4.
Celestina--and the convention 20, 26; comparisons with Jane Austen 37, 53, 71, 163; Romantic enthusiasms 38, 47, 81, 95, 163; sensibility 30; women and the patriarchy 27, 37, 46, 53, 71, 183nt2.
Desmond--and the convention 20, 26, 141.
Emmeline, the Orphan of the Castle **19-20**--the active heroine 26, 29, 36, 118, 119; and the convention 19-20, 24, 26, 28, 33, 35, 55, 56, 62, 70, 140; bookish living 39, 46; comparisons with Jane Austen 24, 25, 36, 42 (Delamere), 58, 62, 70, 92, 101, 140, 156, 181nt75; sensibility 30, 36, 42; women and the patriarchy 19-20, 25, 15, 29, 38, 70, 156.
Ethelinde, or the Recluse of the Lake--and the convention 20, 34, 40, 64; artistry 35, 38, 132; comparisons with Jane Austen 25, 26, 38, 58, 120, 132, 171; the ideal marriage 28, 53, 179nt42; manners 26, 38, 171; the passive heroine 20, 120; Romantic enthusiasms 38, 95, 127; women and the patriarchy 31, 68, 77.
The Old Manor House--the passive heroine 20, 113; sensibility 34; women and the patriarchy 20, 27, 35, 36 (Monimia), 49, 114.
Marchmont (including Althea Dacres)--and the convention 29; artistry 28, 35, 129-130; comparison with Jane Austen 26; sensibility 36; women and the patriarchy 4, 27, 31, 38.
Montalbert: sensibility 36 (Rosalie Lessington); women and the patriarchy 27, 28.
The Young Philosopher--comparison with Jane Austen 31; social criticism 173.
Smith, Leroy W. 61, 78.
Social criticism re women 50, 58, 61, 98-102, 113-119, 129, 148-150, 155-158, 166-170, 171-172, 175. (See also Independence, Social escape for women, Social protest for women).
Social escape for women 39, 49, 124-129, 139-143, 175.
Social protest for women 2, 5,15, 23, 24, 25, 31, 39, 51, 133, 135-137, 155, 156. (See also Social criticism for women).

Southam, B.C. 181nt3, 187 ixnt6.
Steeves, Harrison R. 177nt1.
Sterne, Laurence: *Tristram Shandy* 6.
Stone, Lawrence 4, 177nts6,8.
Tanner, Tony 125.
Tave, Stuart M. 25, 181nt78.
Ten Harmsel, Henrietta 143.
Thomson, James 65.
Tompkins, J. M. S. 17, 26.
Trilling, Lionel 115.
Utter, Robert Palfrey 180nt68.
Wallace, Robert K. 106, 163.
Walpole, Horace 4.
West, Jane: *A Gossip's Story* 22, 37.
Williams, Raymond 86.
Wollstonecraft, Mary 1, 4, 22, 31.
Wordsworth, William 38, 127, 174.
Wright, Andrew 115, 116.